Wicked Women of DETROIT

TOBIN T. BUHK

THE
History
PRESS

Published by The History Press
Charleston, SC
www.historypress.com

First published 2018

Manufactured in the United States

ISBN 9781467138451

Library of Congress Control Number: 2018945678

CONTENTS

Introduction

SOMETHING WICKED
THIS WAY COMES

MURDER IN WAX, CIRCA 1899

Detroiters love a good murder mystery. They always have, long before
Detroit became the Motor City and even longer before it earned the dubious
nickname "Murder Capital." This fascination with horrific homicides goes
back to the gaslight era, when the most popular attraction in the city depicted
grisly recreations of murder and mayhem in wax.

This captivation with crime was evident in the long lines leading out of
the Wonderland, an amusement complex located at corner of Woodward
and Jefferson. The most popular attraction was the first-floor Chamber
of Horrors—a wax museum that re-created the late nineteenth century's
most heinous crimes with near photorealism. The blood-spattered exhibits
contained around a dozen tableaus peopled by over one hundred wax
villains. The flickering of dim gas lanterns added to the sinister aura.

As visitors strolled through the galleries, they could witness Kemmler
strapped into the electric chair moments before the executioner turned on
the juice; the room of Mrs. Mary Latimer, murdered by her son Robert, as it
appeared the day after police found her body propped against a chair in the
bedroom of her Jackson home; a Port Huron lynching victim dangling from
a tree; and other ghastly scenes.

Museum manager M.S. Robinson, a former lawyer from Chicago, had a
knack for staging scenes so revolting that the city's more puritanical succeeded

in shutting the wax museum down in 1890. After the mandated closure, Robinson reopened the Chamber with new and even bloodier scenes.

Detroiters loved it.

They spent hours studying the grim exhibits. It became so popular, particularly among women, that Robinson kept the Chamber open from 10:00 a.m. to 10:00 p.m. and enlarged the accommodations for ladies.

While Detroit's upstanding women watched their greatest nightmares materialize in wax, Michigan's most dangerous women lived and worked in the city's real Chamber of Horrors. The women's wing of the Detroit House of Correction housed sadistic serial killers, wives who murdered their husbands for insurance money, con artists, madams, prostitutes, shoplifters and others.

The Women's Wing at the Old Detroit House of Correction, circa 1899

On the eve of the twentieth century, the Detroit House of Correction—one of four state penitentiaries at the time and Michigan's sole institution for long-term female inmates—contained sixty-five women serving sentences that varied from several weeks for violations of minor city ordinances to life for the "big M." At any one time, the old House held about two to three women serving life sentences, and over its life span, from 1861 to 1926, it housed about three dozen women serving the maximum penalty allowed under Michigan law. Prison authorities did not segregate female inmates by crime, so these felons—the most dangerous women in Michigan—rubbed elbows with short-timers.

A *Detroit Free Press* article, written by a reporter who visited the Women's Wing of the House of Correction in 1899, captured a scene of the city's most wicked women paying their debts to society in one of the prison shops.

The women sat facing one another on long wooden benches, their flannel prison-issued dresses draping to the floor. An occasional whisper rose above the din, but this was a rarity since the prison matrons strictly enforced the silence rule. Their fingers jerked spasmodically as they sewed buttons onto cards—the partial penance they paid for prostitution, public drunkenness, theft and murder. Sunlight streamed in from a line of windows and fell onto the tables, and at least once during the shift, each one gazed through the bars at the world on the other side of the whitewashed brick wall.

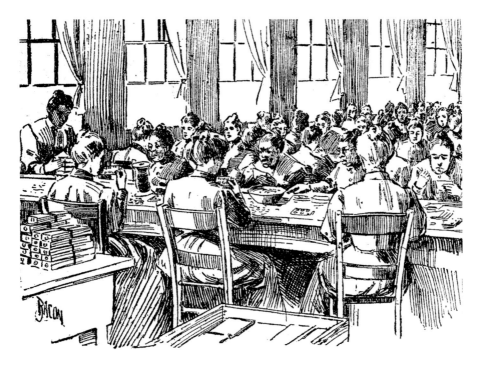

A *Detroit Free Press* artist sketched this scene of women inmates hard at work inside the House of Correction's prison shop in 1899.

The inmates all wore the same prison-issue garb, but they all took different paths into this room.

Although serious offenders once known in the papers as Pope, Echols, Roberts and Lawrence had swapped their surnames for inmate numbers and had disappeared from the public eye behind layers of brick and iron, they remained subjects of curiosity for years after the papers documenting their crimes had yellowed.

Nellie Pope, who conspired to murder her husband in 1895, frowned as a matron led a reporter into the factory. The matron thought it best to walk past the volatile Pope, known to use physical violence if she felt threatened. A head taller than the other inmates, the statuesque Pope was an intimidating and frightening figure best left alone.

Tucked into one corner of the room, Fanny Echols, whose murder of her husband fifteen years earlier led to a life sentence, toiled away at the buttons. The writer described Echols as "a buxom good-natured looking colored woman."

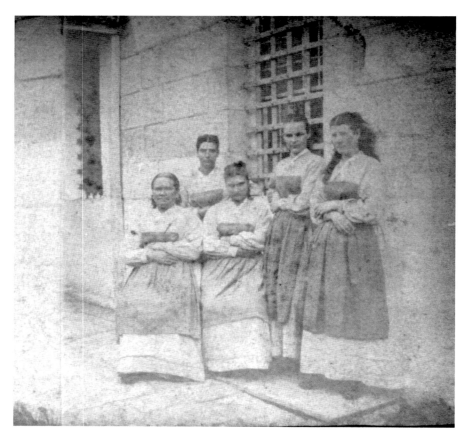

Woman inmates of New York's Sing Sing Prison pose for a photographer, preserving for posterity the prisoner's couture, circa 1870. Their "sisters" inside the big house in Detroit wore nearly identical prison-issued outfits, while the matrons wore all black. This stereograph formed part of a series, "Hudson River Scenery," by photographer Gustavus W. Pach. *Author's collection.*

Next to Echols sat convicted thief Dora Roberts. Dora and her husband, Walter, robbed a Champlain Street saloon owner of $200. A constable in the right place at the right time caught Dora with her hand in the cookie jar when, as he chased her out of the saloon, she dropped a roll of stolen greenbacks into a spittoon.

Alice Lawrence, who received twenty years for conspiring to murder her husband in Holland, raised her head and watched as the reporter slowly passed her bench. When their eyes met, Lawrence felt a pang of shame and quickly dropped her head.

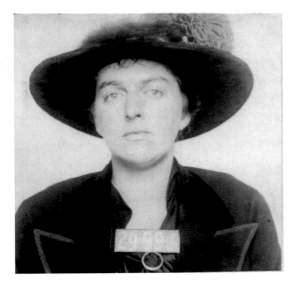

San Francisco Police mug shot of a notorious check forger from Detroit who went by several aliases. A repeat offender, she went to San Quentin in 1908 following her second California arrest. Before the advent of protective features on fiscal paper, check forgery became a popular endeavor among early twentieth-century women offenders, and such petty criminals made up the majority of female inmates inside the old Detroit House of Correction. *Author's collection.*

Most of the Women's Wing residents were serving brief sentences for any number of minor offenses, many of them leaving the House only to return later for identical convictions.

The matron led the reporter to a table where two gray heads bobbed in rhythm with their hands. Both women had done so many stints in the House for drunk and disorderly convictions that they considered it home.

The matron pointed to one of them: "That's Mary Scanlon at the end."

When she heard her name, Scanlon glanced at the writer just long enough to reveal a face crisscrossed with deeply etched furrows and skin the color and texture of an old paper bag. One side of her mouth curled up in a half-hearted attempt at a smile. "She's an old offender," the matron noted.

"Who's that?" The writer pointed at the woman sitting next to Scanlon.

"Oh, that's Ellen Bushey—this is her home, poor Ellen."

Scanlon and Bushey had plenty of company. A majority of the House's female residents served short-term sentences for public intoxication. Women such as Minerva Maxwell and Lizzie Lawson, who was once described as a "colored maiden of 31 summers," earned thirty days each as "tipplers."

Murderers like Nellie Pope fascinated the writer, but something about Scanlon and Bushey absolutely captivated her. In her article, she pointed out the double standard prevalent in turn-of-the-century law enforcement. "In the gilded café, the man in the dress suit drinks something to drown his sorrows," she noted. He becomes violent and smashes a window, but nothing happens to him.

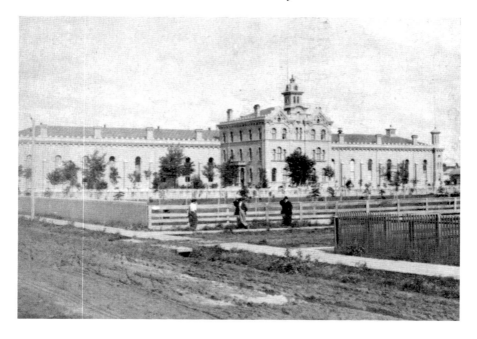

Left: This list, which is a composite of three pages from the 1910 U.S. Census, contains the names of all House of Correction inmates serving sentences lengthy enough to consider them residents. Five of them are lifers: Sarah Quimby, Nellie Pope, Jennie Flood, Mabel (Koren) Larson and Mary McKnight. *National Archives.*

Below: The morbid loiter in front of the Detroit House of Corrections, trying to catch a glimpse of an infamous resident or two. *Robert N. Dennis Collection of Stereoscopic Views, New York Public Library.*

"But it isn't so with the old gray-haired castaway. She has troubles, too, and tries to get rid of them. She begs a drink somewhere, and then crawls off into the alley. The policeman finds her, rings up the patrol wagon, and off she goes to jail."

The tone of the unnamed reporter's article, and the mentioning of this she-pays, he-doesn't-pay double standard, suggests the *Free Press* writer was a woman with an eye for social reform.

She had a point. Many of the women carding buttons in the prison factory that sunny afternoon in 1899 ended up inside the prison after convictions for public drunkenness. Other repeat offenders included shoplifters and liquor law violators: selling alcohol without a license, running a blind pig (an unlicensed saloon) or selling on a Sunday.

The residents of this House were the wicked women of Detroit.

The legal system that brought them to the House was much different than its twenty-first-century descendant. To fully understand their stories, it becomes necessary to examine law and order of yesteryear, particularly the role and treatment of women in the legal process.

FEMALE DETECTIVES, OPERATIVES AND MOLES

In the prim-and-proper world of the late nineteenth century, at a time when a man riding in a carriage with a married woman became a subject of scandal, female perpetrators had a leg up on male detectives. A gentleman didn't search a lady, especially if it involved any bodily contact. And he certainly couldn't go undercover without whispers that he was in bed with his suspect—an accusation not unknown to Detroit constables, particularly those who worked vice cases involving brothels. Sometimes, these investigators literally went under the covers with madams and their inmates as payment for looking the other way, which led to good copy for reporters but migraines for police chiefs (see chapter 8, "The Great Bordello Scandal"). Police brass attempted to avoid such scandals by hiring female operatives.

The stories of these operatives, who often shielded themselves with anonymity, are fragmentary and present an interesting challenge for the historian. They also represent some of the most interesting tales in the history of the Detroit underworld.

Sometimes, they worked in an official capacity, like Theresa Lewis (see "Blood Feud"); sometimes, like Annie Smith, they worked as unofficial

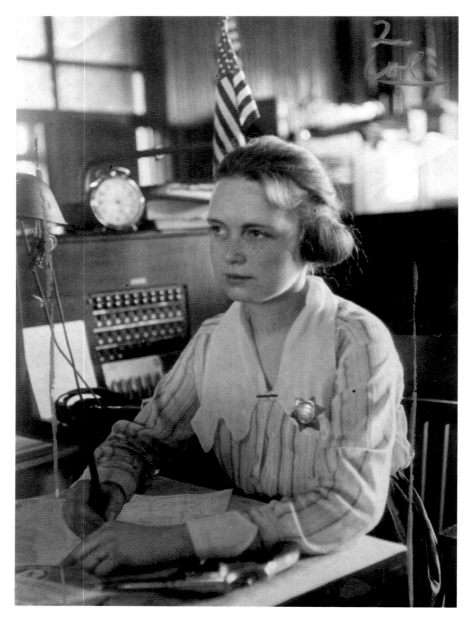

As suffrage neared reality, police departments began to hire more female operatives, such as Viola Lorenzen. The nineteen-year-old, who worked telephones at Chicago's River Forest Police Station, expressed an interest in police work. In 1918, she became Sergeant Lorenzen. When interviewed about his female sergeant, Chief R.C. Goss said that he noticed a lot less profanity around the station, since the suspects brought into the station didn't want to swear in front of a lady. *Author's collection.*

informants with ulterior motives of their own. Smith wanted to rid old Delray of the competition, so she had no qualms about betraying her fellow madams for offenses like violating the city's liquor laws (see "The Great Bordello Scandal").

Minnie McMurray, a crusading do-gooder who characterized herself as a "high-class detective," played a key role when, in 1906, Detroit authorities decided to crack down on physicians practicing without licenses. McMurray slipped undercover as an ailing patient, purchased a bottle of "Juniper Jelly" from "Dr." Eliza Landau for one dollar and subsequently trapped the elderly woman for practicing medicine without a license.

Female private detectives working in a quasi-official capacity, as well as full-time female officers hired as Prohibition agents, also played a key role in busting bootleggers during the Roaring Twenties. They succeeded in large part because they could put their hands where male agents couldn't.

Because a male agent didn't dare frisk a female suspect and therefore couldn't find her hidden stash, perhaps tucked into a brassiere or a stocking, bootleggers were quick to exploit the loophole by employing female smugglers. These bottle smugglers effortlessly slipped through the grasp of agents until U.S. Customs officials wised up and hired female operatives to conduct searches on women suspected of violating Prohibition laws (see chapter 11, "The Women of Wet Detroit").

FEMALE SUSPECTS, REPORTERS AND "JUNIOR G-MEN"

Sometimes a male suspect walked into a police station and, after a vigorous interrogation with a blackjack or rubber hose, limped back out of it. Because police didn't want the prying eyes of the press to see evidence of this heavy-handedness, they kept reporters away from men in custody.

This desire to avoid accusations of impropriety had the opposite effect when it came to female suspects. Often, police allowed reporters to sit in on official interviews with women accused of crimes, and in this context, reporters became de facto detectives who even posed questions to the accused. Quick to point out an inaccuracy, discrepancy or downright lie, they helped police identify soft spots in a suspect's story or holes in an alibi. This "Junior G-man" status is best illustrated by the story of Gertrude Schmidt, who had to face a hostile crowd of reporters that shadowed her every move (see chapter 10, "Bluebeard's Women").

The result of a reporter's semi-official status is a historical legacy to true crime buffs. Entire impromptu conversations with female suspects, which would never appear in court records or police files, have survived in the historical record through newspaper articles, in which women accused of crimes are fleshed-out through dialogue, description and nuances such as facial expressions and hand gestures.

This Is a Man's, Man's, Man's World...

The trials of high-profile, headline cases became popular forms of entertainment, particularly among women, who often overpopulated the single pew assigned to them in the courtroom. This overcrowding became such a problem, newspaper reporters regularly carped about straining their necks to see over the broad brims and massive floral decorations of the era's "Merry Widow" hats. The drama that occurred behind courtroom doors, such as tearful admissions, verbal sparring, and vivid descriptions of sexual impropriety—especially interesting to spectators since these types of things did not appear in the expurgated print media of the day—doubled as reality entertainment in an era long before television came into existence.

There was one place in the courtroom, however, strictly off limits to women: the jury box. Except in a few western territories, juries consisted entirely of men until women achieved the right of suffrage.

While this male-centric jury system bothered many women on the right side of the law, it pleased many on the wrong side of it, particularly women accused of murder.

Illinois state attorney John E.W. Wayman of Chicago, who faced an epidemic of husband slayings in 1912, criticized the male juror as putty in the hands of a manipulative female murder defendant. After watching, helpless, as all male-juries acquitted one defendant after another despite overwhelming evidence of guilt, Wayman concluded it was nearly impossible to convict a woman of murder under the current system and so became an early advocate of judicial reform.

According to Wayman, the male juror's inability to see a female defendant with any objectivity became particularly evident when the woman stood accused of murdering her spouse. "The ordinary man such as a juror is finds it difficult to differentiate between an exceptional and abnormal woman, as most murderesses are, and the everyday woman he

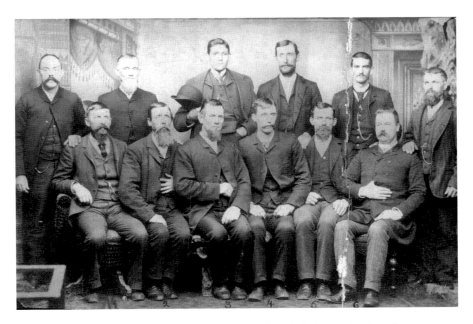

Cabinet card of a typical nineteenth-century jury. All-male juries persisted until women achieved suffrage in 1920. *Author's collection.*

has known since he was a boy," Wayman argued during a 1912 interview. "When a woman appears for trial before him, straightway in his own mind he manufactures some extenuating circumstances, some excuse, to account for her commission of the murder."

Wayman provided an interesting dissection of the male juror's perceptions of female defendants:

> *He feels sure that this woman who looks so much like the women of his own family must have been abused and hounded and driven insane by the cruelty of the man she killed. So in almost all cases the juror, unsophisticated in the subtle psychology of the woman criminal, has made up his mind long before he retires to the jury room that the woman on trial committed her crime during some violent brain storm that rendered her irresponsible.*

When asked if a female defendant needed to be good looking to beat the murder rap, Wayman responded, "Not at all. All that is necessary is for her to be a woman. A jury of men will do the rest."

He then went on to explain how appearance swayed a jury:

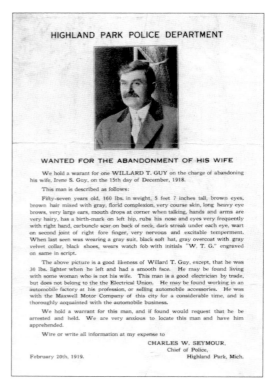

It (was) a man's, man's, man's world. Just before Christmas in 1918, Willard Guy walked out on his wife for another woman. Left high and dry, which meant nearly destitute without Willard's income, Irene took her complaint to Highland Park top cop Charles Seymour, who issued this wanted notice in February 1919. Willard later returned to Irene, who more than likely gave him a black eye and then gave him a steak to put over it. The couple lived together for the rest of their lives, until Willard's passing in August 1933. Just four months later, Irene died of a broken heart, literally, when she suffered a sudden cardiac death. While spousal abandonment remains on the books in many jurisdictions, it is rarely prosecuted today. *Author's collection.*

Jurors being ordinary men, read a woman's character through their eyes. If she looks like an ordinary woman they rate her as an ordinary woman. If she is pretty they are sure she is not guilty. If she has a certain motherliness they know her to be innocent. The most eloquent prosecuting attorney— and the prosecutor in such cases is usually as popular as the villain in the play—could not make them believe that the face of a saint sometimes hides the heart of a fiend.

The male juror, he continued, "does not understand a normal woman's mental processes. When it comes to dealing with the mental processes of an abnormal woman he is a rudderless bark on an uncharted sea drifting helplessly and hopelessly."

Crafty women facing all-male juries quickly realized how to take advantage of these "rudderless" jurors. Notorious con artist Carrie Perlberg, who made her living by fleecing the naïve, yanked hard on the jurors' heartstrings when she noted that a conviction would leave her poor child motherless

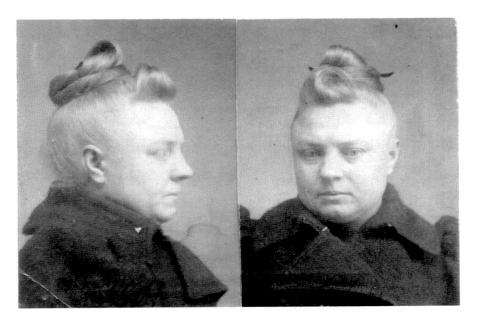

Mug shot of Carrie Perlberg, circa 1903, a confidence artist and thief who once rented a baby to score sympathy points with the all-male jury at her trial—a gambit also used by Isma Martin. *Author's collection.*

and destitute. None of the jurors knew, or even suspected, that the childless Perlberg had rented the baby from a friend for her appearance in court. Her ploy worked. She beat the rap despite overwhelming evidence of her guilt.

"There is but one remedy," Wayman concluded. "That is, to give women the right to serve on juries."

The idea of a female juror was like arsenic to female defendants such as Louisa Lindloff, a serial poisoner tried for murdering half a dozen victims in 1912. "I want no women to sit on the jury that tries me," she emphatically stated. Lindloff felt she could easily turn twelve men, but with the addition of even one woman, the dynamic changed and the jury became much harder to fool with emotional rhetoric.

This home-court advantage disappeared as women began to claim their role in the judicial process with the passage of suffrage laws. This seismic shift in the courtroom landscape generated shock waves that especially shook up old-timers who stubbornly held onto old-school thinking about a woman's rightful place. The earthquake hit Michigan in 1919.

That year, Michigan women began appearing in the jury box, to the chagrin of some men who feared the maternal instinct would emerge during

Portrait of Chicago's Louisa Lindloff, the so-called seer tried for half a dozen murders in 1912. Lindloff feared no man but was positively terrified of the woman juror. "I want no women to sit on the jury that tries me," she said. *Author's collection.*

deliberations and prevent female jurors from making rational decisions based on cold, hard logic.

A 1920 *Detroit Free Press* editorial reflects this age-old stereotype: "Whether a woman juror is fair or partial, whether she is swayed more by emotion or by intellect, in short, whether she makes a different sort of juror from a man, is to be tried."

Progress was particularly slow in Detroit.

Although women served in justice court as early as 1919, it wasn't until May 1921 that Margaret McDonnell blazed a trail as the first woman juror in Wayne County circuit court. Others were not quick in following her through the thicket of male-dominated jurisprudence. The September 1921 court session contained a lone woman juror—Estella Jamieson—and the January 1922 session contained just 2 women in a pool of 188. The number of women jurors increased to 14 in 1923, and from that point on, juries consistently contained at least 1 female member.

These pioneers in the jury box were well respected by people within the system. In a 1927 interview about the subject, Detroit circuit court judges Harry J. Dingeman and Joseph A. Moynihan praised woman jurors for their attentiveness. "I notice that they take careful notes of testimony as it is given," Dingeman said, "and I am more and more impressed with the keen grasp they have of business details that, seemingly, would be foreign to their usual mode of life."

"Criminal work is naturally distasteful," Moynihan added, "but never once has a woman asked to be relieved from sitting on a jury in my courtroom even when she was told that the testimony would be salacious."

Assistant prosecutor Ben Cole's comments provide a glimpse at how male lawyers felt about women jurors' perceptions of criminality:

> *A woman of advanced years, in my opinion, is apt to be too sympathetic to serve in criminal cases. But I find the same thing is true of the old men, so that is not a criticism of women, as women. A young woman is apt to have the same failing, but the young man may have the same weakness. I do believe that the woman of mature years is a distinct help to a prosecutor in criminal cases, especially where women are on trial.*

Cole added that he would not want a woman juror if he was defending a woman. "They understand motives as a man can never do, and I find they weigh the motives dispassionately in researching conclusions." In other words, female jurors were just too hard to fool with mere rhetoric alone.

A Coven of Wicked Detroiters

Finding enough wicked women to fill this volume posed less of a problem than determining which ones were wicked enough to warrant inclusion. I shied away from cases involving justifiable, excusable or understandable homicides, such as an abortionist convicted of manslaughter for accidentally killing a pregnant patient or a battered wife forced into a kill-or-be-killed scenario by a Jekyll-and-Hyde drunk of a spouse. I also avoided garden-variety murders without a unique feature or fascinating twist and instead gave special consideration to cases involving feuding women or women investigators. I also selected cases representative of the various eras so the reader may follow the development of Detroit through some of its most inglorious moments. Not all of the cases involve violent crimes; indeed, some of the most fascinating stories involve con artists, thieves, smugglers and bigamists.

To be fair, not all of the wicked women in this volume were all that wicked. Some of them were only perceived as such in their time, which made them eligible for inclusion. The wickedness of the Bluebeard's Women, for example, was more of a media construct than a reality. The anti-German sentiment that overtook Detroit during World War I, coupled with the circumstances of the case, conspired to condemn the two women in the eyes of dyed-in-the-red-white-and-blue newspaper-reading Americans. Wipe off the mascara of media sensationalism, and sometimes clearer and cleaner (although not necessarily spotless) faces appear.

Those familiar with and interested in the mean streets of the Motor City might recognize more than a few of the place names mentioned throughout this text. Some of the places are still standing, and most of the streets still exist. If these places could talk, they would tell of wily, wicked women who did their share to turn Detroit into Murder City, USA.

To meet them, turn the page, but beware, this is not a trip for the faint of heart.

1

ALL IN THE FAMILY

(1870)

*S*he was a strange figure with a shadowy past, condemned by the press as having a "depravity of human nature that is horrible beyond anything developed [in Detroit] for many years." Detroit reporters dubbed her the "Colored Lucretia Borgia," and her case was so shocking that the story spread from the midsized midwestern metropolis to the headlines of the nation's largest newspapers.

No known photographs of Virginia Doyle exist, but the historical record has left some tantalizing clues. Census records describe her as "white," her death record describes her as "black" and newspapers characterized her as "mulatto." Born a slave in Virginia in 1833, she may have ridden the freedom train to station one—Detroit—along the western route of the Underground Railroad.

Once in Detroit, Doyle joined a growing enclave of former slaves who settled in the vicinity of Beaubien Street. Death seemed to follow her every step, and in 1870, she became the focus of a headline crime that both stunned and bewildered Detroiters. The case also taught the reading public to be wary of pudding and port wine served up by overly ambitious relatives.

Nineteen-year-old George Talliaferro began to wonder if some strange curse had descended on the house at 274 Beaubien near Mechanic, where he lived with his grandmother Catherine De Baptiste and his best friend, James E.D. Ellis. The hardy De Baptiste had an iron constitution that served

her well in the harsh climate of Michigan, but in February, she suffered from the first in a sequence of sudden, violent illnesses.

Talliaferro had cause for concern. De Baptiste was the family matriarch and the only real mother he knew—a woman he called "Ma." His birth mother and De Baptiste's daughter, Virginia Doyle, lived in another part of the city. She kept her distance, rarely visiting unless she wanted something. At some point, De Baptiste and her daughter had a falling-out; there were whispers, but whenever the issue arose, De Baptiste dismissed it with a grunt and a wave of her hand. Then, suddenly and unexpectedly, Doyle showed up on De Baptiste's stoop in mid-February. The first bout of Ma's mysterious illness occurred a few days later.

It was a serious omen. Several people closely associated with Virginia Doyle had an unexpected visit from the angel of death.

Doyle came with baggage that included three husbands, two of whom died untimely and highly suspicious deaths.

A longtime friend of the family, James Ellis knew all about Virginia's marital history. Her first husband—George's father—died about fifteen years earlier. He suffered from sudden, acute stomach pain and died in bed amid whispers of "arsenic."

History repeated itself when Virginia remarried a few years later. Her second husband died after a sequence of crippling stomach pains left him prostrate and weak. On his deathbed, he confided to Ellis that he suspected Virginia had poisoned his food and asked Ellis to order a postmortem.

The postmortem never took place, but Ellis witnessed something sinister that convinced him Virginia had something to do with her second husband's demise. Just days after the suspicious death, Virginia hired a boy to shimmy under the crawl space beneath her house. Ellis watched as the boy emerged, carrying a packet of white, crystalline substance that Virginia promptly tossed into the stove.

Virginia went on to husband number three—a mechanic from New York named Doyle who boarded in Virginia's house. When Doyle left for New York on February 15, he suggested Virginia go to stay with her mother on Beaubien. At least, that was the story Doyle told when she knocked on De Baptiste's door.

Three days later, Catherine De Baptiste suffered a sudden bout of illness after Virginia served her a saucer of pudding. Just minutes before the near-fatal desert, Ellis had noticed Virginia dividing the pudding into sections and ladling the portion for De Baptiste into a saucer. De Baptiste immediately felt "awful strange." A dull sense of nausea became knots in the stomach that quickly evolved into agonizing abdominal cramps.

Ellis called Dr. Edward Kane, who administered an emetic to purge the old woman's stomach. After De Baptiste vomited up the "mush," she began to feel better.

The next day, the pains returned after De Baptiste downed a baked apple served up by Virginia. Since Dr. Kane's treatment during the previous incident seemed to work, Talliaferro raced to the nearest chemist and purchased castor oil to induce vomiting. When De Baptiste recovered, Ellis and Talliaferro told her they thought Virginia was trying to poison her. Incredulous, she demanded proof before she would ever believe such a thing.

Ellis vowed to stop Doyle. He put all of the food prepared for De Baptiste under lock and key and set a trap. He made a bottle of beef tea, marked the cork, set it on the dining room table and left the house for twenty minutes. He figured Doyle would jump at the opportunity to make another attempt on De Baptiste. Sure enough, when he returned, the mark on the cork indicated that someone had tampered with it.

Talliaferro and Ellis confronted Doyle, who predictably denied everything.

Doyle's next opportunity came on February 23, when De Baptiste asked Talliaferro to buy her some port wine. Ma poured a large glass for herself but left it on the dining room table when she went upstairs to bed. Remembering the goblet, she sent George to fetch it for her.

Talliaferro found the glass sitting in the exact spot where De Baptiste said it would be, but he also noticed something strange: white flakes floating on the surface. He looked at Doyle, who was sitting at the table. "My grandmother didn't want any sugar in this," he said. Doyle shrugged. She turned her head as Talliaferro sipped the wine.

It didn't taste sweeter or different than any other port wine he'd had, so he went ahead and served it to De Baptiste. Both he and his grandmother spent the night writhing with sharp stomach pains. When Talliaferro awoke the next morning, he found the half-filled wineglass sitting on the night table besides De Baptiste's bed. White specks hovered at the bottom of the glass.

He took it downstairs to the kitchen and poured off the wine, leaving just a little fluid and the mysterious white sediment in the glass. He and Ellis were studying the sediment when Doyle came into the kitchen. Talliaferro

pointed out the white stuff to Doyle and asked her how she thought it got there. "I don't know," she said, her voice filled with irritation. "I don't know."

In an act of stunning defiance, Doyle hoisted the glass and sipped the strange lees, swishing it around in her mouth. She stared at the boys for a few seconds, her cheeks bulging and eyes glistening, then ran outdoors and spit it out on the paving bricks.

When Talliaferro said he wanted to have the contents of the glass tested by a chemist, Doyle's eyes widened for a moment, then narrowed as she smirked—an expression that seemed to say he was being paranoid. At this point, George Talliaferro later testified, he became convinced that he and Ellis had foiled an attempt to poison "Ma" De Baptiste.

Talliaferro took the glass up to De Baptiste, who remained in bed weak from a night of retching, and asked her to hide it some place where Doyle would not find it.

He knew Doyle would begin searching for the evidence that could convict her.

Once again, he correctly anticipated Doyle's next move. After chopping some wood in the yard, Talliaferro came inside to warm up and found Doyle upstairs hunting for the glass on the pretense of making the beds. He gave the "smoking" glass to Ellis, who locked it in a bureau. For the next few days, they moved the goblet from hiding place to hiding place to keep Doyle from finding, and destroying, the sinister evidence it contained.

A few days later, Talliaferro tiptoed out of the house and took the glass to chemist Alfred F. Jennings. The chemist confirmed Talliaferro's suspicions: the white powder residue at the bottom of the glass was the heavy metal poison arsenic. Jennings estimated that the wine glass contained as much as five grains—more than enough to do-in Ma De Baptiste.

The chemist's findings put Virginia Doyle in a cell at Central Headquarters and in the headlines. A *Free Press* reporter described the accused poisoner: "She took the matter very coolly, wearing a countenance not at all anxious, and smilingly declaring her belief that she would get some one to bail her."

As the trial approached, public fascination with the mysterious figure grew. The soft-spoken thirty-seven-year-old Virginia native with a light southern drawl captivated the reading public. In between shots of whiskey at the local saloon or over tea in the family parlor, Detroiters debated the case, and for the first time, many of them heard the word *matricide*. What, they wondered, would motivate a woman to poison her own mother?

Talliaferro supplied one possible answer to this question when he testified at the preliminary hearing. De Baptiste owned her house, which sat on a sizable piece of real estate. Upon De Baptiste's death, Virginia Doyle would inherit the property.

The trial opened to a packed house on April 9, 1870.

Detroit's sizable population of female crime aficionados and armchair detectives, whose thirst for melodrama was quenched by high-profile murder trials, flocked to the courthouse. These shows—the best plays in town—always attracted a large audience of women. When they overflowed the women's section of the gallery and spilled out into other rows, they drew the ire of reporters who had to crane their necks to see over a line of gaudy hats.

Many of them had watched the trial of Rosa Schweisstahl a year earlier, and the inevitable comparisons emerged in hushed conversations from the courtroom gallery. Both Schweisstahl and Doyle chose arsenic to do their dirty work but for different reasons. Schweisstahl used poison to remove one lover and make room for another, whereas Doyle spiked her mother's food to acquire her property.

Jennings testified about finding arsenic in the wine glass. "I analyzed the contents of the glass brought to me by the last witness and discovered them to be arsenic. Some portion of it was found up along the rim, therefore I judge that there had been a greater quantity in the glass than there was when it was brought me."

The chemist explained how a heavy metal poison would interact with port wine.

It is not more soluble in wine than in water. If you put it in water, particles will float, and if a person should drink what would float on top of a glass of wine, it would kill him. Wine being denser than water a greater quantity will float on wine than upon water. I think that if the arsenic which I found in that glass had remained in the wine all night, it would have been almost entirely dissolved.

So, Jennings concluded, the tiny white chips floating in De Baptiste's wine glass had been put there just minutes earlier, when the glass was on the dining room table.

The prosecution's star witness, James Ellis, took the stand after the morning break. The twenty-seven-year-old from Fredericksburg, Virginia, came to Detroit as a teenager sometime just before the Civil War began.

"Mrs. Doyle had mixed some wine and toast which made ma [De Baptiste] deathly sick from 8 to 9 o'clock that evening." He described the poisoned goblet. "I poured the wine out of the glass that was nearly full into an empty one and found about half a teaspoonful of sediment in the former. That day the old lady was very sick."

Ellis never heard Doyle say a cross word to Ma, but he did hear her say something sinister at about the same time she came to stay with her mother. "Last winter I heard her say that she had one more deed to accomplish and then she would be free. I told her that she had better be praying and get her soul converted," Ellis told the spellbound jury.

In a bizarre twist, the *Free Press* reporter sent to cover the case, Charles B. Lewis, was called to the stand to collaborate Ellis's story about the poisoned wine. Ellis, he explained, had told an identical story during an interview.

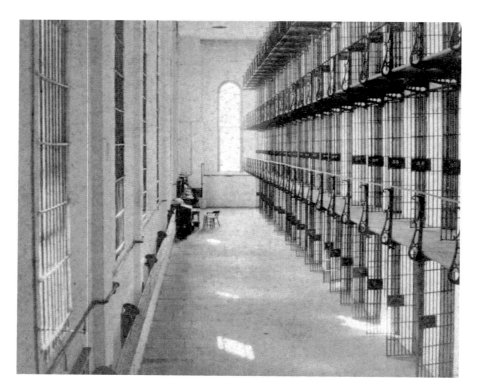

Sundowners stream through the barred windows and fall onto the floor of a cellblock inside the old Detroit House of Correction in this undated stereograph. Interior photographs of nineteenth-century prisons are rare, and this is one of the only known images showing the inside of the infamous prison. *Author's collection.*

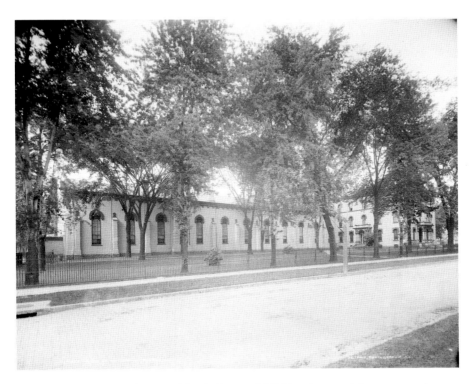

Behind a peaceful line of trees resides the home of Michigan's most violent women: the infamous Detroit House of Correction, built in 1861 on the site of a former cemetery. When a photographer for the Detroit Publishing Company took this photograph circa 1900, the facility was the state's only institution for women serving long prison terms. *Detroit Publishing Company, Library of Congress Prints and Photographs Division.*

After testifying, Lewis took his seat in the audience and continued to jot down notes about the trial.

At the end of the brief trial, Virginia Doyle addressed the court. In his day-after report of the trial, Lewis quoted the statement, first correcting the grammar and removing the vernacular.

What made it into the papers was a composite statement of "main points" stitched together by Lewis:

> *I am entirely innocent of what I am accused. My mother is a passionate woman, and so am I, and we have occasionally had disagreements, but I don't know anything about putting poison in her wine. In fact, I never saw arsenic but once, and that was when my first husband, Talliaferro, brought some home and sprinkled it on a piece of bread for rat poison. I could not*

have opened the wardrobe where George put the [wine] *glass, had I been disposed. At the time I was about to marry Doyle, mother threatened to burn father's will, but she got over that, and the ill-feeling was settled.*

Those who believed Doyle's explanation whispered about Ellis or even Talliaferro spiking Ma's wine, but this made little sense as both played a role in saving the old woman's life and in starting the investigation. Talliaferro brought the poisoned wine to Alfred Jennings and, later, went to Central Station to request that police arrest his mother.

What remained beyond a shadow of a doubt was that someone dosed De Baptiste's wine with arsenic, and the jury believed that person to be none other than her daughter, Virginia Doyle.

The court sentenced Doyle to twenty years in the Detroit House of Correction, where she went to work doing the prison's laundry alongside fellow convicted poisoner Rosa Schweisstahl.

Doyle's twenty-year sentence was cut short by cancer. She died in the Detroit House of Correction on May 10, 1878, at the age of forty-five.

2

BLOOD FEUD: THE LEWIS-LYONS "GO-AS-YOU-PLEASE MATCH"

(1882)

*S*ophie Lyons may just be the wickedest woman in Detroit history. A career criminal by the time she reached eighteen, Lyons relocated from the mean streets of New York to Detroit and became such a nuisance that police took drastic measures to remove her from the scene.

Lyons's nemesis was Theresa Lewis, one of the first female undercover detectives in Detroit history. But Lewis's sketchy reputation came back to haunt her when, during the course of her investigation, she found herself on the wrong side of the cell bars.

The infamous Lewis-Lyons feud evolved into an epic confrontation between a zealous undercover agent and a woman dubbed "The Queen of the Underworld." On three separate occasions, they went toe-to-toe in court, and on two separate occasions, they went toe-to-toe, literally, in street brawls that left both battered and bloody.

Drops of frozen rain struck the courtroom windows with the sound of a hundred fingernails tapping against glass. Coal and firewood became valuable commodities as a cold front descended on Detroit in January 1882. Inside the frosted widows, however, the heat would soon become intense. Sophie Lyons would take the witness stand, where she would do her best to smear her arch-rival, Theresa Lewis. It was the type of odd

situation that made terrific headlines: the suspect testifying against the investigator for theft.

The rustling of papers and hushed chatter ceased, creating an eerie silence as Sophie Lyons walked into the courtroom. Reporters, sent by their newspapers to cover the showdown between Lyons and Lewis, began scribbling descriptions of Lyon's black dress and matching veil, which concealed her eyes. One correspondent began to sketch the infamous queen of underworld Detroit.

As she sauntered down the aisle, Lyons smirked, her mouth curled up at one end in an expression of self-assuredness. She glanced at her nemesis and smiled.

Theresa Lewis leered at Lyons. As she frowned, a deep furrow appeared between her eyebrows, and lines radiated outward from the corners of her eyes. Her entire face tensed and took on the appearance of a clenched fist. Lewis could not survive on the same stage with a gifted actress like Lyons, and she knew it.

As a little girl, Sophie Lyons dreamed of a career in vaudeville, but she never made it under the limelight. Instead, the courtroom would become her stage. To an audience of twelve men in the jury box and a gallery filled with curious onlookers and reporters, Lyons put on a performance that generated more ink in the papers than shows of the most famous vaudevillians. A talented and accomplished role player, Lyons could take off one guise and slip into another like some women changed shoes.

She could play innocent, spiteful, wronged or witty.

She could play a socialite or a girl from the gutter, all with a charm and charisma that could persuade twelve men.

Sophie Lyons was already a legend in the criminal underworld by the time she moved to Detroit in 1877. She had an early start, beginning her life of crime as an impish purse snatcher exploited by a seedy stepmother in a grim fairy tale without the happy ending.

A native of New York City's Lower East Side, Sophie entered a life of crime at age six when her stepmother, Anne Levy, allegedly forced her to take to the streets as a purse snatcher and shoplifter. The wicked stepmother imposed a quota of three purses a day. Caught shoplifting in 1869, twelve-year-old Sophie began the first of an estimated forty stints behind bars.

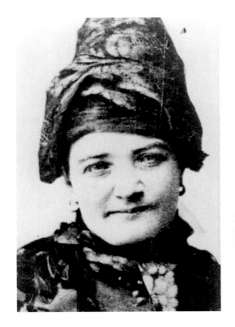

Doe-eyed Sophie Lyons flirts with the police photographer's camera in this mug shot. A former New York City detective included this photograph in his epic 1886 study of malfeasance titled *Professional Criminals of America*. Byrnes described Lyons as "Pickpocket and Blackmailer." *Library of Congress Prints and Photographs Division.*

At sixteen, she married Ned Lyons—a bank robber of national repute—and went to work as an operative in his gang. Together, they pulled off a Manhattan bank heist, a crime that netted them an estimated $3 million and made national headlines. Police faced enormous pressure to make a bust. They turned the city upside down looking for Ned and his attractive young wife. They kicked in the doors of known hideouts, strong-armed informers and bullied known acquaintances.

Eventually, they collared both. Sophie got five years in Sing Sing's women's wing. Ned got four but shortened his sentence to a few months when he sawed through the bars of his cell.

Ned would come back for Sophie.

On December 19, 1871, he engineered a daring escape for his wife during a blizzard. In the guise of a fruit seller, Ned parked a carriage in front of the women's prison. Sophie, a trustee, pushed her way past the guard on duty and made a break for the carriage. Before anyone knew what had happened, the couple had raced away through the snowstorm. They made a beeline for the border and spent the next few months running a confidence game in Montreal.

The power couple of crime returned to New York, where they began to fleece vacationers on Long Island. Recognized by a detective, Ned and Sophie went back to Sing Sing in handcuffs to finish their sentences.

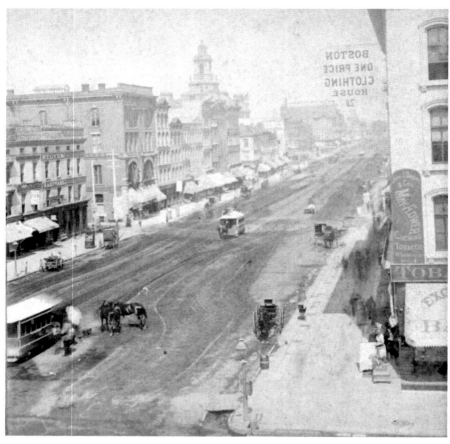

Above: Woodward Avenue streetcars are frozen in time on this stereograph image, circa 1880, taken during the era of Sophie Lyon's Detroit. *Robert N. Dennis Collection of Stereoscopic Views, New York Public Library.*

Left: A *New York Herald* artist rendered this sketch of Sophie Lyons, "Queen of Criminals."

Sophie decided that she had had enough of Ned; she vowed not to return to him.

Likewise, the State of New York made a vow to get rid of Sophie and released her on one condition: she must leave New York.

Ned-less, the Queen of the Underworld arrived in Detroit in 1877.

By the end of her first year in the city, Sophie had run afoul of the law when constables nabbed her pilfering lace from a Woodward Avenue haberdashery. The crafty con artist concocted a way to avoid a jail sentence. While awaiting trial, she knotted together the bedsheets on her cell cot and hanged herself just before the guard made his rounds. Sophie had timed the incident perfectly; the guard revived her, and the judge took mercy on her with a suspended sentence.

From Detroit, Sophie traveled to St. Louis, where she used the promise of sex to lure an older, married man to a hotel room and tried to blackmail him into writing her a sizable check to go away quietly. He refused; she lost her temper and, in a maniacal frenzy, tossed his clothes out of their hotel room window. The scene created such a ruckus, police arrested both Sophie and her older paramour, who as predicted refused to press charges. From St. Louis, Lyons traveled to Boston where, under the alias "Kate Lorangie," she sweet-talked an aged lawyer named Charles Allen to her room at the Revere Hotel and threatened to expose him if he didn't write a her check. Allen pressed charges for extortion, but the slippery Lyons beat the rap with a hung jury.

Back in Detroit, Sophie set up shop as the queen-pin of a theft ring that radiated out of Detroit to surrounding cities as far as Cleveland. Dozens of worker bees pilfered from their employers, shoplifted and grafted in small-scale confidence games. Lyons funneled all of the stolen merchandise to her fence, Bob McKinney, who pawned the hot items in various places throughout Detroit.

One of Sophie's most trusted confidantes and part of her Detroit entourage, thirty-eight-year-old widow Theresa Lewis occupied a room in her boardinghouse.

The widow had a secret: she was an undercover agent for the Detroit Metropolitan Police.

By the time Sophie returned to Detroit following her St. Louis and Boston gambits, authorities had cooked up a scheme to remove her from the scene for good. They hired a female operative and planted her in Sophie Lyons's overgrown garden of thieves.

Enter "Detective" Theresa Lewis.

By 1881, longtime Detroiter Theresa Lewis had survived a series of agonizing misfortunes. In the previous two years, Lewis had lost her husband, Robert, who died in an insane asylum, and thirteen-year-old son, Frank, who died of a congenital heart defect. To make ends meet, she ran a boardinghouse on Jefferson Avenue.

Like Sophie Lyons, Lewis was an adept actress who could slip into and out of a role as quickly and as effortlessly as changing her clothes. It would be a skill that would serve her well in the coming months.

During the summer of 1881, she went to work for Police Superintendent Andrew Rogers, who hired her to keep tabs on the activity of Sophie Lyons. Lewis rented a room in Lyons's boardinghouse on Twenty-Third Street, bringing with her several blank notebooks that she planned to use to jot down evidence. With a fictitious sob story of being deprived of her home by thieving family members, Lewis quickly earned her landlady's confidence and witnessed, from the "Lion's Den" as she called it, Sophie's criminal enterprise in action. Each night, under the kerosene lamp in her room, she made copious notes of what she had seen and heard.

Of all the merchandise palmed by Lyons and her gang of sticky-fingered thieves, her undoing in Detroit came down to three gold watches.

On September 24, 1881, the remains of President James Garfield visited Cleveland during a sort of postmortem whistle-stop tour. Sizable crowds gathered as people came from all over the Midwest to pay their respects to the slain president. For pickpockets like Lyons and her gang, the festivities provided an irresistible opportunity; they could bump into whomever they wanted without raising suspicion and then fade into the crowd with a pocketful of jewelry.

Lyons and Lewis made the railroad trip from Detroit to Cleveland, where Lyons circulated among the crowds and picked the pockets of unsuspecting mourners. Among the day's haul were two gold watches, which she boxed up and sent to her housekeeper, Sarah Brew.

The housekeeper locked the watches in a drawer of Lyons's bureau.

Back in Detroit, Lewis sneaked into Lyons's room and found the gold watches. She took the hot goods straight to police headquarters and presented them to Rogers, who wrote down a detailed description of each watch, including any notable physical characteristics, before ordering Lewis to return them to the bureau drawer and keep watch for any suspicious activity.

Back at the boardinghouse, Lewis witnessed Lyons giving the watches to Bob McKinney with orders to sell them, which he did to local pawnbroker Jacob Smit. Lewis sent word to Rogers, who dispatched Detective Jesse Williams to Smit's pawnshop, where he found the pilfered merchandise.

This chain of evidence—recorded by Lewis in one of her journals—would become a problem for both Lyons and McKinney.

On October 5, 1881, Lewis's acumen as a private eye became evident. That afternoon, she saw Lyons and McKinney walking with Sarah Brew. Her suspicions raised, she decided to tail the trio.

When they boarded a streetcar and headed down Michigan Avenue, Lewis hired a carriage and followed them for a while. Along the way, she darted into her sister's house to borrow a blonde wig, hopped back into the carriage and ordered the driver to catch up with the streetcar. When the streetcar stopped, she climbed aboard. Now in disguise, she could blend into the crowd without Sophie recognizing her. She even shoved a handful of pebbles into her mouth to disguise her voice with a gravelly tone.

Lewis slipped behind Lyons in line at the Grand Trunk Railroad and eavesdropped on her conversation with the ticket agent. She overheard Lyons say she planned to visit Ann Arbor the next day, October 6. Lyons had something planned.

On October 6, 1881, a dense crowd crammed into Floral Hall in Ann Arbor during the county fair to watch the hot air balloon demonstration. With so many bodies huddled together in one place, the scene was perfect for a pickpocket. As all eyes followed the balloon's ascension, a woman resembling Sophie Lyons bumped into elderly Harriet Cornwell and nicked her gold watch.

A few days later, Sarah Brew received a letter from the postman. Since Brew could not read, she handed the letter to Theresa Lewis, who read it

aloud. "Sarah, go to the express office, get the watch and chain and put them in my box. Don't let anyone see it. Sophie." The note was written in Sophie Lyons's distinct scrawl. After Lewis read the note, Brew plucked it from her hands and tossed it into the fire.

Lewis subsequently witnessed a heated discussion between Brew, Sophie Lyons and Bob McKinney. Both Lyons and McKinney were upset because Brew went to the express office, as directed, but erred in giving the clerk the address of Lyons's boardinghouse. It would be a critical error.

Acting on Lewis's tip, Andrew Rogers went to the express office, where he found the package. Inside was Cornwell's stolen timepiece.

Sophie Lyons faced two separate charges stemming from the theft of two watches in Cleveland and a third in Ann Arbor. These legal troubles mystified Lyons, who did not understand how police had managed to crack her system. She had stolen the watches under perfect conditions and sent them to an illiterate housekeeper who subsequently passed them off to her fence, McKinney, who sold the merchandise under assumed names. The information had to have come from someone inside her sphere. Someone, she now realized, had betrayed her.

By December 1881, the street-smart Sophie had smelled a rat, and she made overtures to Lewis about moving out of her boardinghouse. Lewis gathered as much property as she could carry and took it to Rogers's office, where she turned over the merchandise as likely stolen.

Once Sophie learned about the police department's plant, her vindictive side emerged. She marched straight to police headquarters and reported to Patrolman James McDonnell that Theresa Lewis had stolen various items from her, including an opera glass, a gold thimble, assorted jewelry and some bolts of fine cloth. She presented an itemized list of missing things and demanded Lewis's arrest. A search of Lewis's trunks revealed several of the items on Lyons's list, so McDonnell clamped a pair of "bracelets" on Lewis's wrists and dragged her to Rogers's office.

Rogers believed that Lyons's complaint against Lewis was a "put-up job." Regardless, the complaint led to a highly publicized examination that took place in mid-January 1882. Justice John Miner had the unenviable job of trying to sift fact from fiction.

The courtroom swelled with the curious who wanted to watch the first official match between the local widow-turned-detective and the infamous

Queen of the Underworld. Theresa Lewis came to the courtroom with several books containing notes she took during her investigation, and Detroit Police superintendent Andrew Rogers came to court ready to defend his operative.

Witnesses contradicted one another. One witness claimed to have seen the gold thimble in Lewis' possession years prior to her association with Sophie Lyons; another swore she saw the same thimble at Sophie Lyons' boardinghouse.

Several witnesses testified that Theresa Lewis had a bad reputation "for truth and veracity." An equal number testified that they never knew her to lie.

In an ironic twist, Sophie Lyons took the stand to testify against the woman sent to gather information against her. She wore a veil that shielded the top portion of her face from the gallery. When asked about the veil, she explained that she was ashamed of her past and did not want the public to see her face. As the items from Theresa Lewis's trunk were placed in front of her, she identified each one as her property.

"I have had the opera glass in my possession for thirteen or fourteen years, and the ring for about one year," Sophie testified. "I missed them from my house on October 10, and found them in Mrs. Lewis' baggage. The pin is also mine; my husband made me a present of it. The solitaire diamond stud is my property."

Sophie gave an emotional history of the diamond stud. Her late husband, Ned, gave it to her and made her promise to never part with it. The story made an impact on several in the courtroom, although her act did not fool the *Free Press* correspondent, who later wrote, "Her tale was so affecting that one shyster was seen to wipe a drop of suspicious looking water from the corner of his eye, and three others went out to get a drink."

On the stand in her own defense, Theresa Lewis also claimed the diamond stud with an equally moving story involving a dead husband, testifying that she plucked it from her late husband's shirt as he lay in his coffin. The *Free Press* correspondent was equally suspicious of this tale. "Fortunately, she has had more than one husband," he sardonically quipped, "and it was perhaps equally fortunate that one of them is dead. Her story of how she removed the glittering bauble from the shirt front that lay above the pulseless heart of her dead and gone hubby was simply thrilling."

Of all the witnesses who testified, Julia Thompson was the most valuable to Lewis's defense. Unlike the other witnesses—a group that consisted of an alleged fence, a convicted fence, a woman known as a career criminal

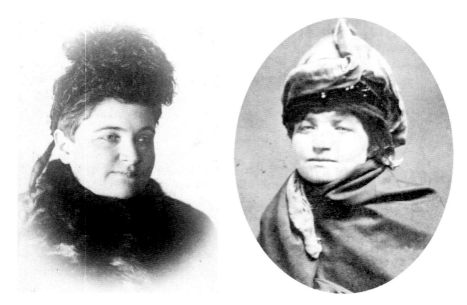

Two faces of Sophie Lyons. Sophisticated society lady (*left*) and dreamy-eyed scammer with bedroom eyes (*right*). When she first came to Detroit, Sophie was known as a heavy user of morphine, a habit that earned her the epithet "the notorious Detroit morphine eater." On a few occasions, she used her sex appeal to entice respectable men to her hotel room and then blackmailed them with exposure if they didn't pay up. *Left: Sophie Lyons, James Alba Bostwick, after unidentified artist. Albumen silver print; Right: Sophie Lyons, unidentified artist circa 1887. Albumen silver print. National Portrait Gallery, Smithsonian Institution; gift of Pinkerton's Inc.*

and others of questionable character—Mrs. Thompson enjoyed a spotless reputation. She testified to having seen several of the allegedly hot items in Theresa Lewis's possession years earlier. She went on to identify the more expensive items, including the diamond stud, by specific physical characteristics like scratches.

In his summation, Lewis's attorney William B. Jackson attacked the character of Sophie Lyons in language so strong, she began to weep.

Jackson's rhetoric paid off; Justice Miner tossed out the case against Lewis. Theresa Lewis had beaten the venerable Sophie Lyons in court.

Lyons's legal troubles, however, had just begun.

Just after the case against Lewis concluded, Justice Miner summoned Bob McKinney to the front of the courtroom. While Sophie Lyons's mouth dropped open, Miner informed the alleged fence that he now faced two counts of selling stolen merchandise—the two gold watches Sophie Lyons stole in Cleveland.

Sophie's eyes widened when Miner called her name next. He informed her that she faced two counts of theft stemming from allegedly stealing the two gold watches.

Then, the two Cleveland watch owners—Elizabeth Sheldon and Fanny Zak—testified.

"I remember the 24th of September last," Zak recalled. "There was a large crowd in the city. While going through the market, between 9 and 10 a.m., with a lady friend, I missed my watch, which I valued at $50. The watch was snapped off at the ring. It contained the initials 'E.H.L.' I missed the watch a half hour later. I went immediately to the jeweler who had repaired it for me and got its number." Zak said she next saw her watch in the hands of a Detroit detective, who asked her to come to Detroit to testify against Sophie Lyons.

The testimony of Sheldon and Zak convinced Justice Miner, who set a date for the McKinney/Lyons examinations in Detroit Police Court. In the interim, Lyons would face her arch-enemy in an Ann Arbor courtroom, where she would try to convince a jury she didn't steal Mrs. Crawford's pocket watch. To do that, her attorney would need to discredit the widow-turned-detective. This set up a second epic confrontation in court. The Lyons-Lewis show was headed west.

Both Lyons and Lewis had claimed the diamond stud, and both had provided, under oath, a different postmortem provenance for it.

Dead men tell no tales, but living jewelers do. While both women wanted the valuable bauble, it actually belonged to neither of them—a fact that became clear in the most bizarre, and most telling, incident in the entire drama.

After Lewis's examination, Sophie wanted the diamond stud back, but no one knew who it belonged to, which led to some head-scratching. Thanks to a little legal wrangling by her attorney, Sophie Lyons won the right to obtain the piece if she paid a bond of indemnity in the sum of twice its value.

So, Wayne County sheriff Clippert took the diamond stud to local jewelers Roehm & Wright for an appraisal.

Roehm scrutinized the piece. "Where did you get this?"

"Why do you ask?"

"Because it is ours. It was stolen from us over a year ago," Roehm claimed.

"How do you know it is yours?" the stunned sheriff asked.

"Because it has a flaw in its side and has my private mark upon it."

Roehm pulled a slim volume from the bookcase behind his desk. "In this I enter every stud I purchase," he explained, "designating it by a private number which is scratched upon the setting. Opposite the corresponding number in the book I write a description of the jewel. This one is 149. Now take this glass, and you will find the number 149 upon the gold beneath the stone, and, upon its side, a flaw that is perceptible to the naked eye." He handed a magnifying glass to Clippert.

Clippert's jaw dropped open as he spied the telltale marks.

The diamond stud offered the best testimony about the veracity of statements made by Sophie Lyons in court. And by Theresa Lewis. Both evidently lied about owning it—even conjuring up sympathetic fictions that they knew would score points with the all-male court—and one of them likely stole it. In the end, neither would possess it.

The stud, valued at $185, wound up back in the showcase at Roehm & Wright, and Theresa Lewis's reputation took another hit. The district attorney considered pressing charges but decided against it; he needed Lewis to testify against Sophie Lyons.

Lewis escaped the controversy, but the man who hired her did not.

The feud may have provided the last nail in the coffin containing Andrew Rogers's career. Dogged by political adversaries and the press alike (the *Detroit Post* repeatedly labeled him a drunk), he resigned as superintendent of Detroit Police. Although he would later deny that his resignation stemmed from his association with Theresa Lewis, he couldn't deny that the timing suggested otherwise; he left office at approximately the same time as Lewis's examination on larceny charges.

On the evening of Tuesday, February 7, 1882, the two key figures in the upcoming trial—the defendant and the key witness against her—just happened to board the same train headed to Ann Arbor.

Almost immediately, Sophie noticed Theresa Lewis standing on the platform. She quickly approached the unsuspecting woman, pointed to her gloves and claimed Lewis stole them from her, too. Sophie clawed at her eyes, but Lewis managed to turn her head just in time and wound up with red scratches down her cheek. The two women grabbed each others' hair and began tugging. The shrieks were loud enough to echo throughout the busy terminal. A crowd of curious onlookers formed a circle as the two combatants kicked and pawed at each other.

Following the din, a night watchman pushed his way through the circle and pulled them apart. They wobbled aboard separate cars of the train, each with a face crisscrossed by bright-red lines.

It would be much ado about a gold watch as the courtroom in Ann Arbor filled to capacity in February 1882. Everyone wanted to catch a glimpse of the infamous Sophie Lyons, unveiled. Curious housewives rubbed elbows with Detroit reporters, who anticipated the feud would come to a head when Theresa Lewis took the stand.

Lyons's defense followed a line that Detroit Police didn't hire Theresa Lewis to find evidence to convict Sophie Lyons—they hired her to manufacture it. The lawyers put forth a theory that Lewis's story about tailing Lyons around town was fabricated and that a woman who resembled Sophie Lyons—not the Queen of the Underworld herself—stole Mrs. Cornwell's watch. To prove their case, they put witnesses on the stand who swore they saw Sophie Lyons in Detroit on October 6. The prosecution called a handful of eyewitnesses who likewise swore they saw Sophie Lyons on the train to Ann Arbor and, later, at the fair on October 6.

As expected, the case hinged on star witness Theresa Lewis. For over four hours, both the prosecuting and defense attorneys grilled her about every minute detail of her story, but she did not waver. Following her epic turn on the stand, a parade of prosecution witnesses testified about her reputation for honesty; an equal number testified for the defense about her reputation for telling yarns.

At the end of the five-day trial, the twelve gentlemen in the jury box sifted through the conflicting testimony and decided to believe Theresa Lewis. They found Lyons guilty of larceny, and the court sentenced her to four years in the Detroit House of Correction.

Theresa Lewis had finally won the feud, or so it seemed.

Upon review, the state supreme court reversed the conviction. Lyons and Lewis were headed back to court. The second Ann Arbor watch trial would take place the following January.

Between the first and second Ann Arbor watch trials, Lewis took the stand against Lyons's fence, Bob McKinney, in April 1882. McKinney faced

larceny charges for his role in pawning the Cleveland watches to J.M. Smit under the alias "Harry Woodburn."

Lewis explained that whenever Lyons was on one of her theft tours, McKinney would always show up at her boardinghouse the day before she returned. Like clockwork, he dropped by the Twenty-Third Street boardinghouse on Thursday, September 29, 1881, and asked Sarah Brew if any packages had come for him from Lyons in Cleveland. Lewis watched as Brew handed McKinney a small parcel containing the gold watches.

While on the stand, Lewis identified the watches recovered from Smit. The serial numbers proved they belonged to Fanny Zak and Elizabeth Sheldon of Cleveland.

Lewis's testimony doomed McKinney, whose career as a fence ended later that afternoon when Justice Miner sentenced him to four years at the state prison in Jackson.

The second Ann Arbor trial took place in January 1883 and was a virtual duplicate of the first. Theresa Lewis took the stand and told the same story. The same witnesses swore they saw Lyons in Ann Arbor, and the same witnesses swore they didn't.

The defense did manage to produce a surprise witness who raised more than a few eyebrows: Police Superintendent Andrew Rogers, who resigned his post in February 1882 amid rumors that he was asked to leave because Theresa Lewis faced charges stemming from her feud with Sophie Lyons. The chief denied it, but everyone knew that he had hired an agent with a sketchy reputation.

On the stand, Rogers characterized Lewis's reputation for honesty as bad. "I can name a hundred instances that bear me up," he said. Evidently, he felt very strongly about Theresa Lewis. Several times during his testimony, he lost his temper, triggering stern warnings from the court.

Rogers's repeated emotional outbursts hurt his credibility with the jury, who once again chose to believe Theresa Lewis. Her story didn't change; she didn't waver in her testimony, and she was a sympathetic witness. And this time, Lyons's lawyer Colonel John Atkinson's attempts to discredit her seemed more like character assassination than viable efforts to get at the truth. Besides, the jurors reasoned, even if Lewis had a bad reputation, Lyons's was worse.

Once again, the jury found Sophie Lyons guilty. Convicted a second time for the same offense, she was sentenced to four years by the court.

She went, kicking and screaming, to the Detroit House of Correction to serve her time.

By May 1883, Sophie Lyons had spent three months in the Detroit House of Correction. Still a person of interest to the press and public alike, Sophie agreed to sit for a brief interview with a reporter.

Hard time had taken its toll on the Queen of the Underworld. She had just emerged from a serious illness that gave her a gaunt, skeletal appearance.

The reporter described her as

> *no longer the attractive and rather pretty looking woman she was when walking about the streets of Detroit some months ago. Her complexion is very sallow, her once shapely and well cared for hands have lost their symmetry and look rough and coarse. A coquettish sparkle of the eyes and a girlish arching of the neck and shrug of the shoulder when greatly pleased at some remark, only remain to remind one of the woman who has had a strange and erratic career…*

Lyons assumed the role of an innocent woman wrongly convicted, framed by the Detroit Police. There was little doubt whom she blamed for her unjust incarceration. Even the reporter was surprised by her reaction when he mentioned the name "Theresa Lewis."

"This was sufficient to excite her to anger to the highest pitch," he wrote. "Every sentence she uttered against her was wormwood and gall. Every muscle of her face and body suddenly grew rigid, her hands became firmly clenched and her frame fairly trembled with suppressed passion and hate."

She sneered when the reporter noted that Theresa Lewis wanted to write a biography of "The Life and Times of Sophie Lyons" and used the opportunity to smear her antagonist. She remarked that Lewis's autobiography would make more exciting reading than her own but swore to beat Lewis to the punch and write her own life story.

Lyons turned away, apparently embarrassed, as other convicts passed by and said, with a hint of sadness creeping into her tone, that she missed her veil.

The reporter finished his article with a description of Lyons peering out of the prison's barred window. "Looking back he [the reporter] caught sight of Sophie standing near the window looking out upon the fresh, green grass in the prison yard, and fancied she was longing for that liberty which will probably not be hers for some time to come."

He was wrong. For Sophie Lyons, history would repeat itself—again.

The Michigan Supreme Court reviewed Lyons's reconviction and once again reversed it, leading to yet another trial, scheduled for October 1883, and yet another confrontation with Theresa Lewis. Sophie Lyons was thrilled. She would get another chance to publicly discredit her bitterest enemy.

By October 1883, however, the state's linchpin had become seriously ill when she began a lengthy fight with breast cancer. As the trial date approached, it became clear that Lewis would be in no condition to take the witness stand, so the court postponed the third Ann Arbor watch trial and rescheduled it for the next session, to take place in March 1884.

The third Ann Arbor watch trial, originally planned for October 1883 but delayed due to the illness of Theresa Lewis, finally got underway in mid-March, 1884. At great expense to the state, jurors heard what had now become the same, sad saga from the same witnesses. The trial's novelty came when Lyons's attorney described an elaborate theory, he said, to put Sophie Lyons inside a frame.

Colonel Atkinson, in his two-hour closing statement, described a conspiracy theory in which millionaires from Jackson, aided and abetted by the police commissioners of Detroit, wanted to convict Lyons at any cost and framed her with evidence fabricated by their plant, Theresa Lewis.

The entire case, he argued, depended on Lewis's story, which was full of holes. There was simply no way that she could have disguised her identity enough to fool Sophie Lyons. The note Lyons allegedly sent to Sarah Brew, with instructions to destroy it, made little sense; the housekeeper could not read. And none of the eyewitnesses could conclusively place Sophie Lyons in Ann Arbor on the day Mrs. Cornwell's watch was stolen.

In his closing statement, Washtenaw County prosecuting attorney Whitman pointed out that the conspiracy envisioned by Colonel Atkinson would be preposterous. Such a theory would involve a Sophie Lyons lookalike, since several eyewitnesses saw someone remarkably similar in appearance prowling the campgrounds on October 6. The lookalike then

sent the purloined watch to Detroit, where the package was picked up by Lyons's housekeeper, Sarah Brew.

Despite Atkinson's farfetched conspiracy theory, the jury did not believe Theresa Lewis. This time, they voted to acquit Sophie Lyons. The ordeal over a $300 watch, which cost thousands of dollars in court fees, had finally ended.

Lyons had won the day, but she still wanted her pound of flesh, which she would attempt to get on a Detroit street corner.

Just a week after the third Ann Arbor trial ended, the feud between Lyons and Lewis climaxed on the corner of Woodward Avenue and State Street. Lyons spied her mortal enemy walking past the Finney House and pounced on her.

She grabbed a fistful of Lewis's hair and yanked with all of her might, popping the pins and sending her hat fluttering down the street. Before Lewis could react, Lyons kicked her in the stomach, a blow that dropped her to the ground.

The melee caused a crowd to form, and when it became clear that the two pugilists were the infamous press darlings, the onlookers decided to let them settle their feud without intervention.

Lewis, stunned from the blow to her midsection, swung her arms wildly in the air; in a frenzy, Lyons continued to kick her, the points of her boots digging into the fallen woman's sides and chest, until passersby decided to step in and end the fray.

Driblets of blood ran from both sides of Lewis's mouth as two men helped her to her feet. Her eyes glazed over and her head slumped down, so they carried her into the drugstore next to the Finney House while Lyons skipped away untouched.

The attack compounded Lyons's legal problems with an assault charge; from her bed at No. 62 Madison Avenue, Theresa Lewis vowed legal revenge. "She took her boot heel and kicked me," Lewis groaned to a reporter from her bedside. She would have one last opportunity when Lyons went to court for the Cleveland thefts—the examination continuously delayed pending the outcome of the on-again, off-again, Ann Arbor fiasco.

Battered and bruised, Lewis managed to square off with her old adversary for one final time during Lyons's examination on larceny charges stemming from watches Lyons allegedly stole during the Cleveland funeral of President Garfield.

Despite failing health, she gave a lively and spirited turn on the witness stand. She proudly lauded her achievements as a detective and claimed that Rogers hired her to obtain evidence against not just Lyons but other thieves working in Detroit as well—evidence that she kept in a dozen written ledgers.

As Lyons's lawyer Colonel John Atkinson cross-examined Lewis, she accused him of accepting stolen property—notably gold watches—as payment for services rendered. Her tone chafed Atkinson, who snorted that he wasn't the one on trial. Weary of trying to break Lewis's resolve and expose a crack in her story, Atkinson dismissed the wily witness.

Theresa Lewis stepped down from the stand for the last time. Once again, she had prevailed. The court found sufficient evidence against Lyons and ordered a trial, but the state's linchpin had become deathly ill.

By the end of the year, Theresa Lewis was losing her battle with breast cancer. A doctor at the College Hospital operated in December 1884 and removed a large tumor. Her health briefly improved before she relapsed a month later.

With his star witness bedridden, prosecuting attorney Robison had little choice but to hold off on the funeral watch trial. His chance to prosecute Lyons for the Cleveland thefts would never come.

On May 11, 1886, Theresa Lewis finally succumbed to breast cancer. As she lay dying at St. Mary's Hospital, Lewis expressed her belief that the second physical altercation with her bitter enemy, when Lyons jumped her and ruthlessly kicked her in the chest, aggravated her cancer—a common belief of the time echoed by contemporary newspapers.

Sophie Lyons never did any real time for the assault on Theresa Lewis. She would later claim that Lewis started the fight, and with the only witness six feet under, the case disintegrated. Lewis's death also deprived the state of its only real witness against Lyons for theft in Cleveland, so once again she beat the rap. But Sophie's time in Detroit had come to an end. With her fence in prison and her likeness known by every beat cop in the city, she had little choice but to move on.

In early 1886, the infamous Sophie Lyons left Detroit and returned to her native New York. Within six months, she notched another conviction for shoplifting and with it another prison stint of six months.

Sophie Lyons hated Theresa Lewis so much that the mere mention of her name caused her to fly into a rage. This emotion may have remained with her for the rest of her life. In her 1913 memoir, aptly titled *Why Crime Does Not Pay*, she does not once mention the name "Theresa Lewis."

3

ARSENIC AND OLD ROSA

(1885)

A *Detroit Free Press* reporter described Rosa Schweisstahl's crime in hyperbole typical of a Victorian-era newspaper writer: "No more wicked, deliberate murder was ever committed in this city, and what renders it doubly heinous, is the fact that…her victim was old, sick and helpless."

The once wicked woman, however, atoned for her wicked ways when she became a guardian angel behind bars.

On the afternoon of December 25, 1885—while Detroiters celebrated Christmas by unwrapping presents and feasting on turkey—a celebration of a different sort took place behind the walls of the Detroit House of Correction.

A long line formed as one by one, the female inmates passed the open coffin. Some uttered hushed eulogies; others reached out and touched Old Rosa's wrinkled hand. One twenty-something inmate, her cheeks streaked with tears, slowly approached the casket. She bent over at the waist and kissed Rosa on the cheek—an act that triggered an emotional reaction from the others in line. "With one impulse," wrote a *Free Press* reporter who witnessed the scene, "all the women began to weep."

A few reporters, sure not to miss the dramatic send-off for one of the gaslight era's headline makers, watched the curious scene unfold in one of the prison's spacious galleries. "There were women of all ages, nationalities,

color, and attired as they were in the blue and white plaid gowns of the institution.... [T]hey grouped about the coffin, now and then one touching the cold cheek or brow as though to make sure that death was really present."

They were saying goodbye to one of the city's most notorious criminals, who, over the course of her sixteen years behind bars, evolved from reviled murderess to beloved friend. Matronly Rosa Schweisstahl—at seventy-three years old, easily the institution's oldest female inmate—became a mother figure for many of the younger inmates, most of them serving short sentences for selling liquor on Sunday, selling booze in an unlicensed saloon or selling themselves in one of the city's brothels. Ironically, the prison social maven was sentenced to a life of solitary confinement when she first entered the system in 1869.

Prison superintendent Joseph Nicholson hired a local embalmer, whose display awed the *Free Press* reporter. "The remains lay in a neat casket, shrouded in a handsome garment of black cashmere with black satin trimmings, while in the worn and wrinkled hands, clasped so peacefully over her breast, was a large bouquet of calla-lilies, ferns and other white flowers."

Nicholson respected the lifer, calling her the "woman of the house." He gave an impromptu eulogy as the line of inmates, clothed in their prison-issue flannels, slowly snaked past Rosa's coffin:

> *As Superintendent of this institution I say gladly, and with earnestness, that I never heard Rosa speak ill of any person, and I never heard of her being harsh or thoughtless with any of you. She was patient, faithful, obedient, and to many of you she was a helpful, devoted friend. Poor old Rosa was, in brief, a lovely character so far as any of us know through our intercourse with her.*

Nicholson urged his listeners to follow Rosa's example and treat others with kindness.

As the undertaker carted "the woman of the house" out of the House, he passed an inmate going in the other direction. Sentenced to a long term, she quipped, "I wish to God that was me."

Old Rosa's crime was a sensation for post–Civil War Detroit, and she quickly became an object of fascination.

Rosina Christina Rothman Miller was born in Germany in 1812. Details of her early life are sketchy, but by 1869, she had become a fixture in the home of Detroiter Henry Schneider.

Although she later denied a marriage ever took place between herself and Schneider, she lived with him as his wife. Schneider's sudden and unexpected death on January 26, 1869, raised eyebrows, but when Rosa married Nicholas Schweisstahl before rigor mortis set in on her first husband, authorities decided to disinter Schneider's body and take a look at his last supper.

Rosa had a lot to explain when a chemist, Dr. S.P. Duffield, found twenty grains of white arsenic in Schneider's stomach—several times the fatal dose of three grains—and when investigators found a druggist on Grand River from whom a woman matching Rosa's description purchased poison. Just a few days before Schneider's death, she purchased arsenic on two separate occasions. She wanted to kill some rats, she told the druggist.

The timing of Rosa's marriage to Nicholas Schweisstahl hinted at something sinister. They became engaged on Sunday, January 24, and agreed to marry on the following Sabbath. Schneider died on Tuesday, January 26, just two days after the engagement, which gave rise to whispers that Rosa had used arsenic to remove Henry and make room for her new husband. Investigators were quick to recognize the possibility that she would also obtain Schneider's house in the process.

Rosa buried Schneider on Thursday, January 28, and then exchanged vows with Schweisstahl three days later, on Sunday, January 31, 1869. This was less than a week after her first husband's death—a fact emphasized by reporters who covered the case, despite Rosa's insistence that she had never married Henry Schneider in the first place.

It came as no surprise that Rosa denied any involvement in Schneider's death. When told of the charge, she said, "I have no friend in this world to speak for me, but the Father in Heaven, He knows that I am a desolate old woman. My husband was too good a man for poison, and…I didn't done it. If there is any body who will say they seen me done it I will confess, but if there ain't any body that seen me done it, I won't own up." But her cryptic statement in broken English hinted at a guilty conscience.

That guilty conscience led to several conflicting statements from behind the bars of her cell at the county jail. At first, she offered an innocent explanation: Henry died after eating too much sauerkraut. She admitted purchasing arsenic but stood by her earlier explanation that she had acquired the poison to take care of rats that had overrun their house.

Eventually, though, Rosa changed her tune. During one interview with Deputy Sheriff Defoe, she admitted giving arsenic to Henry and said she intended on pleading guilty. She repeated that confession to a *Free Press* reporter, adding that she preferred a prison in which she worked for her keep. Rosa despised idle hands. Then she retracted her statement and said she didn't do it, after all.

Rosa later confessed, again, but this time added an accomplice. She told Deputy Sheriff Cross that she willfully fed poison to Schneider at the instigation of her lover, Nicholas Schweisstahl. According to Rosa, he gave her fifty cents and an order: purchase arsenic and mix it into Schneider's food.

With a possible murder charge hovering over him, Schweisstahl described to Cross the circumstances surrounding his courtship of Rosa—a story that shocked Detroiters.

He first met Rosa, he explained, in early January when she was selling "wooden-ware" in the city's markets. A widower, Schweisstahl needed a companion and mother figure for his four children, so despite the age gap between them, he proposed marriage.

Rosa deferred, explaining that she lived with her infirm brother at 42 Crawford. If she agreed to marry Schweisstahl, she would leave her brother destitute. She asked him to be patient and wait for awhile. Buoyed, he agreed but said he would like to meet Rosa's brother.

Once again, Rosa balked. Her brother was peculiar, she said, and didn't like strangers in his house. Indefatigable, Schweisstahl continued to press his case until finally, on Sunday, January 24, Rosa relented and agreed to marry him. The nuptials would take place on the following Sabbath, Sunday, January 31, 1869. Rosa's "brother" conveniently passed away the previous Tuesday. She would bury him on Thursday and have plenty of time to prepare for the Sunday wedding.

A few days later, the newlyweds went to 42 Crawford to remove some of the furniture and household items. While there, Schweisstahl found several boxes of arsenic.

They were empty.

Suspicious, Schweisstahl began to nose around the neighborhood and discovered, to his shock, that old Henry Schneider wasn't Rosa's brother but her husband. At least, that is what the neighbors believed. He now believed that Rosa had agreed to marry him while still married to another man, who subsequently had died just two days after she accepted his proposal.

Schweisstahl's narrative made Rosa out to be a two-timing, felonious gold-digger looking for a new mine to excavate. It was the type of spice reporters

loved to sprinkle on their columns. Rosa became a larger-than-life villain in the newspapers, and ladies audibly gasped as they read articles about the salacious case.

Rosa's partial confession triggered a first-degree murder charge, and since Cross didn't really believe Schweisstahl's complicity in the crime, the murder cross would be Rosa's, and Rosa's alone, to carry through the judicial process.

During the trial, testimony painted a portrait of Rosa as spoiled vixen who depended on old man Schneider for support. When he became infirm in his advanced years, she ridiculed him and threatened to ship him to a poorhouse.

The most compelling voice against Rosa came from Rosa herself, not in direct testimony, but through other witnesses who heard her confess to purchasing arsenic and willfully giving it to Schneider because, she said, he had become despondent and wanted to commit suicide. That she provided the poison gave the jury all the evidence they needed to send Henry's angel of mercy off to prison.

The jury took just five minutes to decide Rosa's fate. Upon hearing the verdict, Rosa uncharacteristically exploded. "My God!" she exclaimed. "I didn't done it."

She was more collected a week later when Recorder Swift sentenced her to life in prison—a fate Rosa received quietly. When asked if she had anything to say, she meekly uttered that anything would be better than spending another idle day in confinement. She could not stand idle hands.

Rosa's prison odyssey began at the state prison in Jackson in June 1869. In the women's wing, she rubbed elbows with seven other inmates, including three serving life: Sarah Haviland, who murdered her three children in Calhoun County in 1866; Amanda Simmons, a teenage mother who committed an eerily parallel crime to Haviland's when she led her three children to the edge of the Kalamazoo River during the summer of 1869 and drowned them one by one; and Wayne County wife Susan Sheeley, a twenty-one-year-old who murdered her husband in 1867.

A life sentence in solitary confinement for Rosa meant doing the prison's laundry, which she did without incident until 1875, when prison authorities transferred the female convicts to the new facility in Detroit.

Women in the state prison lived in a separate building but shared other facilities with the male inmates. When the Detroit House of Correction

opened in 1861, it contained separate facilities for the female population, so it became the de facto state prison for long-term women inmates.

Only Sarah Haviland remained in Jackson, where she worked as a domestic at the warden's residence. Schweisstahl, Simmons and Julia Cargin, sentenced to life for plotting the murder of her brother-in-law in 1877, traveled by carriage to Detroit. On the other side of the prison's palatial façade, they toiled in the prison shop carding pearl buttons.

Rosa's hands would not be idle in the House of Correction. For sixteen years, she worked off her sentence of hard labor in the prison's factories, where she became a role model for other women prisoners. The time behind bars transformed wicked Rosa, the two-timing murderess, into "Old Rosa," the beloved benefactor of Michigan's bad girls.

NELLIE'S GHOSTS

(1895)

*A*t six-foot-four, convicted murderess Nellie W. Pope stood half a head taller than most of the guards inside the Detroit House of Correction. A larger-than-life villain found guilty of perpetrating one of the bloodiest crimes in the blood-spattered pages of Detroit history, her legend grew to enormous proportions behind bars.

The *Detroit Free Press* dubbed the murder of local dentist Horace Pope "one of the most atrocious, cold-blooded, and deliberately-planned murders" in the city's history. The end of Dr. Pope came as he slept peacefully in a rocking chair.

Just before sunrise on Saturday, February 2, 1895, a frantic, haggard and pale figure approached Detroit Police constable Shick. Through a barely intelligible garble, William Brusseau said he wanted to report a murder. He had killed Dr. Horace Pope, a well-known dentist, out of self-defense. He tugged at the arm of Shick's tunic and led him to a ground-floor flat at the corner of Michigan Avenue and Washington Boulevard.

With a kerosene lantern in hand, Patrolman Shick tiptoed through the darkness of the bedroom and stepped toward the silhouette in the rocking chair. It was just before six o'clock in the morning. The sun had yet to rise, and the entire residence had the appearance of a charcoal drawing. The figure—legs outstretched, hands folded in his lap and head tilted to the

side—looked to be sound asleep, but as Shick came closer, the black-and-white image turned into a ghastly tableau of crimson. Blood and brain matter had slowly oozed from a gaping hole in the side of his head, forming a red-and-white rivulet that ran down his neck and onto his shirt. So many spots of blood streaked the wall in front of him that it looked like it was covered with paisley wallpaper.

Shick spotted the possible murder weapon—an axe, its blade streaked with blood and covered with hair—leaning against Pope's chair.

The crime pulled the sheets back to expose a scandalous affair going on right under the nose of Horace Pope.

Pope and his wife, Nellie, lived in a first-floor flat at the intersection of Michigan Avenue and Washington Boulevard with their eight-year-old daughter, Bernice, and Nellie's live-in male nurse, William Brusseau. A native of Canada, Horace

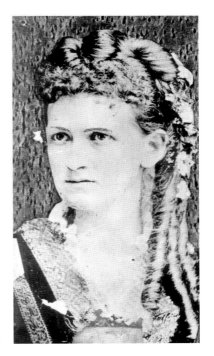

A youthful Nellie Pope bears a serious, pensive countenance in this cabinet card portrait, circa 1890. Newspaper writers often described her as "statuesque" for her height and imposing demeanor. *Author's collection.*

Pope graduated from the Boston Dental School in 1875. A year later, he earned a medical degree from the University of California. While in California, he met Nellie Withers, a young widow whom he knew as a child back in Canada.

In 1880, he wed the twenty-year-old, and the couple relocated to Detroit. They welcomed a daughter, Bernice, in 1886.

Known throughout the neighborhood as a nag, Nellie wore the pants in the Pope household. Her request was Horace's command, and she enjoyed playing the dominant to his submissive. Horace, however, grew increasingly unhappy with his domineering wife, whose violent tendencies had escalated.

According to T.W. Davis, a pharmacist and longtime friend of the Popes', Nellie incessantly browbeat and bullied Horace. At one point, she pushed him down a flight of stairs to collect twenty-five dollars from an insurance

company. The dentist became despondent and tried to escape the constant abuse through suicide. After his one unsuccessful attempt, Nellie decided to take out several large insurance policies in her husband's name, prompting Davis to warn Pope that he would one day become a victim of murder.

In 1892, Nellie got pregnant but lost the baby during childbirth. After that, her world changed. She began to take laudanum in progressively larger doses. As her drug habit escalated, she spent more and more time in opium-induced stupors. That same year, William Brusseau entered the drama.

In 1893, thirty-five-year-old William "Billy" Brusseau, a barber and fellow opium addict, worked in a barbershop on Belle Isle. A ladies' man, Brusseau eventually lost his job because of the constant attention he received from one particular admirer: a tall, bony woman named Nellie Pope. At some unspecified point, Brusseau and Nellie Pope had become lovers. In addition to a strong attraction for each other, they shared the same need for morphine, laudanum and opium.

Nellie had a job already lined up for her barber-beau. On the pretense of fainting spells caused by heart trouble, she had no trouble convincing Horace to hire Brusseau as her live-in nurse for a salary of fifteen dollars a week.

Brusseau immediately moved into the Pope residence to care for Nellie. Within days, he had supplanted Horace Pope as the man of the house. Brusseau and Nellie shared the bedroom while the cuckolded dentist virtually lived in the kitchen. The dental chair in the front room gathered dust, and the residence became more of a hovel than a home as the Pope marriage deteriorated. Junk piled up in every room, and dirty clothes lined the walls, creating a stench strong enough to prompt complaints from neighbors.

Over the next two years, Brusseau and Nellie Pope lived the high life. Nellie's drug use spiraled out of control. By the winter of 1895, she was taking forty drops of laudanum three times a day.

They made an odd couple, the ex-barber and the dentist's wife. At five-foot-seven and 155 pounds, William Brusseau literally stood in the shadow of Nellie Pope, who was nine inches taller and outweighed him by 60 pounds. She also exerted a tremendous influence over him.

Horace Pope went along with the arrangement, but it was a highly dangerous affair. Both Brusseau and Nellie knew that Pope was worth much more as a dead man; life insurance policies in his name totaled over $15,000.

Dr. Pope's fatal moment came on the morning of February 2, 1895.

It was self-defense, Brusseau told detectives as they questioned him. The dentist came home, gun in hand, and took a shot at him. Brusseau managed to knock away the gun. He then forced Pope down into the rocking chair and struck him with the hatchet.

Nellie lay comatose in an opium-induced slumber and didn't know what had happened. After the killing, Brusseau picked her up and made a bed for her in the front parlor. He watched over her for awhile before leaving to report the incident.

"Don't you know that Pope was asleep when you hit him with the hatchet?" Sergeant Baker asked.

"No, I don't." Brusseau appeared confused. Pale as a ghost, beads of sweat formed on his forehead and streamed down his cheeks. He mumbled, sometimes incoherently, and trembled almost convulsively. Nonstop fidgeting made him appear to be in perpetual motion.

Baker knew Brusseau's self-defense story was a tissue of lies. The wounds on the dead man's head, the hair on the axe blade (Pope was bald in the front of his head), and the positioning of the body all indicated a behind-the-back attack. The overwhelming evidence made Brusseau's story sound so absurd, Baker asked him if he was high. "What is the matter with you? Do you take morphine, or what?"

"I have not taken a drink in a long time," Brusseau replied. It was an evasive and purposely ambiguous answer.

"How many times did you strike him?"

"I don't know," Brusseau responded. "That is what I can't remember, but I will think of it and tell you fellows the facts. But Mrs. Pope had nothing to do with it. She knew nothing about it."

Brusseau's story about Nellie Pope being unconscious during the entire incident was just as incredible. Still, he insisted, "Mrs. Pope had nothing to do with it. She knew nothing about it."

Despite Brusseau's self-defense story, the crime scene evidence suggested another scenario, one that had Brusseau, hatchet in hand, tiptoeing behind Dr. Pope as he sat in a chair. He swung the blade with such force that the blow scalped the unsuspecting man and coated the wall with blood. Brusseau

continued to hack away at the doctor's skull until the head was nothing more than a bag of skin containing shattered shards of skull.

Brussueau then pulled a revolver from his pocket, fired one shot into the wall, dropped the gun and raced to the nearest police constable to report his killing of Dr. Pope in self-defense.

Two days in a cell without morphine had turned William Brusseau into a shell of a man. He didn't remember the crime, didn't remember the story he told to Sergeant Baker.

The ex-barber promised to come clean if, and only if, the police promised to protect him from his volatile lover. "I am very much afraid of her," he said. A smile and nod from Baker loosened Brusseau's lips, and he started babbling.

"I went to sleep in the front room about 2:30 o'clock in the morning. The next I remember is when Mrs. Pope shook me and said, 'Get up, Billy, get up, I want you.' She again said, 'Billy, Billy, get up.' When I got up the doctor was sitting in the rocking chair, and the screen was in front of the door."

Brusseau said he didn't remember details about the actual murder. When asked about spots of blood on his arm and trouser leg, he claimed that Nellie Pope rubbed blood on him.

He went on to detail Nellie Pope's designs to murder her husband:

> *For six weeks, she kept planning to kill him, and she urged me to do it. But, you know, I would not do it, for I am too much of a coward. Six different times she built a big fire in the coal stove and then took the top off so that he would suffocate, but each time he awoke and opened the window so that the fresh air would come in. Then she decided to kill him by cutting his throat or shooting him.*

Brusseau depicted Nellie Pope as a wicked witch who had entranced him. "I don't know what's the matter. I seem to be looking into a fog. She had me, and I had to do whatever she said."

And that meant running all over Detroit buying laudanum from various pharmacies and paying premiums on the various policies Nellie had purchased for her golden payday. He even shadowed Horace Pope around town and reported his every movement to Nellie, who wanted to keep track of him to make sure he didn't try to change the beneficiary on the insurance policies. If Nellie asked Brusseau to do something, no matter how extreme it seemed, he willingly obliged.

Investigators didn't entirely swallow Brusseau's new revelations. They believed Nellie held him so firmly under her thumb he would do anything she commanded, including murder, but they didn't believe his hands were spotless, either.

Brusseau was the weapon. The hand manipulating it belonged to Nellie Pope.

Brusseau's rambling confession put a pair of handcuffs on his lover's wrists, and Nellie Pope became the most morbidly curious character in the city.

Unlike her lover, Nellie refused to talk. She wouldn't talk to police, to Brusseau, to reporters or to anyone about the case.

As murder charges lingered over Nellie Pope, rumors about her past began to make their way through the streets, abetted by the sensationalist chroniclers who wrote for the city's newspapers. Tales circulated about a first husband who died under mysterious circumstances in California, about a Canadian family that Nellie tried to defraud out of land, about her almost hypnotic hold over Horace Pope, William Brusseau and an unknown number of others.

In an attempt to explore Nellie Pope's psyche, renowned hypnotist Mademoiselle Charcot paid a visit to the female ward on the second story of the Central Police Station, where the alleged murderess awaited trial.

The acclaimed hypnotist left the station frustrated at her inability to break through the icy veneer of Nellie Pope. "I never saw such a woman in my life," declared Mademoiselle Charcot after her brief visit with Pope, "and I could do no more with her than if she were a bit of stone. Three or four times I caught her eye, and though I tried hard to hold her it was an impossibility. It was like looking into the eye of a cat more than anything else."

Charcot was convinced that the cat-eyed Pope's overpowering persona gave her the ability to control others, particularly weak characters like William Brusseau:

> *That woman has a very strong will, and can exert a terrible influence over other persons. She has no use for the female sex, her character shows that very plainly. I think Brusseau was infatuated with the woman, and she held him so that he could not leave her. Her mind was too strong for him, and she could make him do anything. I have seen all classes of women, but she is the worst.*

As the trial approached, Nellie played the role of feeble victim. She complained of heart trouble and whined for her "medicine"—a potent cocktail of laudanum and whiskey. When the turnkey refused, she rattled the bars of her cell and screamed. Eventually, her jailors gave in and provided her a bottle of medicine to keep her calm.

After a few days in a cell sobering up, Brusseau gave a description of Dr. Pope's murder lucid enough to fit the forensic evidence and one that really put Nellie in jeopardy of a life sentence for premeditated murder.

Every day for weeks leading up to the crime, he said, Nellie Pope nagged him to murder her husband so she could collect the insurance money. He didn't want to do it, but she had this strange power over him and he couldn't resist. The two concocted a plan, which went into effect at about three o'clock on the morning of February 2.

Feigning illness, Nellie lured Horace to the rocking chair, where he sat and listened to her symptoms while Brusseau waited at the back of the room with a hatchet. When Nellie gave the signal—she waved her right hand—Brusseau emerged from the darkness and planted the blade in the back of Pope's cranium. Brusseau recalled:

> *He was leaning over when I struck him on the head. I shut my eyes when I did it, for I felt a sick feeling creeping over me. After the first blow Pope fell back, and Mrs. Pope said: "Hit him again," and I struck him. "Hit him again," she called out, but I do not know how many times I struck him. I staggered back half fainting, for I felt the horrible deed.*

Nellie Pope, Brusseau said, never once lost her resolve or her nerve:

> *After it was all over we sat and talked over the self-defense idea, and about twenty minutes after Pope was killed his wife sat up in bed and fired off the revolver, so as to make it appear that the shot was fired by Pope when he was near her bed.*

Both Pope and Brusseau faced possible life in prison. Nellie Pope went in front of a jury first.

The two-week trial took place in June in front of a packed house consisting mostly of women who came to witness some real-life melodrama. They didn't leave disappointed.

Brusseau's latest rendition of that fateful morning, repeated on the witness stand and trimmed with a dramatic show of emotion, including tears and a crackling voice, was damning to Pope's defense. He hoped that charring Pope's name would help sway the jury during his trial.

In an attempt to dilute the damaging facts presented against her, Nellie Pope attempted to elicit sympathy with the jury. To help her, she enlisted the help of eight-year-old Bernice. She taught her daughter to cry on cue, and several times during testimony, upon command, the child sobbed loud enough for the jurors to hear.

Bernice played her part perfectly—although at one point, a bystander overheard her ask, "Will I cry now, Mama?"

The climactic moment in the trial came at 2:30 p.m. on June 5. After deliberating for less than an hour, the jury returned a verdict of guilty.

Upon hearing the sentence, the characteristically histrionic Pope slipped into character as the unhinged convict and went into hysterics. She clutched Bernice and wailed.

"Nellie W. Pope, stand up," Judge Chapin commanded. "Have you anything to say why the sentence of the court should not be passed?"

Nellie choked back a tear. "I'm not guilty, your honor, that's all."

"Oh, Mama, Mama," Bernice wailed as the judge sentenced her mother to life in prison. She clutched her mother's blouse as the bailiffs separated them.

Back in her jail cell, Nellie Pope asked for her usual: a glass of whiskey spiked with laudanum.

While Nellie quaffed her potent cocktail, a reporter interviewed Brusseau about the sentence. "It was nothing more than she deserved." He stuck by this testimony, characterizing it as "absolutely true." "It was, every single word of it."

"Have you any sympathy for her?" the reporter asked.

"None."

Brusseau's tryst with Nellie Pope would prove to be a costly affair. Later that summer, Brusseau was sentenced to twenty-five years at hard labor for his part in the crime.

As an alleged murderess, Nellie Pope captivated Detroit; as a convicted murderess, she became even more of a fascination. Her constant shenanigans inside the Detroit House of Correction kept her name in the headlines. According to some reports, she thrived on the notoriety and often quizzed incoming inmates about her newspaper coverage.

She confounded prison authorities with constant misbehavior, from small-scale scraps to larger brawls with fellow inmates. At first, the warden put her to work in the prison shops alongside the rest of the female inmates. But she had a habit of accusing other prisoners of conspiring against her; the resultant battles led to work stoppages, so the warden isolated her as much as possible.

She constantly complained about illness and whined for her medicine. She malingered to avoid work details and accused prison guards of abuse. Several times a day, she demanded to see Captain Joe Nicholson to lodge complaints.

It came as no surprise to Nicholson when, a year into her incarceration, Nellie Pope tried to escape her life sentence by feigning insanity. She told Captain Nicholson that a ghost was harassing her.

Nicholson described the situation to a curious *Detroit Tribune* reporter, who hoped to catch a glimpse of the infamous woman. "She commenced to tell that it was the doctor [Horace Pope] that she saw; said that he came every night and stood and looked at her until she nearly died with fright."

The warden believed that if anyone deserved a good haunting, it was the Detroit hatchet-murderess:

> *"Oh, well, Nellie," said I, "If that's the case, I can't do anything for you. Anybody that bars and bolts will keep I can relieve you of but when it comes to ghosts, I'm all at sea. I have no pull with them. Besides, if the doctor chooses to come and visit you, and I could help him along any, I should feel it my duty to do so. Spirits are privileged beings, and I think a sight of one now and then might do you good. No, Nellie, I can't bar out the doctor's ghost."*

"I think myself if one ever deserved to be haunted," Nicholson added, "it is this same Nellie."

"And is the haunt still after her?" the reporter asked.

"No, I think not," he replied. The ghost, Nicholson explained, eventually stopped harassing his most famous inmate. "She worked the ghost game for some little time, but finally gave it up. If the doctor's spirit still glares at her

in the dead watches of the night, I am not annoyed with any more recitals of it. Would you like to go up and take a look at her?"

A matron led the eager reporter to the women's ward, where he spied a tall, thin figure by a barred window: Nellie Pope, sewing buttons onto cards.

> *Her tall, masculine figure was slightly bent over her work, her dull, yellow hair combed away from her brow, and her somewhat sallow complexion rather colorless than otherwise. She looked neither sad nor happy, simply indifferent. Torn from her home and her child by her own act, confined within these walls for the rest of her natural life, she eats, drinks, sleeps, and sews buttons and sees ghosts.*

In August 1896, Nellie made headlines for a stunt she pulled while attending Sunday services in the prison chapel. According to custom, the women prisoners listened to the service from a balcony about ten feet above the men, who sat in pews on the ground floor. In the middle of a prayer, Nellie leapt from the balcony onto the male prisoners, who broke her fall.

She raced toward the minister, screaming, "I am innocent! I am innocent!"

After the incident, Nicholson decided that Nellie should attend private religious ceremonies.

Over the next decade, Nellie mellowed a little in her behavior but not in her crusade to prove her innocence. Hell-bent on leaving the House as a free woman, she assumed the role of the unjustly imprisoned martyr and constantly lobbied to clear her name. Her behavior inside the House, however, came back to haunt her, and her repeated efforts at parole failed.

While Nellie carded buttons in the Detroit House of Correction, her co-conspirator toiled at hard labor in the state penitentiary at Jackson. After his conviction, Billy Brusseau changed his story once again and claimed that he, and he alone, was responsible for the Pope murder. He reverted to his earlier self-defense tale and alleged the police tortured him into implicating Nellie. They strung him up by his thumbs, he said, and left him in intense pain for hours until he agreed to tell their version of events.

His drug habit and constantly evolving narrative about the murder destroyed his credibility, but that didn't stop him from trying to do a solid for his ex-lover.

Billy Brusseau never fully escaped the magnetic draw of Nellie Pope. Dying of heart disease, he performed one final act of obedience on his deathbed in 1906. He absolved her of all wrongdoing in the murder. "Mrs. Pope had nothing to do with it," he said as he lay dying in the prison infirmary. "She knew nothing about it."

It took another decade, but eventually, Nellie got her wish.

Noted prison reformers Robert and Susie Ogg lobbied on her behalf, finally convincing Governor Woodbridge Ferris to give Nellie Pope a late Christmas present in the form of a parole dated January 1, 1917. Nellie Pope's parole was just one in a record number issued by Ferris as his term ended, but the governor's gift to Nellie led to an outcry among incensed citizens, and her House cell doors opened amid accusations that Ferris's clemency had wiped away a just verdict.

She was still a curious figure two decades after the incident that made her one of the most notorious women in the city's history, reporters shadowed her as she walked out of the House of Correction on New Year's Day.

"I want a chance to be good," she told a reporter as she stepped into an automobile for the first time. "I want the public to give me a chance. I want fair treatment. I am innocent of the crime for which I have spent a long time in prison. And it has been a long time—a long, long time."

Nellie Pope spent the next decade making children's clothes at the Salvation Army using the seamstress skills she learned in prison. She spent evenings reading the Bible.

Not satisfied with her freedom alone, she continued the fight to clear her name, which finally came in 1928 when Governor Fred W. Green issued an unconditional pardon—an official exoneration that wiped away the stain of her thirty-three-year-old conviction. The act was inspired largely by Brusseau's deathbed confession two decades earlier.

Nellie Pope was no longer a murderess, at least on paper.

She never reconciled with Bernice, who was eight when court bailiffs pulled her from her mother's arms after Judge Chapman read the sentence. Following the trial, Bernice was adopted, changed her name and essentially ceased to be Nellie's daughter. She reportedly resented her mother for robbing her of a family and never visited Nellie in the House of Correction. At the time of her birth mother's release, she was twenty-seven, married and a mother.

Bernice had no desire to see her mother, and Nellie honored that request. "She is married, happy, and has children of her own. Our lives must stay far apart," Nellie explained during a 1928 interview.

Nellie W. Pope, at one time the most infamous murderess in Detroit history, died in May 1929 at the age of sixty-nine and was interred in Woodlawn Cemetery. Thirty years earlier, the press described her as a sinister, ugly ogre. The *Detroit Free Press* was much gentler in its postmortem description: "Wrapped in the silent majesty of death, the face of the once-beautiful Nellie Pope showed a broad brow, high-bridged aquiline nose, and firm chin, still features of strength."

5

INCREDIBLE ISMA,
THE CAMERA-SHY CON ARTIST

(1897)

A compulsive liar of the highest order and a brilliant con artist, Detroit native Isma Martin ran a sequence of scams that terrorized the Midwest in the 1890s. With a natural talent for role-playing, she became a major force in the traditionally male-dominated world of the confidence game and ran rings around her pursuers. Even after she was finally caught, she managed to evade the police photographer with a quick-change trick.

For some reason—either a strong sense of pride or embarrassment—Isma hated peering into the camera's eye and once even threw a fit when a newspaper sketch artist tried to preserve her profile in ink.

Isma Martin's date with the Cincinnati police photographer took place on a steamy June morning in 1897. Her arrest came after a frustrating, serpentine chase during which she stayed one step, and only one step, ahead of the heat.

She rolled her eyes as Sergeant Kiffmeyer, superintendent of the Bertillon branch of the Cincinnati Police Department, adjusted his camera. Martin didn't want her photograph taken, and she made that clear. Her face turned beet red as she balled up her fists and stomped her foot. Her lawyer, she said, told her not to pose for a mug shot, and that was that. At one point, Kiffmeyer thought she might begin ravaging his equipment.

She simply refused to sit in front of the camera. In an era when a photographer's subject needed to hold a pose, the "notorious adventuress" from Michigan was the worst customer Kiffmeyer ever faced, and given the nature of his job, that was really saying something. He had propped up drunks too inebriated to sit upright, and he had wrestled down suspects too angry to pose, but getting Martin into the chair was like forcing a cat into a tub of water.

Kiffmeyer's job involved taking two mug shots—a frontal and a profile view—that along with a battery of measurements represented the nineteenth century's state-of-the-art identification system for criminals. Upon the arrest of a suspect, a police officer would take the necessary measurements while a police clerk inked the numbers into a ledger. The Bertillon Department would then make an index-sized card that contained these measurements along with a suspect's mug shots. One copy of the card would go into

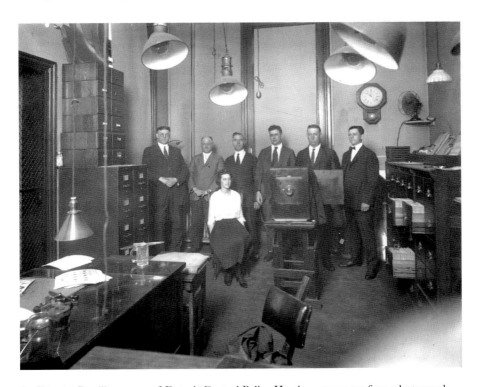

Staff in the Bertillon room of Detroit Central Police Headquarters pose for a photograph. Note the fingerprint cards and mug shot cards on the table to the left. Seated is Clara Langnickel, the clerk who ran the sting on fortune-tellers in 1914. *Courtesy of the Burton Historical Collection, Detroit Public Library.*

In her 1897 mug shot, Isma Martin clowned for a frustrated police photographer. *George Grantham Bain Collection, Library of Congress Prints and Photographs Division.*

A *Cincinnati Enquirer* newspaper artist sketched Isma Martin as she sat in court in June 1897. When she noticed the journalist drawing her likeness, she quickly covered her face.

the department's Rogues Gallery, with duplicates sometimes going to other police departments. In an era before fingerprinting, these Bertillon cards helped collar numerous criminals.

It took quite a bit of needling and cajoling before Kiffmeyer finally managed to convince Martin to sit for the mug shot, but as soon as he stepped behind the camera, she made a clownish face that rendered the image all but useless. For Martin, it was one final con in a long career of confidence games. Kiffmeyer acquiesced and didn't attempt to snap a profile picture; the wily woman had beaten him.

A *Cincinnati Enquirer* reporter who came to sketch the curious twenty-six-year-old vixen summarized the incident. "At last his [Kiffmeyer's] resources were exhausted, and only one picture, and that with a distorted face, had been secured of the smooth Isma to adorn the local rogues' gallery." His use of the word *adorn* was facetious.

Ismenia T. Martin, the daughter of Joseph and Frances (Brennan) Martin, was born in 1871. Her father worked as a builder, and her mother kept house and looked after Isma and her six siblings.

Isma's sticky fingers developed early when she began shoplifting from Detroit stores. By her late teens, the elaborate scheming that would lead to nicknames such as "The Notorious Adventuress" began to develop. In 1890,

she tried to hoodwink a ticketing agent with the Detroit, Grand Haven and Milwaukee Railway.

She showed up at the ticketing office along with a child she borrowed for the occasion and a sob story. She presented herself as Fanny Brennan—having appropriated her mother's maiden name—a destitute single mother in desperate need of a ticket to Chicago that she could not afford. The "daughter" lent an air of legitimacy—and a powerful emotional appeal—to the scam. Fanny told Chief Clerk Bierce that, in exchange for a ticket, she would send the company some furniture she had.

Bierce fell for it, but when Fanny Brennan signed the ticket as Fanny Martin, he became suspicious and called the police, who already knew the teen as a well-known con artist in the area. The incident led to a mug shot photograph, subsequently placed in Detroit's venerable Rogues Gallery, but no time behind bars. She avoided a stint in jail when the prosecutor took pity on her and declared he didn't have enough of a case against her for obtaining money on false pretenses; no money or goods had exchanged hands, and Ismenia did promise to pay for the ticket with a likely fictitious stash of furniture.

Even by that early time in her career, Ismenia T. Martin had established a reputation: the *Free Press* article detailing her attempt to obtain a free ticket came under the telling headline "Isma Martin Again."

Isma was a lightning rod for trouble, but she had a knack for avoiding any serious shocks. She stole $8,000 worth of diamonds from the wife of Detroit business scion Frank Leslie, but she sidestepped an arrest by returning them. Caught for forging checks in Denver, Colorado, she managed to fast-talk her way out of jail time with a little help, and money, from her Detroit relatives.

As she grew older, however, Isma's scheming—and stories—became bolder. Learning her lesson from the ticket debacle, Isma hit on an effective way of choosing false identities: by finding a "Martin" and claiming to be a relative. If the police came looking for her, they would inevitably go to door of the wrong Martin. She thumbed through the Detroit city directory and studied the names of area Martins she could adopt as it suited her purpose.

Her piece de resistance occurred in Grand Rapids, where she swindled several high-society ladies to the tune of over $1,950.

The Grand Rapids gambit occurred in late January 1897. Representing herself as daughter of Detroit Police chief John Martin, Isma ingratiated herself to Gertrude Anderson, a society lady she met at a boardinghouse. Martin told the gullible woman that her brother manufactured bicycles in Cleveland and she could obtain a set of wheels at a cut-rate of thirty-eight dollars. Anderson told her friends, each of whom wanted her own set of wheels and thought nothing about handing over the token payment. With a razor-sharp keenness about human nature, Martin recognized the basic human inability to let a bargain slip away.

As the wheel money rolled in, Martin worked a secondary scam as a life insurance agent, once again enlisting the help of the gullible Gertrude Anderson. She told Anderson that her company—Home Life Insurance Company of New York—offered a $200 prize for the top-grossing sales agent. Martin promised Anderson $25 for helping her, deviously hooking her victim to help her victimize others, and the pair hit the bricks. Martin subsequently sold several policies to Grand Rapids residents.

When Detroit Police superintendent John Martin (no relation), who knew all too well Isma's dangerous and expensive fictions, caught wind of the scam, he immediately sent a telegram to Grand Rapids authorities. Martin, however, smelled something fishy. Beating a criminal rap by hours, she hopped aboard an outbound train, her purse stuffed with greenbacks.

Ismenia the "Notorious Adventuress" pulled her next big scam in Covington, Kentucky. In April 1897, "Helen Martin" showed up on the doorstep of the Shea residence, where the widow Shea lived with her daughters Ella and Anna. An affluent family, the Sheas had friends and relatives in Detroit, including Captain Stephen Martin.

To wheedle her way into the confidence of the widow, Isma claimed to be Captain Martin's niece. She boosted her credibility when she said she knew the Boultons and Walkers—prominent Detroit families and longstanding friends of the Sheas.

The widow wined and dined Isma for two weeks. The Shea daughters were especially enamored with their gregarious guest. Ella wrote to her cousins in Detroit and said she would bring "Helen" along on their next visit.

On May 5, Helen Martin left on the pretense of collecting life insurance payments in St. Louis for her employer, the Mutual Life Insurance Company.

Instead, she traveled to Columbus, Ohio, to visit Peter Shea—the widow's brother and a prominent businessman.

Shea never questioned Helen Martin, who cleverly used her newfound acquaintances in Covington and Detroit to establish her credentials as a friend of the family. During her two-week stay, Martin had little trouble talking Peter Shea into purchasing a life insurance policy. He paid her a premium, and she headed back to Covington.

Then Isma Martin's lies began to catch up to her. She told Ella and Anna she had stayed just two days with Uncle Peter and spent the rest of the time traveling on business, but Peter Shea sent his sister a letter detailing Martin's two-week visit.

Martin may have caught wind of the Sheas' growing suspicions because she promptly left for Cincinnati "on business." Her timing couldn't have been better. At about the same time Isma exited stage left, Ella Shea received a reply from her cousins in Detroit. "Helen Martin," the letter said, was a well-known alias of the notorious con artist Isma Martin. A description of Isma perfectly matched "Helen."

Meanwhile, Peter Shea decided to do a little digging and discovered that Helen Martin did not work for Mutual Life. Fearful for his sister, he made a beeline to Covington but missed the insurance fraudster by footsteps.

Then Isma Martin made a fatal error in judgment: she returned to Covington. When she stepped off a streetcar in front of the Shea residence, she found Peter Shea waiting for her. She admitted everything, returned his sixteen-dollar premium payment, and asked that the Sheas send her things to the Dennison Hotel in Cincinnati.

Returning the ill-gotten loot had always worked for Isma Martin in the past. This time would be different.

On Saturday, May 29, 1897, "Helen Martin" registered at Cincinnati's Dennison Hotel. The next day, she made an unsuccessful attempt to talk the hotel clerk, A.C. Johnstone, out of five dollars before leaving the hotel.

Minutes after Isma left the hotel lobby, Ella Shea—still stinging from her dear friend's duplicity—approached Johnstone and asked if "Miss Martin" of Detroit had registered at the hotel. She explained that Martin was a notorious criminal wanted in Michigan. Johnstone, she suggested, should notify police immediately.

Acutely aware of hotel thieves who prey on unsuspecting travelers, Johnstone phoned Cincinnati police chief Deitsch, who told him to keep a lookout and let him know when Martin returned.

Martin, however, had an almost sixth sense when it came to detecting trouble. She felt the heat, so instead of returning to the hotel, she hired a messenger boy named Earl Mitchell to pay her bill and retrieve her valise. She also told Mitchell to drop the bag if he sensed footsteps following him.

Johnstone managed to stall Mitchell until Detective Jackson arrived at the hotel. Jackson, careful to keep his distance from the wary messenger, tailed the boy. At some point, Mitchell caught on to the tail, which led to a cat-and-mouse chase through the streets of downtown Cincinnati. The comedic chase went on for over an hour, with Jackson huffing and puffing as he pursued Mitchell, who lugged a large valise containing Isma's clothes, over the red brick streets.

Jackson finally caught up to Mitchell, who demurred and refused to give up Isma. Threatened with arrest as an accomplice, the kid softened and agreed to point out Isma Martin.

Exhausted, Jackson slapped a pair of bracelets on Martin's wrists. She admitted to facing trouble in Detroit but downplayed it as nothing but minor civil—not criminal—matters. Besides, she pointed out, her father was Detroit top cop John Martin.

Jackson, who had exchanged telegrams with John Martin about Isma's criminal history, knew better.

Isma Martin went to the Bertillon Bureau for photographing while a team from Grand Rapids left for Cincinnati immediately.

The arrest made headlines in three cities: Cincinnati, Grand Rapids and Detroit. A reporter for the *Cincinnati Enquirer* described the con woman: "Miss Martin is about 30 years of age, dresses neatly, is far from pretty, but has an intellectual face. She is a very smooth talker, and guards well her secrets."

During the extradition process, Isma noticed a newspaper artist sketching her likeness. "Instantly she slammed an umbrella which she carried to the floor and covered her face with her hands, while she protested against the manipulator of the pencil being allowed to sketch her face." Nonetheless, the artist managed to capture Martin's likeness for posterity. The sketch, which appeared in the next day's edition, would become the only known representation of the infamous con woman other than her clowned mug shot.

After completing the transfer protocol, Grand Rapids deputy sheriff Woodworth and female detective Clair W. Haines escorted the prisoner to Patrol Wagon No. 1.

Isma blanched at the sight of the paddy wagon. "Do you expect me to ride in that wagon?" she snapped. "Why don't you get a carriage for me?" A *Cincinnati Enquirer* reporter who watched the scene said Isma "tossed her head in the air" at this moment.

"You have put us to enough expense already," Woodworth replied, "and we don't feel disposed to grant any of your requests."

"Why can't we walk to the depot?"

"Well," Woodworth explained, "we don't expect to walk a mile to the station with you." The slippery prisoner would almost certainly try to escape.

Grumbling something about "no way to treat a lady," Isma Martin climbed into the wagon.

Isma Martin came face-to-face with one of her victims, Gertrude Anderson, when the bicycle trial convened in Grand Rapids on June 24, 1897.

It was all-out war between Anderson and Martin in the courtroom. A *Grand Rapids Herald* reporter described Martin's reaction when Anderson took the stand. "Miss Martin leaned back in her chair and with a quick, nervous action pulled her veil down over her tightly compressed lips. She fixed her eyes on the witness in a steady gaze, which Miss Anderson apparently did not like."

As Anderson testified about Isma Martin's web of deception, Martin jotted questions on a notepad for her attorney, William McKnight.

During the cross-examination, McKnight tried to discredit Anderson by accusing her of working as an accomplice, pointing out through Isma Martin's craftily worded questions that she agreed to participate in the life insurance scheme in exchange for a finder's fee of twenty-five dollars. She even introduced Martin to clients who purchased insurance policies. The stratagem didn't work.

After a lengthy deliberation of twenty hours, the jury delivered a verdict of guilty. Martin received the sentence with her signature expression: a cavalier, devil-may-care mien. She shrugged, flashed a thousand-dollar smile to the reporters in the gallery and skipped down the corridor as a deputy sheriff led her to the county jail. The larceny conviction did not take the bounce out of Isma Martin's step.

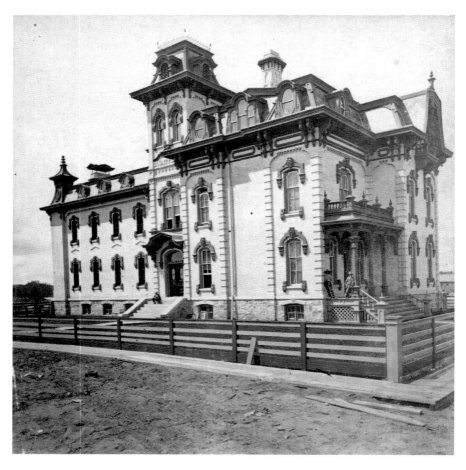

Stereograph of the Kent County Jail in Grand Rapids, Michigan, circa 1870, by photographer Schuyler Baldwin. The sheriff occupied the residence attached to the two-tier cell blocks, and his wife cooked meals for the inmates. During the "bicycle trial," Isma Martin occupied the "women's cell," located directly above the doorway on the east side of the building. Once convicted, Martin paid her legal penance in the old Detroit House of Correction. *Grand Rapids History and Special Collections, Grand Rapids Public Library.*

Judge Burlingame delayed sentencing until the supreme court could review the trial transcript and rule on Martin's appeal.

She spent the next ten months in the Kent County Jail. It was hard time. She complained of sharp pains in her side, she stopped eating and her weight plummeted. Doctors, however, could find nothing physically wrong with her, prompting a scathing commentary from a *Grand Rapids Herald* reporter. "Some day, perhaps, when this generation shall have passed away," he wrote,

"some learned physician, yet unborn, will startle the suffering world with a new pink pill for pale prisoners or a pleasant porus [*sic*] plaster or some other sovereign cure that might have chased this pain from Isma's side had it only been found in time to do so, but it is yet too soon."

The reporter believed that Martin faked the illness so she could swap a prison cot for a hospital bed. He also characterized her refusal to eat as a pseudo hunger strike motivated by a palate conditioned in Detroit's cafés and unaccustomed to jailhouse gruel. He described the once vibrant Isma Martin: "She says if she doesn't look out she will waste away, and Isma really wouldn't have very far to waste before she would vanish into thin air."

It took a year, but in April 1898, the supreme court rejected her appeal.

The remaining color drained from Martin's cheeks when she heard the sentence: eighteen months in the Detroit House of Correction. It was a gentle penalty, but as a native of Detroit, she knew the prison's rough-and-tumble reputation and had read stories about murderess Nellie Pope's sometimes violent confrontations with other prisoners.

Martin did not fare well behind bars in Detroit. The prison experience seemed to sap her vitality, she suffered from chronic illness and as the new millennium approached, she was emaciated. House of Correction superintendent Nicholson worried that she might die behind bars, a fear that led to Martin's parole in February 1899.

Once outside the House, Isma Martin made a speedy recovery. She traveled north to Mackinac Island, but her reputation had preceded her. Police confirmed her identity as a notorious con artist and, fearing she might con unsuspecting high-society tourists who flocked to the island during the spring and summer months, decided to run her off the island.

She landed back in Detroit, in her father's household. When the census takers came knocking in 1900, she gave her profession as "newspaper reporter." She apparently decided to go straight and report on the news instead of making it.

Martin remained a confirmed bachelorette and was dedicated to her job as a correspondent for the *Detroit Free Press*—the same rag that detailed her earlier exploits. She died in October 1931 at the age of fifty-eight.

Her obituary said nothing about her history as a camera-shy con artist who financed her twenties by "writing" short stories and peopling them with the gullible.

THE DETROIT BORGIA

(1905)

The *Detroit Times* described her as "one of the most heartless monomaniacs ever brought to the notice of authorities in the United States." The forty-year-old was attractive and educated and either a serial poisoner with no apparent motive or the victim of an amazing series of coincidences. For much of 1905, she became the center of a mystery that made national headlines. The case led Detroiters to ponder the immortal question, "Would any of you like to eat at a restaurant where Rose Barron was doing the cooking?"

It all began with a batch of muffins made with baking powder containing a very special ingredient.

In 1905, Detroit was a vibrant place buzzing with activity. The Ford Motor Company had shifted into high gear. Although Ford's iconic Model T would not appear on the roads until 1908, the horseless carriage business was booming. By the end of 1905, the company would move from its Mack Avenue plant to a larger facility on Piquette Avenue.

In January, however, all eyes focused on an apartment building located at the intersection of Bagg and Park Streets. The Alhambra was an upscale, turn-of-the-century tenement at the apex of its existence. Its six stories contained two dozen rooms and a café, staffed by a cook who provided meals for residents.

Thursday, January 19, was a typical afternoon at the Alhambra café. Mr. and Mrs. Collins complained about the cold snap that afflicted the city; Wallace Franklin and his wife debated whether the horseless carriage would eventually replace horses. Franklin insisted the automobile would never supplant the ever-dependable equine. Besides, he argued, only the rich could afford automobiles.

By evening, twelve of the people at the table became deathly ill with eerily similar symptoms: indigestion, vomiting, diarrhea, fever and chills. While the boarders agonized with crippling cramps, the city heath inspector seized the remains of the lunch before the main course became cold. He passed them to the city chemist, Edward H. Hayward, for testing.

Hayward was a real character with a colorful background. A pathologist at St. Mary's Hospital, he was an acknowledged expert in chemistry and bacteriology and lectured widely on both subjects.

Dr. Hayward also knew something about arsenical poisoning. He played a seminal role in the infamous Maybrick case when he inspected the stomach of John Maybrick and concluded that Maybrick died of arsenic poisoning.

At first, Hayward suspected ptomaine poisoning and ran a battery of tests. Nothing if not thorough, he tossed caution to the wind when he sampled leftovers of the fateful Alhambra supper and waited for symptoms to occur.

Suspecting something sinister, Captain James McDonnell dispatched two detectives to search the Alhambra. In the kitchen, they found a box of baking powder. "The detectives 'arrested' the box of baking powder," wrote an *Evening News* reporter, and turned it over to Hayward.

In keeping with his methods, Hayward wanted to taste-test the powder. "I was going to eat that baking powder," Hayward told the press, "but [health inspector] Dr. Keifer told me I'd better be cautious." Instead, he took a sample of the power and mixed it with water in a test tube. A white substance separated from the mix and settled to the bottom of the tube. Hayward already knew what it was: a heavy metal poison.

His sample of three-and-a-half ounces contained 195 grains of arsenic—3 grains was a fatal dose.

"I found sufficient arsenic to kill 100 persons," Hayward said.

By Monday, January 23, the boarders were on the road to recovery. Even Ida Collins, who lingered on the edge of life and death throughout the weekend, began to feel better. It was a close shave, but no one died at the Alhambra.

"Now that the baking powder has risen to the place of prominence in the case," the *Evening News* reporter noted with a clever pun, "many of the

victims are blaming the muffins which seemed particularly delicious on the evening of the poisoning."

With the culprit muffins identified, the question on everyone's mind—professional and amateur sleuths alike—was, "Who mixed arsenic in the baking powder?"

Mrs. Turle, the Alhambra proprietor, was mystified. "As far as I know no person would have any motive in trying to poison myself or anyone else," she told police. Four or five times previously, Alhambra diners experienced similar symptoms, although nothing as serious as the January 19 incident. Turle originally believed foul water in the pipes had caused the rash of sicknesses, but now she knew otherwise.

Suspicion immediately fell on Rose Barron, a professional domestic periodically employed by Mrs. Turle as a cook, waitress and cleaner. On Wednesday before the fateful dinner, Barron helped the janitor with housecleaning, which gave her complete access to the kitchen. And the baking powder.

As detectives looked into the mild-mannered woman's background, they discovered a disconcerting pattern. Symptoms seemed to follow meals served by Barron like a following sea in a storm. Police identified five other families that became seriously ill after eating dinners prepared by Rose Barron in the two-month period preceding the Alhambra incident.

Known as shy and reserved, Rose lived with her second husband, Michael Barron, a painter and paperhanger, in a small house on Spruce Street that they rented from a Mrs. Downs. A few years earlier, Rose divorced her first husband and married Michael, whom she met while doing some work in Windsor. A year after the wedding, her father-in-law, Peter Barron, suddenly and unexpectedly died while staying with the newlyweds, ostensibly from heart trouble. The suspicious death and the $2,000 life insurance policy triggered a coroner's postmortem, which amounted to nothing more than a cursory examination of the body.

During the summer of 1904, Rose worked in a St. Louis restaurant that served visitors to the St. Louis World's Fair. Reportedly, several people who dined at the restaurant became sick from an unknown cause. For a short time

that summer, Rose also looked after eighteen-month-old Melville Clayton, who died under mysterious circumstances.

In November 1904, Barron took a job washing clothes for her landlady. At about that time, Mrs. Downs baked a batch of bread and gave loaves to her friends Mrs. Mahoney and Mrs. Williams.

Members of all three families became violently ill. Dr. H.P. Mera, the attending physician, believed arsenical poisoning had caused the symptoms, but all the victims eventually recovered, so the incident did not lead to an official investigation.

Two weeks later, Barron took a job with the Williams family. An hour after she served them a chicken dinner, members of the family became sick, contorted with the same agonizing stomach bends they experienced after eating Mrs. Downs's bread.

Once again, Dr. Mera treated the afflicted, and once again, he believed that arsenic was to blame. He requested the leftovers so he could have them tested, but the uneaten chicken had suddenly, and mysteriously, vanished.

Barron next showed up on the doorstep of Jay McLaughlin, who had hired her as a housecleaner a week before Christmas. Four days later, Mr. and Mrs. McLaughlin, the cook, two servants and a maid became severely ill after eating a roast turkey for dinner. The attending doctor believed that ptomaine poisoning had caused the mysterious illnesses. No one suspected Rose Barron, although she was the only one in the household who didn't become ill.

Oddly, Barron wanted leftovers of the turkey that apparently left everyone deathly ill. She told Mrs. McLaughlin that she wasn't afraid to eat it, but McLaughlin decided to err on the side of caution and burn the suspicious fowl. The next day, Barron again asked for the leftovers, but Mrs. McLaughlin informed her that she incinerated the remains of their near-fatal dinner.

Then came the Alhambra and the almost last supper of January 19.

Convinced a monomaniac who had dosed ten families with arsenic was on the loose, Captain McDonnell ordered the arrest of Rose Barron. On Tuesday, January 24, police hauled her into the Central Station for questioning.

Captain McDonnell handled the interrogation himself.

"What do you know of the arsenic placed in the bread and biscuits in the Alhambra apartments?"

"Why, I know nothing about it," Barron responded in an even, unbroken tone. She didn't appear nervous or at all bothered by her arrest.

"Didn't you put arsenic in the baking powder?"

"No, I did not," she retorted.

"How do you account for the fact that the people all got sick from arsenic where you worked?"

"I can't account for it. I can't help it if I work in a place and the people get sick."

"We have overwhelming evidence against you," McDonnell noted.

"I can't help that. You'll have to prove it."

Despite Barron's placid demeanor, McDonnell believed she would crack in less than twenty-four hours and confess.

Along with the Alhambra victims, the alleged victims of Barron's arsenic rampage numbered fifty. Miraculously, almost all of them survived. Only Melville Clayton and Peter Barron actually died.

Nonetheless, it didn't take long, or a guilty verdict, for the press to dub Barron "The Detroit Borgia," linking her to the infamous Renaissance diva who allegedly poisoned the wine of political rivals with arsenic she secreted in a hollow ring. It was under the nickname "Modern Lucretia Borgia" that Rose Barron's name circulated in the nation's headlines.

"EVIDENCE AGAINST ROSE BARRON IS OVERWHELMING," proclaimed the headline of the *Detroit Times* front-page story devoted to the case. The *Times* labeled her a "monomaniac" and even published a list of her victims—the Alhambra residents and five other families who became ill after eating a Rose Barron–prepared meal.

The *Times* reporter thought he recognized clues about Barron's bent psyche from her physical appearance—a common belief of the time. "Her face is thin, her features angular. She has the marks physicians ascribe to monomaniacs."

Chief McDonnell compared her with Jane Toppan, a nurse from Massachusetts who admitted to poisoning thirty of her patients. Unlike Toppan, who confessed to and even gloated about her crimes, Barron insisted on her innocence. The confession that McDonnell predicted, that he hoped for, never occurred.

An *Evening News* reporter visited Detroit's most infamous woman, the criminal "It Girl" of 1905, in the "matron's apartments" at the Central

Station. Barron characterized herself as a victim of a conspiracy of coincidences.

When asked if she ever purchased arsenic, Barron admitted to buying five cents worth—about 120 grains—around the time her father-in-law died. She acquired the poison, she said, to get rid of rats at Mrs. Downs's house. The arsenic was for rats, she insisted, not people.

> *What would I poison those people for? I couldn't gain anything by doing it. There was no motive for me to do it. It is a coincidence that I have worked in several places where persons have been poisoned, and I am the victim of circumstances. I was sick myself at the time those people were sick in the Alhambra apartments.*
>
> *The day after everybody up there was sick I drank a cup of coffee with Mrs. Turle, in the café, and was taken sick right afterwards, but I did not eat any of the muffins which were supposed to contain the poison. I was also sick at the time my neighbors, Mrs. Downs and Mrs. Williams, were, and we thought that there was something in the air and that possibly our sickness was caused by sewer gas.*
>
> *Yes, after I went to work for Mrs. Mahoney on Sixth street they were taken sick in that house. They had pancakes and chicken for supper that night. I was not sick that time. I took the chicken home and ate what was left, but did not get sick. There is no truth in the story that I asked Mrs. McLaughlin for the turkey after they had been sick.*

In answering the sly reporter's questions, Barron inadvertently presented a possible motive for the alleged poisonings at the Alhambra. She wanted to purchase the café from Mrs. Turle, she said. "Mrs. Turle asked me why I didn't buy her out and I asked her how much she wanted. I expected that on account of the complaints that were made against the café she would give it up and I hoped to get it."

What at first appeared to be a motiveless crime, prompting McDonnell to label Barron a monomaniac, now took on a new, sinister and more mercenary undertone.

Throughout the interview, Barron smiled. The reporter found it odd just how much she smiled. "Your present predicament doesn't seem to worry you?" he asked.

"What's the use?" She sighed. "It won't do me any good to worry. I didn't do anything and I can afford to smile."

By the time the trial began in May, Rose Barron had spent three months in jail, and her smile had begun to fade. To fight the mass of circumstantial evidence, she hired a husband-and-wife team of lawyers, Charles and Merrie Abbott. In an era of all-male juries, a female attorney was a rarity.

The trial opened to a courtroom jam-packed with reporters, armchair detectives and onlookers seeking the era's version of reality entertainment. A woman lawyer sitting second chair to her husband added an additional bit of intrigue to the proceedings, especially for the ladies in attendance.

The prosecution presented three possible motives for the crime: Rose Barron poisoned food at the Alhambra because she wanted to deflate the asking price of the café, because she wanted to get back at Mrs. Turle for not giving her the job of cook or because she suffered from monomania.

The prosecution called Dr. Hayward and other chemists who testified that water tainted by ptomaine did not contribute to the mysterious illnesses. Running water, he explained, typically did not contain such bacteria. For ptomaine to exist, Hayward said, rotting organic matter had to be present in the pipes, but an inspection revealed no such pollution. The water came from the city's mains, which he described as "pure."

In an attempt to prove a pattern and to sway jurors, the prosecution called witnesses to testify about collateral cases.

Mr. and Mrs. Clayton described their son Melville's death after Rose Barron prepared his food. Drs. Sanderson and Clark, who examined Baby Clayton's organs after a later exhumation, testified about finding arsenic in the remains.

The Abbotts set out to prove the defense theory that polluted water caused the outbreak of illness in the Alhambra, and they called tenants who testified to being served glasses of discolored water with black specks settling to the bottom.

Rose Barron wept and used her husband's sleeve as a handkerchief as Prosecutor Bumps gave his closing remarks. She stiffened when Bumps stepped closer and pointed to her husband. "He has stuck by this woman through thick and thin, but he doesn't know when he may be flirting with death." Michael Barron frowned.

Bumps also pointed out an interesting connection among the alleged poisoning incidents.

"It is a singular fact in connection with the poisoning at the Alhambra, at the McLaughlin home, and in the Mahoney family, that, each time, Mrs.

Barron was about to leave. Each time she came around the next day. What for? To see how her victims were getting on?"

He ended with a strong piece of emotional rhetoric aimed at the jurors. "Would any of you like to eat at a restaurant where Rose Barron was doing the cooking?"

In his summation, Charles Abbott indicted the women in the audience—many of them residents of the Alhambra and witnesses for the prosecution—for doing their part in framing an innocent woman. He characterized them as harpies preying on one of their own kind.

"If this woman isn't convicted," Abbott said, "it won't be the fault of Lieut. Baker or of these ladies in the front row, who have been here every day and every hour of this trial."

Michael Barron echoed this misogyny when he spoke with a reporter as the jury deliberated.

> *She's a woman clear through—is Rose. Loving, unselfish warm-hearted. Do you expect anyone to act herself with all those women behind her in the courtroom—those richly dressed women with their faces set hard against her and their minds prejudiced? Do they show her any sympathy? No. The only sympathy that has been shown her came from men—men who have a little heart in them. But women—they don't have heart for other women. When a woman's down, she can't look to one of her own sex for pity.*

The all-male jury debated until two of them keeled over from exhaustion. Three times they informed Judge Phelan about their gridlock, and three times he sent them back for more. In the end, they stood split into two groups: seven for acquittal and five for conviction. They just couldn't agree that Rose Barron put arsenic in the can of baking powder. Clearly, someone had laced the food, but no concrete evidence existed as to whom.

Rose Barron's ordeal, however, wasn't over just yet. Officers escorted her back to the county lockup pending a second trial.

As summer approached, the psychological trauma of the trial had unhinged Rose Barron. Friends feared for her health and managed to persuade officials to release her. Valeska Grotzka, a twenty-four-year-old schoolteacher from Berlin, Germany, led a drive to raise the $1,000 bail needed to release Barron.

When asked about her benevolence, Grotzka explained that she had followed Barron's case from the beginning. "I believe she is innocent," she

said, "and, anyway, it is a shame to keep a human creature, sick as she is, from the blessed fresh air and blue skies."

Grotzka's faith in Barron's innocence, however, would be put to the test six months later.

In February, Rose Barron entertained some friends, including Valeska Grotzka and her father, Paul, at her boardinghouse on Jones Street. During the party, Barron presented her benefactress with a coffee cake. After eating a slice, Valeska complained about a burning sensation in her throat, and within hours, both she and her father had become violently ill. Given Barron's alleged predilection for heavy metal–laced desserts, the incident triggered a full-scale investigation.

Captain McDonnell confiscated the cake and took it to the city chemist for testing.

Once again, Rose Barron protested her innocence. "I'll hang myself if you do not let me go my way," she said. "I want to live in peace and quiet. Why does everybody suspect poor Rose Barron? They never have convicted me of poisoning anybody, have they?" Indignant, Barron said both she and Michael ate slices of the cake and neither became ill.

Convinced Barron tried to poison them with the coffee cake, Paul Grotzka confronted Barron. "I asked Mrs. Barron this afternoon, when she came to my shop, 'What was it you put in that cake?' She said, 'Why nothing at all. The eggs were not quite as fresh in that cake as in the rest I made, and perhaps the baking powder wasn't good.'" Two days later, the city chemist submitted his report to Captain McDonnell. The coffee cake contained no arsenic. Whatever made the Grotzkas ill came from something else.

Triumphant, Rose Barron addressed the press. "I knew it," she said. "I told them so. We ate a part of the cake made from the same batch, and we weren't sick. It is all a part of the scheme to convict me."

The timing for Rose Barron could not be better. While the prosecutor contemplated a second trial for the Alhambra poisonings, Barron—bolstered by the city chemist's findings in the Grotzka affair—used the press to her advantage and campaigned for her innocence.

As a result, the second trial never materialized. From their boardinghouse on Jones Street, Rose and Michael Barron continued to criticize the police force and claim that corrupt detectives tried to frame Rose for the Alhambra poisonings.

Both the press and the reading public alike did not believe Rose Barron's conspiracy theory and continued to suspect her of "toximania."

In the wake of the Grotzka affair, the *Detroit Free Press* published a bit of verse that provided a fitting epitaph to the state's case against Rose Barron, alleged mass poisoner:

They found no poison lurking
In Mrs. Barron's cake;
And we will never know what caused
Paul Grotzka's stomach ache.

Just how arsenic got into the baking powder in the Alhambra café, and who put it there, remains an unsolved mystery to this day.

The site of this bizarre affair, the Alhambra building (present-day address 100 Temple) still stands as a reminder of a bygone era and a possible serial poisoner who preyed on unsuspecting Detroiters.

CRYSTAL BALLS:
"MOTHER ELINOR" AND THE
FLYING ROLLER COLONY

(1907)

*W*oman is the greatest and noblest creation of God," explained Reverend Mother Elinor. "It is the old Eve through whom man fell—it is the new Eve—the exalted, modern woman through whom man must be saved."

The "New Eve," she explained, was free "from the degradation into which she has been plunged for centuries." This philosophy was decades ahead of its time, foreshadowing the women's liberation movement of the sixties. This feminist mystic, however, was not as she appeared.

Her Scotland Yard file #1,327,106 was two inches thick and chronicled a con game that spanned two continents. A criminal chameleon, she masqueraded under a dozen aliases. In Detroit, she went by the name "Mother Elinor L. Mason," high priestess of the Flying Roller Colony, a religious sect with headquarters on Henry Street.

In January 1907, a *Free Press* reporter was granted an audience with Elinor L. Mason, the matriarch of a religious cult known as the Flying Roller Colony. The group maintained branches in Windsor and Detroit, and its members exhibited an almost fawning adulation of Mason.

Mason sat by a crackling fire and grinned as the reporter approached her. Bedecked in a silk gown, the low-cut V-neck revealed a thick gold, gem-

encrusted coil dangling around her milky-white neck. Tufts of white hair hovered over her head like a halo of clouds.

"As she puts out both hands to greet you," he wrote, "your gaze is riveted to the jewel-laden fingers of both hands that flash blindingly in the firelight."

"I," she paused for dramatic effect, "am Reverend Mother Elinor." She waved her hand and the gemstones glittered.

She smiled as the reporter gazed at her rings. "Yes, I have many rich jewels. See this pigeon blood?" She pointed to a crimson stone. "It's worth $5,000. This circlet of rubies is $15,000. This pink pearl? Oh, that is priceless. I have a strong box filled with wonderful jewels—oh, they are worth at least $150,000."

The Reverend Mother sensed the reporter's confusion that, despite the fervent vows of poverty sworn by the men of her colony, she bedecked herself with the opulence of a Russian grand duchess. "It isn't for me." One by one, she plucked the rings from her fingers and tossed them onto a nearby table. "I wear these things to please my children, but for myself, what do I care for these?" she asked as she flung the "pigeon blood," which landed on the wooden surface with a metallic peal.

She had no need for material wealth, she insisted. As the most powerful woman in all of Christendom, she boasted, religious and political leaders bowed to her grandeur. With a snap of a gem-covered finger, she would have instant access to over $50 million in assets and a private yacht to take her anywhere in the world.

"How old are you?" The reporter asked bluntly. Despite her gray hair, she didn't look that old. Her face, neck and hands were free of wrinkles.

Mother Elinor chuckled. "Guess."

"Not a day over 45."

"Ah, how lovely you are," she responded, slowly pronouncing each syllable, her voice rising and falling in a playful tone. "Beloved, what would you say to me if I were to tell you that I am nearly one hundred years old?" Her voice raised an octave and she held up her arm in a grand gesture, as if addressing a congregation. "I am over 88 years old. How much I shan't tell you, but not many years will roll by ere I have reached the century mark, and I shall yet be young, because Christ promised that we should not taste death unless we sinned. I,"—again, she paused for effect—"have not sinned." Mother Elinor beamed with self-satisfaction.

She held up a silver oval dangling from the chain around her neck. Pope Pius IX, she explained, gave her this token—the medal of the Immaculate

The criminal chameleon known in Detroit as "Mother Elinor," the scion of a religious group known as Flying Rollers, poses for a photograph, sure to show the cameraman, and the viewer, the sizable ring on her finger. She once told a reporter that material wealth did not matter to her. *George Grantham Bain Collection, Library of Congress Prints and Photographs Division.*

Conception. Then she began to describe the New Eve philosophy. "We of the New Eve reverence and love this purest type of womanhood the world has ever known, because we stand for the emancipation of woman from the degradation into which she has been plunged for centuries."

She was a paragon of the new womanhood.

The reporter smelled something fishy and ended his story with a provocative statement. "You find yourself wondering how long before we shall know the truth about her."

His statement was prophetic. The ugly truth behind the divine vision would emerge three months later and stun Detroiters.

There was trouble in Paradise for the New Eve.

She fell out with longtime cult member John Swinden, an affluent Detroit lawyer who had fallen completely under her spell and had lent her a small fortune in jewelry. When Swinden wed without Mother Elinor's consent, she ordered him expelled from the cult. She did not, however, return the defrocked lawyer's gemstones.

The quixotic and mercurial "Swami," as she sometimes liked to be called, also had a run-in with U.S. Immigration officers. When crossing over into Detroit from the Windsor chapter, she refused to pay a "head tax," insisting she was an American citizen. This dispute opened up a line of inquiry that would lead to a startling truth for the Flying Rollers.

By March, the flamboyant High Priestess of Detroit had drawn so much attention to herself that people began to ask questions. Word of the enigmatic woman reached clear across the Atlantic to Scotland Yard, which recognized her description as "Editha Loleta Jackson," a paroled convict who defrauded the New Eve sect in London before fleeing the jurisdiction in December 1907.

A copy of Jackson's criminal dossier—Scotland Yard file, #1,327,106—arrived in Detroit four months later. Clipped to the jacket was a picture of Jackson, a spitting image of Elinor Mason. The scar over "Jackson's" left eye and two moles on her left cheek were dead giveaways to Detroit followers who queued up to identify the mug shot. Flying Roller member F.E. Swinden was first in line. He positively identified Mother Elinor as

Jackson, and claimed that before she excommunicated his father, John Swinden, she stole a fortune in jewels from him.

The documents inside the jacket chronicled the many faces of the New Eve.

In New York, she was known as "Ann O'Delia Diss de Bar," a swindler par excellence. Born in 1848, she was the daughter of rural Kentucky schoolteacher John C.F. Salomon. At age fourteen, she began to represent herself as a spiritual medium. She shed her past and gave herself a royal pedigree, claiming to be the illegitimate child of a Bavarian king and a dancehall beauty named Lola Montez.

In 1871, the twenty-four-year-old did a stint in a psychiatric hospital, where she tried to murder a doctor. Tried and acquitted, she left the hospital and married Paul Massaur, an orderly from the institute. They had a child, but domestic life did not suit the restless clairvoyant and she abandoned her family.

Madam de Bar took to the road in the guise of a spiritual medium. She worked small towns, where she used her extraordinary powers to reveal hidden truths, for a fee. Then, she would leave, outpacing a fraud charge by a few steps. Her grand deception came when she wheedled New York lawyer Luther Marsh out of a fortune by conjuring spirits with a few magic tricks and sleight of hand. Marsh became so enraptured by Madame de Bar, he even deeded his Madison Avenue property to her. The scheme caught up to her in 1888 when she was convicted of fraud and did the first of several prison terms. Burned in the Big Apple, she targeted Geneva for her scheming, which she did under the pseudonym "Vera P. Ava."

Ms. Ava spent two years in a Swiss prison following a larceny conviction. She changed her identity to "Edith L. Murray," but the new moniker didn't throw off the hounds. Arrested on a charge of false pretense, she stood trial, beat the rap, boarded a ship and landed in Chicago under the name Vera P. Ava. Another fraud conviction led to a short stay in Joliet Prison. When she emerged two years later, she married a wealthy Chicagoan named William McGowan, but once again, she decided a life of domestic bliss did not suit her. She walked out on her husband and headed straight for New Orleans.

She began to work her spiritual medium con with Frank Dutton Jackson and introduced herself as his wife. In May 1899, the Jacksons had worn out their welcome in the Crescent City. They traveled all the way from Florida to South Africa, swindling the naïve and unsuspecting by conjuring spirits and predicting the future.

Diss de Bar and Jackson next traveled to London, where they masqueraded as Theodore and Laura Horas. Theodore established a religious cult, and

Laura helped him lure young girls into prostitution on the pretense of joining his religious organization. The scheme earned the couple lengthy prison sentences following a December 1901 conviction. For her pandering, Laura Horas received seven years.

Paroled from Aylesbury Prison in August 1906, she immediately went to work defrauding the New Eve group. She showed up on the doorstep of the cult with a tale of divine revelation realistic enough to convince the leader, Prince Michael. He wrote a letter endorsing her as the rightful leader of the Detroit and Windsor branches. She left England in December 1906 with several valuable pieces of jewelry that belonged to the prince and other cult members.

A few months later, she appeared in Detroit as "Mother Elinor Mason," where she duped the Flying Rollers with her endorsement letter, New Eve rhetoric and apparent generosity. She claimed to own six thousand acres of land in Florida and gave each member a deed ostensibly to begin a new colony. In turn, they gave her access to group funds and fine jewelry to wear.

When Swinden fell out with the cult queen, he contacted Prince Michael, who tried to withdraw his support via cablegram. His attempts backfired. The Flying Roller trustees had fallen so deeply under the spell of Mother Elinor, they excommunicated the prince instead.

Along with the criminal dossier came a letter from the governor of Dartmoor Prison that left little doubt about Mother Elinor's true identity. Addressed to Detroit Police superintendent Downey, the letter read, "Prisoner C671, F.D. Jackson, is anxious to know the whereabouts of his wife, Edith [*sic*] Loleta Jackson. She is supposed to have sailed from Liverpool, November 30, 1906, and she gave her future address at that time as 137 Henry Street, Detroit." The address—137 Henry Street—was the Detroit headquarters of the Flying Rollers.

Mother Elinor had a lot to answer for, but no one knew where to find her. In mid-March, she disappeared without so much as a goodbye to her followers in either Windsor or Detroit.

On April 1, Mother Elinor was to appear before the trustees to clear up questions about her identity and to answer Swinden's allegations that she embezzled Roller funds and approximately $10,000 worth of jewelry.

As a small legion of newspaper reporters stood over them, the Rollers sat in a circle and waited several hours for the mysterious figure to

appear at their "god house" on Henry Street, but it became apparent that their matriarch had played an April Fool's joke on them. The lady had simply vanished, leaving the astonished members with nothing more than fistfuls of worthless paper—the "deeds" to her nonexistent parcels of Florida real estate.

Mother Elinor never showed her face in Detroit again.

The criminal chameleon remained underground for two years, surfacing in August 1909 in Manhattan. As Mademoiselle A-Diva Veed-Ya, an occult savant, she hoodwinked a socialite into giving her a teaching position at the Mahatma Institute of New York.

Diss de Bar's reputation as international swindler extraordinaire had preceded her. Unmasked and apparently in a mood for vengeance, she threatened to destroy New York with her powerful thought waves before once again disappearing into the ether. This time she would not emerge.

Her fate remains unknown.

A *Free Press* article published in 1920, when her alleged husband, Frank Dutton Jackson, came to Detroit looking for her and her reputed millions, described her as a one-of-a-kind criminal:

> *This White Mahatma, Queen of the Flying Rollers, reincarnation of the Goddess Isis, Mother of the 144,000, self-styled daughter of King Ludwig of Bavaria and Lola Montez and pretended god-child of Pope Pius the Ninth, was one of the most extraordinary fake mediums and mystic swindlers the world has ever known.*

Fallout from the scandal dogged seers and fortunetellers in Detroit for many moons. Detroit police, ever vigilant for false prophets on their beat, arranged a sting to run them out of business in 1914.

A female clerk with the identification bureau, under the pretense of a desperate woman in need of help, visited several area "palmists" who had advertised in one of the Detroit papers. Clara Langnickel, the clerk-cum-investigator, followed a routine. Once inside the medium's parlor, she asked to know her future, and if the "seer" offered a prediction and

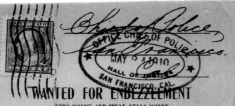

ERNA WAYNE ASSISTED BY M'lle NELLA

THE CELEBRATED CLAIRVOYANTS AND PSYCHIC PALMISTS.

Tells you every Hope, Fear and Ambition of your entire Life, gives names in full, dates, tells of your friends and enemies, in a word, tells everything without asking any questions.

A SECRET YOU SHOULD KNOW--THE POWER TO CONTROL

ERNA WAYNE tells you the exact truth regarding yourself or anyone else. What you can expect and when to expect it. If you are in trouble over your condition or the condition of anyone else, ERNA WAYNE not only tells you the cause, but **removes the cause**, that your desires may be satisfied in Love, Marriage, Divorce, Health, Business, Property, Changes, Lawsuits, Family Troubles, Reuniting the Separated, How to Win the One You Love, Conquer Enemies, etc.

Unlike the fortune teller and pretender, ERNA WAYNE asks no money in advance for readings and positively refuses to accept any fee unless perfect satisfaction is given in all cases. If you are troubled over any affairs, you had better call today, and if ERNA WAYNE cannot help you, will tell you so. Tells you just what you may expect and what to do for your best interests in any matter. Awakens a natural force within you and around you, giving you a secret power to remove the cause of any trouble, influence, unhappiness, disease, poverty, failure or bad luck that surrounds you. Opens up a way for the success and happiness you desire. A power to secretly change the thoughts, actions, habits or intentions of anyone even miles away.

Personal Magnetism developed, Clairvoyance, Palmistry, Healing, Mediums developed. Special attention given to this line. Charges within the reach of everyone. Kind, sympathetic and generous ERNA WAYNE turns no person away. Parlors arranged so that you can meet no one. Hours, 10 a. m. to 8 p. m., daily and Sunday. Remember ERNA WAYNE charges no fee unless found superior to all others. Ladies' maid in attendance.

PRIVATE PARLORS LOCATED AT

Manhattan Hotel, (Opp. Street Car Waiting Room) Uniontown, Pa.

WALK UPSTAIRS

WANTED FOR EMBEZZLEMENT.

ERNA WAYNE AND M'LLE NELLA WAYNE.

These parties are charged with the embezzlement of the sum of $1,000.00 from Miss M. A. Cochran of No. __ North Mt. Vernon Avenue, Uniontown, Pa., on May 18th, 1910.

The reverse side of this card will explain the method employed by these parties to cheat and defraud. They usually go to towns and cities throughout the country, engage rooms for one week and distribute these circulars throughout the town.

DESCRIPTION:

ERNA WAYNE—Age, 50; height, 5 feet 7 inches; weight, 145 pounds; sallow complexion, dark brown hair; small dark mustache; blue eyes set deep in head; wore black sack suit, dark forinhand tie with scarf pin, cluster of pearls and small diamond in center, watch fob with gold plated ten cent piece.

M'LLE NELLA WAYNE—Age, about 48; height 5 feet 6 inches; weight, 125 pounds, hair dark, turning gray; wears small hat turned up at side; with black plumes; two rings on middle finger of right hand.

If located, arrest and wire.

ALEX. McBETH.
Chief County Detective.

Or D. W. HENDERSON, Uniontown, Pa.
District Attorney, Uniontown, Pa.

The popularity of spiritualism and mysticism in the early twentieth century led to all sorts of shenanigans perpetrated by less-than-scrupulous women. Con artists such as "Mother Elinor," a.k.a. Ann O'Delia Diss De Bar, muddied the waters for other clairvoyants, fortunetellers and mystics, particularly those who ran scams of their own, such as Erna and Nella Wayne. A wanted postcard published by Pennsylvania authorities in 1910 describes the false prophetesses' con game on naïve and unsuspecting believers. *Author's collection.*

accepted payment, a detective waiting outside arrested her for violating a statue that banned fortunetellers from advertising in newspapers. Several fortunetellers were taken in the dragnet, most notably Minerva Wise and Anna Parks Hulsh.

Madam Wise's advertisements had been fixtures in the classifieds since 1908. As a "scientific palmist," she washed the hand of her client and, using a caliper, measured the lines and from them predicted the client's future. Using this method, she claimed, she read the palms of several prominent Detroiters, including two judges. She charged one dollar for her services.

The police trap did not deter the indignant clairvoyant. She found other ways to earn money from her gifts. Instead of reading palms, she authored a book about scientific palmistry and gave lectures about various subjects, including a 1919 talk titled "Man as Studied from an Exotic and Esoteric Viewpoint."

Hulsh, a self-proclaimed expert on the business world, worked out of a richly furnished apartment on East Alexandrine Avenue, where she made fiscal forecasts for gullible investors. Her newspaper advertisements described her as "medium" who "reveals readings through glass." The customer would dip his hands into a magical white power and then place them on a white crystal, or "glass." Hulsh would then peer into the crystal and read the future. Like Wise, she charged one dollar for her "magic." After the sting, her name ceased to appear in the classifieds, and she faded into obscurity.

THE GREAT BORDELLO SCANDAL

(1908)

*I*n 1908, Detroit boasted 175 "resorts." Gentlemen seeking short-term companionship could down a few shots of liquid courage before following a paid companion to a room for some "horizontal refreshment." Beat cops, many of them paying customers, accepted bribes from madams and pimps, who preferred greening the palms of police to paying for licenses to pull taps. This was big business, and greenbacks flowed as readily as whiskey, which bordello bartenders poured without licenses, costing the city an estimated $85,000 per year.

Sooner or later, city officials would realize they could no longer afford to turn a blind eye to these establishments.

A feud between two madams in Delray, also known as Little Hungary, exposed the widespread graft in the city's thriving red-light industry and led to one of the worst police scandals in Detroit history.

For several months, Julia (a.k.a. Julian) Toth, madam of a Delray brothel, eyed the steady parade of boys going into and coming out of Annie Smith's place. Smith ran a house of ill repute and an adjacent saloon at 8 Solvay Avenue, just down the street from Toth's. On weekends and most weeknights, Smith's saloon was standing-room-only, crowded with johns awaiting their turn in one of the rooms next door. While Smith's girls did brisk business, Toth's inmates served a few regulars and the

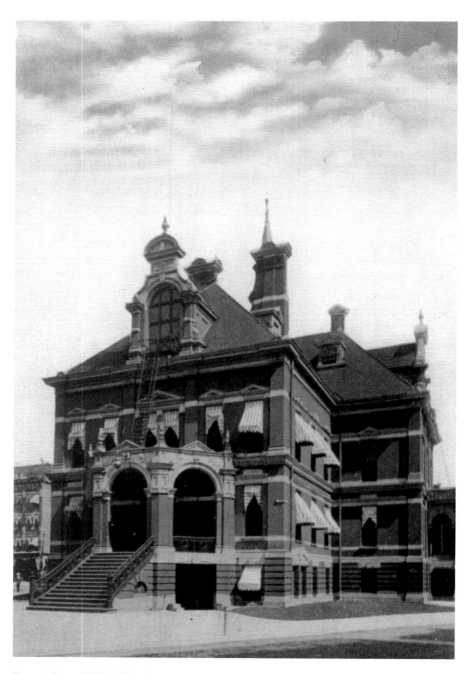

Detroit Central Police Headquarters as it appeared on a postcard from 1908, when it became the scene of controversy involving feuding madams and allegedly corrupt police officers who accepted bribes to look the other way. *Author's collection.*

overflow from her rival madam's establishment. Younger, prettier girls entering the business walked right past Toth's place and headed straight for Smith's bordello.

A native of Hungary, Toth left her husband in the old country and immigrated to the United States in 1897. With no other way to support herself, she entered the bordello business in Detroit, finally earning enough to book passage back to Hungary in 1904. She returned to Detroit with executed divorce papers in hand and her children in tow.

After several decades of hard living, the attractiveness that made Julia Toth a teenage bride in Hungary had long ago faded. Her smooth, milky-white face had become crisscrossed by a network of creases radiating from the corners of her eyes and edges of her mouth. Now forty-one and a single mother of four, she struggled to make ends meet.

Toth, like all the other madams in Detroit, paid a fee to prevent official visits by the "blue coats," but Smith—known as "The Queen of Little Hungary"—kept her illicit machine greased with bribes. An adept businesswoman, she feted officials with elaborate shindigs hosted by a party girl named "Bessie." The guest lists of these exclusive, backroom parties contained several big names in Detroit law enforcement, men who kept Annie Smith and her prostitutes away from the Detroit House of Correction. She didn't mind the costs. Smith knew from her days as a madam in Cleveland and Toledo that it was the price of doing business.

Among the partygoers at her neighbor's place, Toth recognized three in particular: Detective Frank Hibbler, Detective Edward Favor and Captain Frank Newberry. Together, they gave Smith a virtual monopoly in Delray.

Irritated at her inability to gain a foothold in the brothel business, Toth marched straight to the office of Judge Jeffries to lodge a complaint about official interference. Thanks to Toth's interference, Smith faced a charge of running a house of ill repute and a possible three-year stay in the House of Correction, while Hibbler, Favor, Newberry and Police Commissioner Fred W. Smith became the focus of an official probe.

Jeffries cited several reasons for his dragnet. Bothered by the age and number of young boys who frequented Smith's place, he said he couldn't abide such corruption of the youth. He also said that the upstanding citizens of Detroit simply wouldn't stand for police corruption.

In reality, Jeffries's motives were more economic than moral. Because proprietors of the city's sin industry wanted to keep their business running smoothly and quietly, they didn't apply for permits to sell alcohol. This cost the city thousands of dollars in revenue per year.

Two members of the Detroit Police Department hard at work, circa 1910–20. Note the Rogues Gallery housed in a cabinet on the wall. At one time, Detroit's gallery contained mug shots of infamous con women Sophie Lyons and Isma Martin. *Courtesy of the Burton Historical Collection, Detroit Public Library.*

Jeffries wanted to set an example. He ordered the closure of Annie Smith's brothel and leveled charges against her protectors, the three "blue coats" who kept her in business. Hibbler, Favor and Newberry were about to be caught with their hand in Smith's cookie jar.

Although Smith faced dual charges of running a disorderly house and prostitution, she had a trick up her sleeve. In a classic diversionary tactic, Annie tried to focus the attention of investigators on the crooked cops instead of what occurred behind the closed doors of 8 Solvay Avenue. It was a strategy that turned her former friends into enemies.

The twenty-nine-year-old Queen of Little Hungary became an instant sensation. With the effervescence of bubbles rising to the surface of a champagne flute, Smith entertained reporters with her sharp wit, keen sense

of humor and ever-present smile—a personality that made her the hostess of choice among brothel-goers. Once asked how she could remember the specific dates in which she gave "presents" to her "friends" on the police force but could not recall the conversations she had with them, she quipped, "Well, I did not get any receipts for the conversations, but I did get receipts for the presents I bought." Smith's wit had served her well in the dog-eat-dog world of red-light Detroit.

Despite her continual smile, Smith toted some heavy baggage. Born Ann Sprekner in 1878, she first married in 1892 at age fourteen. When her first husband left her a year later, she emigrated from Hungary to New York, where she went to work nursing an elderly woman. While in Buffalo working in an orphan's home, she fell for a saloonkeeper named George G. Walter, who was living with a hooker named "Big Lil." Annie ran off with him to Cleveland, where he changed his name to Jack Smith. The couple wed in 1902 and relocated to Toledo, where Annie Smith opened her first brothel.

Annie Smith was no stranger to a courtroom. In 1899, she worked at a resort on Merrick Avenue run by Mary Barber. She faced a larceny charge when she pilfered twenty dollars in clothes, prompting Madam Barber to call the police. In justice court, Smith claimed a girlfriend had hypnotized her, but the justice didn't buy her novel excuse. He dismissed the case but insisted that Annie do a stint in the House of the Good Shepherd—a reformatory for prostitutes, delinquents and other wayward women.

It didn't work; Annie emerged from the House, unreformed, and returned to the life. Within a few years, she would own her own brothel on Michigan Avenue, where her marriage came to an end when the "blue coats" nabbed her husband, Jack Smith, alias Walter, on a charge of highway robbery. It was the last straw for Annie, who had tired of her husband and his friends pestering her inmates and drinking her liquor. She immediately filed for divorce.

Eventually, Annie Smith's red-light empire would expand into a network of saloons and brothels, including the most popular resort in Delray.

Jeffries and his right-hand man, Assistant Prosecuting Attorney Louis McClear, began their probe by interviewing Smith's entourage.

Smith's bartender Joseph Myrchak and housekeeper Alard Sicket described bacchanalian parties during which champagne flowed like water. Myrchak said one officer, a captain, ate almost all of his meals at Smith's bordello.

The key witness was none other than the Queen herself, who was all too happy to expose corruption within the police department if it kept her out of the House. Smith claimed that in 1906, Detective Edward P. Favor agreed to look the other way in exchange for a bookcase valued at seventy-five dollars. "That isn't all that I gave him," Annie said. "He got lots of money beside that. He threatened that he would make me close up my place if I didn't give it to him. No, he isn't the only one to whom I gave money. It will all come out in the wash."

Some of "the wash" came out when Smith accompanied detectives to Favor's residence at 881 Porter Street and pointed out various items she "gifted" to the detective. Mrs. Favor's eyes widened when Smith pointed out the brooch on her dress as one belonging to the infamous madam. The visit, and the bookcase, led to Favor's arrest in late April 1908.

Smith also said that eleven-year veteran cop Frank Newberry threatened to end her reign when he heard about her allegations of graft. "Capt. Newberry says that he is sorry that he didn't put me out of business, does he? Well, he doesn't dare to put me out. Just after I testified before Justice Jeffries, he told me that he was going to force me out. I told him that he would have to back the patrol wagon right up to the door and carry me away bodily, and he didn't do it. He hasn't the nerve."

Another piece of dirty laundry that Annie Smith dangled on the clothesline for all to see belonged to longtime Delray politician C.L. Coulson.

Justice of the peace in old Delray, Coulson accepted numerous bribes from the madam. Smith said she paid a virtual tribute to the old man. Coulson tried to cover his tracks by claiming he had conducted an investigation of his own. "I probably never would have investigated the conditions had it not been for the requests of parents of boys who frequented Annie Smith's place. The deeper I got into the matter, the more rotten I found it," an embattled Coulson told the press.

Police Commissioner Smith decided to fight fire with fire and close Smith's bordello, but the ever-wily madam beat him to the punch. She closed both the saloon and the whorehouse, sending her inmates to the country for a well-deserved break until the controversy blew over.

Annie Smith, who didn't appreciate Coulson's attempts to crab walk his way out of trouble, turned up the heat when she sent Bessie King to Jeffries and McClear.

When the Queen wanted to make an impression with special guests, she turned to King. The buxom brunette flirted with reporters, who quickly became enamored with Smith's go-to girl. She showed up to the interview wearing a seventy-dollar gown and a massive Merry Widow hat that left reporters searching for superlatives.

King, adept at pushing boundaries, came close to breaking the city's ordinance restricting hat sizes.

"The hat is white straw adorned with a white dove," noted a *Free Press* reporter. "The size of the hat apparently just comes within the dimensions defined in Ald. Delmel's Merry Widow hat ordinance, namely a maximum diameter of six feet." The near life-size dove perched on the brim appeared ready to fly off at any minute.

King described her position in Smith's organization.

"Annie was wise enough to realize that she could make a hit by having me around when she was entertaining some of the smart fellows. When she gave spreads to certain police officers I was always invited and attended." She named several officers, including Favor and Newberry.

King also described a sting engineered by Smith:

> *Coulson, the former justice of the peace, couldn't make a hit with me. I led him a merry chase; got money from him, too. We put up a job on him. When he thought he was working me to help him win a suit against Annie Smith in which he said he expected to get $2,000, I had a couple of detectives and a stenographer from police headquarters listening to the whole thing. They were on the other side of a thin wall. The police were putting up a game on Coulson and he was trying to frame up a case against Annie Smith. I was helping Annie and the police, and made Coulson think I was agreeable to his plans.*

Apparently, Coulson, who failed in his repeated attempts to seduce Bessie King, also tried to enlist her help in framing Smith. The crafty madam sniffed out the plot, turned the tables and set up Coulson. The sordid affair made Coulson look like a dirty old man and a corrupt money-mongering politician.

The little that remained of Coulson's reputation took another hit when the *Free Press* ran an article about Bessie Smith under the playful yet sardonic headline "She 'Did' Mr. Coulson."

The Queen appeared in court on May 22, 1908, to describe the bribery she used to obtain a monopoly in Delray. In front of a large crowd of gawkers, she sauntered to the witness box to testify against her onetime protectors.

In addition to cigars, whiskey and women, she said, she gave a total of $600 cash in three installments to Hibbler, a bookcase and gold jewelry to Favor and diamond jewelry worth $400 along with a crystal tumbler set to Newberry. "Every time I gave him [Newberry] a present," Smith testified, "he said he would have things 'fixed.'"

She bought a $135 punch bowl for Police Commissioner Smith, who later came to the bordello in person and pledged to protect her as long as he remained in office. He also promised to remove the competition and "wouldn't let the Toth woman run no place," Annie testified.

Coulson, Annie said, received several cash payments that she recorded in a ledger.

Smith also said she gave a dress to Deputy Sheriff Wollen for his wife, but her accusation destroyed Wollen's credibility as a witness. The defense subsequently attacked the character of a man who, in the words of a *Free Press* reporter, "would give to his wife the dress of a woman of the under world."

Defense attorney Allan Frazer did his best to discredit Jeffries' star witness, but at the end of his cross, Annie had him in knots. Whenever he pushed, she pushed back harder, adding details that further condemned his clients. During one particularly hostile exchange, Annie dropped a bomb: after the scandal broke, Hibbler had offered her $500 to make her graft allegations disappear.

Frazer's frustration became evident to the small cadre of reporters in the courtroom. "She cleverly comes back with replies that time and again show her questioner that he may be on dangerous ground," wrote one reporter who watched Smith talk circles around Frazer.

As soon as Frazer raised the issue of Annie's past or her position in the sex trade, Annie offered a new revelation, apparently to keep herself out of the limelight. Frazer thrust, Smith parried and counterattacked.

She described a feud that emerged between Favor and Newberry over the size of the diamonds they received; the diamond in Newberry's $395 stud dwarfed the chip in Favor's $65 diamond. Favor wanted a bigger diamond than Newberry. "I can do as much for you as Newberry can and as much against you," he allegedly threatened.

"What did Newberry say every time you gave him a present?" Frazer asked.

"He say he see to it that everything be all right for me."

"Did you want Julian Toth's place closed?"

"No, I don't care. There was enough trade for two places."

At one point during Frazer's cross-examination, the wily witness frustrated the defense so badly that they began accusing Assistant Prosecuting Attorney McClear of supporting perjury. The tension came to a head when Frazer asked if Captain Newberry called her "Annie."

Frazer's second chair, James Murfin, objected to calling the witness by her first name in court. "I won't call her Annie," Murfin screeched. "I don't believe in placing myself on terms of common familiarity with the class of people the prosecution is here associating with."

McClear didn't appreciate Murfin's insinuation that he consorted with prostitutes. "She's not worse than you are," McClear snapped.

After maneuvering the opposing lawyers into a near fistfight, Smith presented two, final revelations before she left the witness stand. The first consisted of a handwritten inventory of gifts she gave to Favor, Hibbler and Newberry. The list contained two dozen line items totaling nearly $2,000.

The second revelation concerned her long-standing relationship with the boys in blue. Apparently, Annie Smith had been in bed with Detroit police for years, occasionally working as a private detective. As the department's eyes and ears in underground Detroit, she alerted Commissioner Smith about an underage inmate at Julia Toth's bordello. According to Smith, Toth used the girl as an expensive curio for customers whose tastes ran to the extremely young.

Smith's testimony consumed three court sessions, but despite Frazer's best attempts to discredit her story, he failed. He repeatedly rephrased questions and tried the rapid-fire approach—shooting several questions at the witness in quick succession—but he could not catch Smith in a lie. She chuckled when she stepped down from the witness stand and laughed as she walked out of the courtroom. The madam's celebratory cackling echoed throughout the corridor as she made her way down the hall.

Annie Smith would have the last laugh—at Coulson's expense. When Coulson failed to find witnesses to support his charge that Smith ran a house of ill repute (Annie had sent her inmates out of the city), Jeffries released her on a $1,000 bond.

Some prominent Detroiters, upset that a fallen woman would bring down respectable families along with her, urged Smith to leave town on the next train. The "Big Four"—the newspaper nickname for well-to-do businessmen who wanted Smith gone—agreed to pay her expenses if she relocated to Arizona, far out of Prosecutor Jeffries's reach.

The prosecution's star witness boarded a train bound for Toledo and disappeared.

Police caught up with Annie Smith and her bartender, Charles Delisle, and arrested both for evading the prosecution. They used the lingering charge of running a bordello as an excuse to pen Smith until their cases against the corrupt cops concluded.

Delisle tried to slip out of the handcuffs by claiming he was in the wrong place at the wrong time when police made the arrests, that he just happened to board the same train as the infamous bordello maven. Delisle, however, couldn't hide his true feelings for Smith, which became evident through the glances they exchanged. Annie, noted an observant reporter, "continually regarded him with looks of affection that caused his florid features to flush a deeper vermillion."

Annie Smith had become a virtual headline machine. Although she could be provocative, defiant and, at times, downright obstinate, reporters loved her. A small group always shadowed her public movements, and they gathered at police headquarters, where Smith gave a brief interview after her arrest.

Smith explained that she had fled the city after four big-name Detroit businessmen threatened her. The Big Four wanted her to testify that Jeffries asked her to point the finger at Smith, Favor, Hibbling and Newberry in exchange for protecting her business, but Annie refused to change her story.

"What, behind bars? Iron bars?" Annie protested, incredulously, as the police matron seized her wrist and gave it a tug. "Where are my friends now?" She said in heavily accented English. "When you weep you weep alone; laugh and the world laughs with you. I do no mean that I weep. I never remember ever weep. I mean when trouble come friends go. While you give diamond rings, punch bowls and money they stick very close."

Annie didn't miss the opportunity to disparage her former protectors. "I feel better now, coax me an' maybe I go to jail, but I want that leather pillow that I gave Detective Favor to sleep on while I in jail. I want that bookcase and cut-glass lamp shade in my room at jail. Some one tell me they be at jail now, so bring them in to furnish my room."

Reporters, who eagerly noted down Annie's every word, followed her footsteps as the matron led her to a cell. As the procession moved slowly down the corridor, she pulled the stopper on a bottle of perfume, and with a few snaps of her wrist, showered the writers.

By this time, Annie Smith had become a villain of semi-mythical proportions, and one reporter feared poison.

"Carbolic acid," he screeched, causing a temporary panic. The group collectively melted; the wave of reporters receded.

Once ensconced in her cell, Smith immediately set about ordering her dinner. "I want bouillon, celery, olives, lots of olives, blue points, frogs' legs, fried chicken, French fried potatoes, peas, tomatoes, ice cream, cherry pie, Swiss cheese and a pot of black coffee."

Upon overhearing Smith's elaborate meal request, a jail attendant quipped, "Give her Queen Anne soap," but the matron just threw back her head in disgust.

Annie never got her elaborate meal; Delisle showed up at the jail with a bankroll and peeled off the $1,000 bail to free his lover.

Smith moved into a spacious apartment over a West Jefferson Avenue saloon, where reporters continued to hound her for a good quote. They rarely left empty-handed.

On one occasion, she described Detroit's prostitutes as harpies perched to attack whenever and wherever they saw weakness:

> *Women have never been kind to me, but some men have. Yes, I know a lot of mens talk flattery, say worse behind woman's back, and soft, meaningless words when near. But all my girls have give me the worst of it. Girls in that business tricky. I don't want to speak to respectable womens. I could not go to their homes and I could not have them come to see me, so I leave them alone. Women in Delray do not speak to me, but most of their husbands do, and I suppose wives would not say their husbands not respectable.*

Detective Edward Favor left the force in disgrace. Dogged by the publicity, his family moved into a one-room apartment above a saloon on West Jefferson, ironically just a stone's throw from Annie Smith's new residence.

Of the four alleged conspirators, Favor faced the music first when his court date arrived in late October 1908. Favor insisted his periodic visits to Smith's bordello resulted from the usual police oversight of disorderly houses. The bookcase was not a bribe, he maintained, but a gift from a woman known for her generosity and nothing more.

After Annie's turn on the witness stand, the jury did not buy Favor's explanation and found him guilty.

Favor became the fall guy for the police department's burgeoning graft problem. A month after Favor's trial, while he awaited his sentence from Judge Phelan, a jury found Captain Newberry innocent of the conspiracy charge. The verdict destroyed any chance of convicting Hibbler of conspiracy, so the prosecutor dropped the charge. Captain Frank Newberry returned to the police force, but the shenanigans at Smith's "dive" cost him his stripes. Busted down to the rank of patrolman, he spent the next few years walking the beat on the mean streets of Detroit.

By the time Edward Favor stood in front of Judge Phelan to hear his sentence, he stood alone.

The hardened detective broke down and begged Judge Phelan to send him to city jail but not the House of Correction, where he would rub elbows with felons he helped to convict. "I know it is hard to be charged with others with a crime and alone to be convicted while the others escape," Phelan said, his voice filled with remorse, and then he dropped the hammer on the detective, in the form of his gavel, sending Favor to the House anyway.

Annie's turn in front of Phelan came in December 1908. She pleaded guilty to "keeping a disorderly resort," an admission that drew a fine of fifty dollars and an additional twenty-five in court costs. "Her smile preceding her, Annie walked up to Clerk Grogan's desk and stripped off several bills from a roll that has apparently marvelous recuperative powers," a *Free Press* reporter noted sarcastically.

A few years after the police scandal, Annie married again. As Annie Ringle, she ran a boardinghouse with a seedy reputation at 194 Fourth Avenue.

Julia Toth, the jealous whistle-blower who started the great bordello scandal of 1908, was deported as an undesirable in 1912. A year later, she married an American citizen and returned the United States. Her son Carl carried on the family business, moving Toth's bordello—furniture, furnishings and inmates—to Wheeling, West Virginia. Many of the Delray bunch didn't want to relocate, triggering white slavery charges for Toth and his twenty-one-year-old girlfriend.

A LUMP OF COAL:
THE MURDER
OF FRANCES BOMHOLT

(1914)

A week before Christmas in 1914, sixty-two-year-old Frances Bomholt was bludgeoned to death as she knelt in prayer by her bedside. The murder mystery led to headlines that captivated readers interested in the macabre. The court of public opinion convened and immediately indicted an unknown male, since the prevailing opinion was that a woman could never have committed such a hyper-violent crime.

"That a woman manipulated the weapon," wrote a *Detroit Free Press* reporter on December 18, 1914, "police are not inclined to believe. The utter brutality of the deed, the callousness and cold-bloodedness of the slayer, they feel preclude this possibility, unless the woman was a maniac. Only a man, brutally insane, or callously indifferent, they maintain is responsible."

"…unless the woman was a maniac." With this clause, the anonymous reporter dangled a clue that he suspected, or perhaps knew, who really slew the elderly woman.

"Hallo," Charles Bombolt said as he stepped into the foyer of the small home at 27 Austin Place, where his sister Frances Bomholt lived with their brother John and her twenty-seven-year-old nephew, Florenz Rueping. The son of Frances's sister Theresa, Florenz loved his aunt like a second mother. Frances kept house and made meals for the two men, who worked at the

Hammond, Standish & Company plant. Over a hearty dinner, the three would discuss the latest news about the war, now in its fifth month. Every German in Detroit knew someone serving in the kaiser's army back home.

"Hallo," Bombolt called again, this time louder. No response. He plucked a watch out of his front pocket. Noon—maybe Frances decided to sleep late. He furtively stepped through the dining room and nudged open the door to Frances's bedroom at the back of the house.

Frances knelt beside her bed, her body slumped forward and head resting on the comforter. Blood covered her neck and shoulders, staining the neckline of her white nightgown crimson. Her steel-gray hair was streaked red.

Bomholt raced out of the room and through the front door.

Within an hour, investigators crowded into the cottage to scour the scene for clues. Detectives John Reid and Fred Dibble combed the residence while Wayne County coroner J.E. Burgess studied the body. Inspector John Downey interviewed Rueping. Badly shaken by the body in the next room, Rueping sat on the edge of the living room sofa and tried to convince Downey that he did not hear the attack because he was sound asleep after a long shift at the factory. It was a hard argument to make. The scene suggested a violent—and loud—altercation.

The positioning of Frances Bomholt's body indicated that she died in a savage attack. She sustained multiple blows that turned her face into a pulpy, unrecognizable mass. The cast-off stains suggested that her killer repeatedly struck her from the front right side with a blunt object, something like a brick. The violent attack left a gaping wound running from the right side of her forehead to the edge of her mouth and another in the back of her head four inches wide and three inches deep. So much blood spatter covered the wallpaper and mirror that it looked the like walls of the small bedroom were sweating blood.

The underside of Frances's left forearm contained another injury that at first stumped Burgess: a series of deep gashes made with a heavy-bladed knife, like a butcher's knife or a cleaver. These wounds ran deep, through a thin layer of golden fat, through the underlying red muscle tissue, right down to the off-white radius and ulna bones. Spaced equally apart from the wrist to the elbow, the uniformity of these gashes did not suggest defensive wounds, as if the frantic woman used her arm in an attempt to shield a frenzied attack, but something altogether more deliberate. Like torture.

A thin blanket of snow covering the yard between the coal shed and the cottage preserved another vital clue: a trail of blood droplets. Streaks of blood ran up the handrail on the back porch, each spaced equidistantly. At the base of the porch, a trickle of blood spots ran to the coal shed at the back edge of the property. Reid and Dibble followed the red line from the back porch to the coal bin, where they found a pool of gelatinous, coagulated blood. They searched through the coal bin but could not find the murder weapon.

Rumor had it that Frances kept a large nest egg of money concealed somewhere in the bungalow. Neighborhood gossip provided the motive—theft—and the forensic evidence provided a chronicle of the crime.

The perpetrator cornered Frances as she gathered coal in the early morning hours of Wednesday, December 16. He tortured her (the slashes on her forearm) into revealing the cache of banknotes, then struck her in the head with a heavy object and left her for dead. She lay there for awhile, which explained the congealing pool of blood, but Frances eventually regained consciousness and wobbled to the cottage, interrupting the thief as he searched for the stash. At this point, the robber may have decided he had no choice but to silence Frances so she could not identity him later.

Dead women tell no tales.

The thief administered a coup de grace in the form of six blows with a blunt object as Frances knelt in prayer.

It was overkill. "Any one of the six blows that were aimed at her head was sufficient to kill," commented Dr. Edward L. Brandt, who later conducted the postmortem at William Hickey's morgue on Michigan Avenue.

While canvassing the neighborhood, Reid and Dibble found an eyewitness who saw a woman emerge from the alley next to the cottage at about the time of the murder. The older lady wore a black hat that could not conceal a red scar running across her forehead.

"It offered no solution," a *Free Press* reporter wrote, "nor did the police learn the woman's identity."

At least that is what Reid and Dibble told the press.

Over the next few hours, Reid and Dibble led a crew that canvassed the neighborhood and interviewed anyone acquainted with the victim. They hit pay dirt with Bomholt's longtime friend, Caroline E. Becker. Becker told the detectives that Frances was a charitable woman who routinely gave food to every "tramp" who knocked on her door.

According to Becker, just about every vagabond in the city had motive (the hidden stash of money) and opportunity to murder Frances Bomholt. That created a nightmare list of innumerable suspects, but Becker narrowed down the field when she identified two hot leads.

Becker had heard about a mysterious man who checked into a Michigan Avenue hotel on the morning of the murder. His refusal to give his name and his blood-soaked shirt and handkerchiefs raised a few eyebrows. She also said that various conversations with Frances Bomholt led to the impression that her relationship with her nephew had soured.

By nightfall, Reid and Dibble had arrested three possible suspects: Frances's brother John, her nephew Florenz Rueping and George Alrey, a forty-eight-year-old itinerant who checked into a Michigan Avenue hotel on the morning of the murder with his shirt covered in blood.

Alrey appeared a likely candidate. A drunk who spent most of his time on barstools in Michigan Avenue saloons, he once rented a room a block away from 27 Austin Place and had likely heard rumors about the old spinster's mattress bank. The money would have bought a lot of whiskey, but Alrey convinced Reid and Dibble that he spent the morning of December 16 at a friend's house sleeping off the previous night's bender. The bloodstains on his shirt came from a bloody ulcerated tooth.

John Bomholt was another dead end. Twenty-four hours in a cell couldn't shake his rock-solid alibi for the morning of December 16. At the time of the murder, he was at the Hammond, Standish, & Company plant where he worked.

Unlike his uncle, Florenz Rueping didn't have an alibi. Damning to his pleas of innocence was the inexplicable fact that he was in the cottage when the murder occurred and had apparently slept through it. Rueping, however, provided an innocent explanation.

On the morning of the crime, he worked the graveyard shift at Hammond, Standish, & Company and returned home at about 4:30 a.m. Aunt Frances served him breakfast, and he went to bed around 5:00 a.m. Exhausted, he slept like the dead and heard nothing at the approximate time of the murders.

Rueping's story seemed incredible. Even next-door neighbors heard the old woman's moans. Still, the deep-sleeping Rueping had no reason to murder his aunt. By all accounts, he loved Frances Bomholt like a mother.

"We have found nothing against him," Reid told the press. "We have absolutely nothing more than a suspicion, that without much foundation. But we will hold him for further questioning."

What Reid didn't tell the press was that he planned to hold Rueping as a ruse so his real person of interest didn't grow suspicious and start destroying possibly damning clues. He knew, or at least suspected, who killed the elderly German matron, but he just couldn't prove it—yet.

Father Augustine Bomholt, a Catholic priest from Dubuque and another of the slain woman's brothers, was in Chicago when the Thursday headline in the *Detroit Free Press* caught his eye: "WOMAN KILLED WITH AXE; TRAMP SOUGHT BY POLICE; ROBBERY MAY BE MOTIVE." He jumped aboard the next outbound train and arrived in Detroit later that evening.

He immediately made arrangements for Frances's funeral, which would take place at Saint Anne's Church on the morning of Saturday, December 19. He would personally preside over the services. The priest also offered a reward of $1,000 for information that would lead to the arrest of the killer or killers of his sister.

"Once I thought she might have been killed by a maniac," Father Bumholt told a reporter as he announced the cash reward. "I don't think so now. It was the work of a cold-blooded, sane man who went to work deliberately."

As for motive, the priest was convinced that it wasn't the result of bad blood, unsettled debt or a brooding feud. "It was robbery."

It didn't take long for Father Bomholt's reward to churn up a new clue. On the eve of the funeral, a neighborhood man came forward with the story that his son passed by the Bomholt residence at about the time of the murder and witnessed a woman with a bloody forehead leaving through the alley by the coal shed. This was confirmation of another eyewitness account of a passerby who had noticed a woman with a "red scar" on her forehead.

Frances Bomholt's funeral service took place on the morning of Saturday, December 19, in front of a throng of friends, neighbors and morbidly curious who packed the pews inside Saint Anne's Church.

Caroline Becker stood, emotionless, and listened intently to the service. Afterward, she mingled with friends and neighbors, who later recalled Becker's odd behavior: she didn't once glance at the body, and whenever she came near the coffin, the color appeared to drain from her face.

Becker didn't realize that she had become the prime suspect. While she attended the funeral of her dear old friend, detectives combed through her residence searching for the one clue that would tie Becker to the murder. They found it in an unexpected place; two bloodstained banknotes tucked into the toe of a shoe.

When Becker returned home later that afternoon, Detective John Reid was waiting with a pair of handcuffs.

A select group of reporters was allowed to eavesdrop on Becker's initial interview with Reid and Dibble. A *Free Press* reporter described the sixty-five-year-old as "an exceptionally heavy woman of Amazonian mould...of German extraction, heavy-boned, heavy-muscled, stoical, taciturn."

Thrice married, twice widowed and the mother of eight, Caroline Becker had a colorful past. Born Caroline Evangelina Freund in 1849, she married a man named Felska. In 1881, the couple emigrated from Germany to Detroit, where they raised their eight children. When Felska died a decade later, Caroline married a man named Becker. Their marriage lasted until Becker's untimely death in 1907. A few months later, she married Charles Schrunk, who abandoned her after a few months.

Alone and without means, Caroline Becker eked out a living by keeping house for William Lange, who was friends with Frances's brother John.

Lange had provided Reid and Dibble with a backstory to the crime. Since both Lange and John Bomholt loved the particular brand of pumpernickel bread that Becker purchased at an east side bakery, she began to buy two loaves. Every morning, including the morning of the murder, she delivered one loaf to the Bomholt residence. On that morning, Lange recalled, Becker hurried him out of the door to work, telling him that she had somewhere to go. He didn't think much about it at the time.

After the murder, Lange told police, Becker gossiped about the crime incessantly. She appeared obsessed with it and launched into a kind of private inquiry that led to the identification of suspects. That effort included pointing Reid and Dibble to the vagrant alcoholic with blood-drenched clothes and, later, the victim's brother and nephew. In retrospect, it became clear that Caroline Becker's investigation was a diversionary tactic designed to deflect blame away from herself.

For hours, detectives Reid and Dibble grilled Becker. In a monotone voice unbroken by pitch or inflection, she repeatedly maintained her innocence.

She tried to explain away the one piece of evidence that allegedly tied her to the crime scene, claiming the "blood" on the banknotes found in her shoe was red dye that bled from one of her dresses. When Dibble pointed out that it was too viscous to be ink, Becker changed her story. She said she handled the money after having cut her hand while hanging clothes.

After five hours of relentless verbal sparring, Caroline Becker appeared unfazed and no closer to a confession the hardboiled detectives craved. Then, a simple gesture led to a shocking, unanticipated result that changed the entire scene.

Dibble waved the two blood-stained banknotes in front of Becker, and her stoic façade began to crack. Her shoulders perceptively slumped forward, tears formed at the corners of her eyes and she began rubbing her hands together in the way a baker kneads dough.

In broken English mixed with a spattering of German, Caroline Becker confessed to murdering Frances Bomholt to obtain her secreted stash. Like everyone else in the neighborhood, she had heard the rumors and became blinded by the possibilities that came with the sudden acquisition of wealth

On that Wednesday morning, Becker said, she came to call on Bomholt and found her friend in the coal shed. She spied a brick-sized piece of coal on the floor by the doorway, lifted it and smashed it on the unsuspecting woman's head with all of her might. The first blow brought Bomholt to her knees. She managed to turn and gaze at her assailant, who smashed her twice more on the forehead with enough force to fracture her skull.

As Dr. Brandt noted during the autopsy, the skull fractures caused by any one of these blows would have killed Bomholt within an hour, but according to Becker's confession, she pushed her way past her assailant and hobbled into the house.

Caroline Becker caught up to her in the bedroom. Three more blows with the lump of coal and Bomholt slumped, face-first, into the bedding.

Becker then rifled through the kitchen drawers, where she found the two banknotes—one ten and one five—tossed the chunk of coal back into the shed and left the premises via the back alley.

The confession tallied with the crime scene except for one important point: the pool of congealed blood in the coal shed indicated that Frances Bomholt lay idle for some time before regaining consciousness and reentering the back door of her house.

Becker's confession also failed to explain the cuts on Frances Bomholt's forearm. She refused to comment about this facet of the case or about the as-yet-undiscovered bladed weapon used to make these gouges. Detectives

believed that she held back these details to preempt an insanity defense; if she copped to bringing a cleaver with her to the Bomholt home, then it would suggest premeditation and destroy her only hope to evade a prison sentence.

Details aside, Caroline Becker made a full confession to the murder. Frances Bomholt died over the paltry sum of fifteen dollars.

Case closed.

Or was it?

Father Augustine Bomholt had a flair for the dramatic, evident when he visited his sister's slayer in the matron's room at the county jail. Caroline Becker adjusted her round spectacles, sneered and cocked her head as the priest pointed a bony finger at her. "May your every moment be filled with the vision of the kneeling, bleeding figure of my sister. May you carry the memory of this foul murder with you into eternity," he railed.

If the priest came to hear Becker repent her sins, he left empty-handed.

Instead, Caroline Becker tried to recant her confession by hurling accusations of police brutality against the detectives who interrogated her.

She also claimed the "official" confession, the one that reached the press, was an inaccurate mass of false statements stitched together to make her appear guilty. Much of the truth, she claimed, was lost in translation from her native German into her fragmentary English. "I couldn't understand everything they said. I asked them to let me talk to somebody that understood German, but they only laughed at me. They stood around me like a lot of crazy men and asked questions quickly and tried to make me say things I didn't want to say."

Reporters didn't swallow the bait. Instead, they depicted Becker as a sort of sexual deviant and seized on a racy tidbit that William Lange told police. He admitted to having intimate relations with Caroline Becker and tried to mitigate that fact by claiming the elderly woman forced herself on him. Far from denying the ribald accusation, Becker admitted to providing sex to Lange and others for whom she kept house, shrugging it off as part of the job description: "It was part of the business."

In the days leading up to her trial, Caroline Becker alternated between calmness and hysterics that prompted one physician to believe she suffered a nervous breakdown. Despite her deteriorating mental health, the show would go on in court.

The weeklong trial culminated on Sunday morning, April 11, appropriately enough, in the midst of a thunderstorm.

After a contentious twenty-two-hour deliberation, during which one of the jurors was carted away after suffering from a breakdown, the remaining jurors reached a verdict, which they delivered to a standing-room-only crowd.

When the foreman, standing just three feet away from Caroline Becker, delivered the verdict of guilty, reporters focused on the now-convicted murderess's demeanor. "Mrs. Becker, numbed doubtless by her terrible, draining vigil, received the shock with no great show of emotion. Her head dropped on the shoulder of her daughter and they wept silently."

With the guilty verdict, Caroline Evangelina Becker became just the second Michigan woman in twenty years, after Nellie Pope, to be convicted of first-degree murder. She would join Pope carding buttons inside the prison factory at the Detroit House of Correction.

Her life sentence ended nine years later, on December 10, 1924, when she received a parole from Governor Alex Groesbeck. Seventy-four-year-old "Aunt Caroline," as the other women inmates knew her, waved a wrinkled hand as she left the prison farm. She died on August 2, 1935, at the age of eighty-six.

BLUEBEARD'S WOMEN

(1918)

*S*uspected serial killer Helmuth Schmidt, who baited women through matrimonial advertisements, gave a partial confession to murdering Augusta Steinbach, a New York domestic he lured to Detroit on the pretense of matrimony. Then he asked for a lunch break. Back in his cell, he scratched something on the wall, knelt down on the floor, raised the hinged steel cot and smashed it onto his cranium. He died from a skull fracture without ever regaining consciousness.

The message on the wall read, "Wife and daughter innocent."

Schmidt tried to indemnify his loved ones with his jailhouse scribble, but his plan backfired; the message only intensified the investigation into his family.

Schmidt's teenage daughter Gertrude became the key to unraveling her father's dizzying trail of aliases. The pretty eighteen-year-old came under intense scrutiny from detectives, reporters and especially from one of her father's victims.

Gertrude's story, wrote a reporter for the *Royal Oak Tribune*, "would outrival the novelist's imagination."

Thirty-five-year-old Augusta Steinbach had devoted herself to caring for the homes of the elite, first in Berlin, then in Paris and, finally, in New York City. In the fall of 1916, she began a correspondence romance with Detroiter

Carte de visite photograph of Helmuth Schmidt, circa 1900. Note the scars on Schmidt's chin. He told his victims that he got the scars from honor duels fought while he attended the university at Heidelberg. *From the estate of Gertrude (Schmidt) Kurth.*

Herman Neugebauer, who promised her a home of her own if she agreed to relocate to the Motor City and marry him.

Augusta packed up her things, including an impressive collection of jewelry she had acquired over the years, into two steamer trunks and headed west to Detroit. As Neugebauer courted her, she stayed in a boardinghouse run by Thomas Hetherington and his wife, Cora. They delighted in listening to the buxom, sanguine woman gush about Herman

Left: Passport photograph of Agnes Domaniecki. Hardboiled Manhattan detective Cornelius Willemse credited her for breaking the case of the "Detroit Bluebeard." *National Archives*.

Right: The only known photograph of Augusta Steinbach—the Detroit Bluebeard's final victim—probably taken in Berlin, circa 1910. *From the collection of a late Detroit reporter*.

and his two sisters: a younger one who liked to smile and play the organ, and an older one with a fixed scowl and a choleric personality. The two sisters also made it into a letter Augusta sent to her best friend and fellow Manhattan domestic Agnes Domaniecki.

In March 1917, Augusta left the boardinghouse to marry Herman. She said goodbye to Thomas Hetherington and disappeared.

No one would ever see her alive again.

A month later, in April 1917, Cora Hetherington received a postcard from Augusta, requesting all mail be forwarded to "Mr. H.E. Schmidt," who lived at 9 Oakdale Boulevard in Royal Oak. It was signed "Auguste Steinbach." Hetherington found the misspelling troublesome. Augusta was fastidious and would not have made such a mistake. Nonetheless, she honored the request and began forwarding Augusta's mail to the Royal Oak address.

As the months progressed, Agnes Domaniecki grew more and more worried about her dear friend who traveled west to marry a man she

The "Detroit Bluebeard" had a mischievous gleam in his eye when he posed for this portrait, c. 1900. This was one of three photographs used by the nation's press during coverage of the case, and its publication led to multiple Schmidt "wives" coming forward to claim part of his estate. *Author's collection.*

had never met in the flesh. She hadn't received a letter from Augusta in months, so she sat down with Manhattan detective Cornelius Willemse. The hardboiled detective tracked Herman Neugebauer to the archives of the *Revue*, which held the original, handwritten advertisements that lonely hearts placed. As Willemse thumbed through the documents, he noticed something odd: several advertisements, placed under various names, all listed the same address. All roads led to 9 Oakdale Boulevard in Royal Oak, where Detroit machinist and German immigrant Helmuth Schmidt lived with his wife, Helen, and daughter, Gertrude, who loved to play the organ.

While one group of detectives arrested Schmidt at Ford's Highland Park factory, another searched his Royal Oak home. They found troves of jewelry secreted in various caches around the house, including one inside Gertrude's piano. Clothes—expensive dresses and furs—spilled out of Gertrude's and Helen's closets.

In the basement, buried in a crawl space under the porch, they discovered a bloodstained dress and a cleaver with a broken handle. Blood streaks led from the furnace to a black stain on the concrete floor, and what was left of Augusta Steinbach—a chunk of hip bone—was deposited in a cavity under the garage.

Detectives immediately began a search of Schmidt's Highland Park home, where they would later find another body, cocooned in a canvas tarpaulin, cemented in a clandestine grave under the cellar floor. Irma Palatinus, Schmidt's housekeeper and possible lover, never left the house.

Schmidt's suicide spared the county an expensive murder trial and put an end to speculation about his role in the disappearance of Augusta Steinbach, but his partial confession raised even more questions. To answer those questions, detectives turned to the one constant in Schmidt's life. His many "wives" came and went, but one person remained to witness the matrimonial parade: Gertrude.

Left: A youthful Gertrude Schmidt at about aged ten. When the story broke, Detroit newspapers ran headline, page-one articles with Schmidt's photograph next to this image of Gertrude. *From the estate of Gertrude (Schmidt) Kurth.*

Right: Gertrude Schmidt, circa 1918. *From the estate of Gertrude (Schmidt) Kurth.*

Born in Berlin, Germany, on January 15, 1900, Gertrude arrived in New York in 1913, where she met her father, who had immigrated to the United States before her. A *Royal Oak Tribune* journalist described the enigmatic teenager:

> *The girl is 18 years of age with large, brown eyes, and an open countenance. Her hair hung loose down her back. Her features are rather coarse except for her mouth which is of a delicate mould. Her hand and the frame of her body are large. She appeared un-sophisticated and simple in manner, but lacked in refinement and in the attributes that usually attend cultured femininity.*

While Pontiac officials believed Gertrude nothing more than an innocent dupe, Detroit detectives believed she played a role in her father's scheming and pushed for formal charges based on two pieces of evidence: Augusta's letters to Agnes, and a postcard Augusta allegedly sent to Cora Hetherington.

Information about Augusta's letters came from Agnes, who traveled to Detroit to help in the investigation. After touring Schmidt's bungalow and identifying several items that belonged to Augusta, she discussed the letters. She didn't keep the correspondence, but she remembered, vividly, Augusta's vibrant depictions of Neugebauer's sisters, dead ringers for Gertrude and Helen, who apparently played along with Schmidt's game. If true, Schmidt presented his current wife, Helen, to Augusta as his older sister. They wondered why a wife would go along with such a scheme if not actively and directly involved in the game.

A more tangible piece of evidence came from Cora Hethington, who kept the postcard Augusta sent requesting her mail go to 9 Oakdale Boulevard in Royal Oak—an obvious ploy to dead-end any inquiries by routing them directly to Schmidt. Agnes studied the card and concluded the signature belonged to Augusta, but she could not identify the hand that penned the note.

Helen Tietz Schmidt admitted that she sent the postcard to her sister in New York, who subsequently mailed it to Detroit, but she denied writing the note on the card. Gertrude insisted she had nothing to do with the card, although the penmanship suspiciously resembled hers.

The case against Gertrude Schmidt became even more damning when Adele Ulrich Braun—the one who got away—arrived in Detroit.

Detroit detectives believed that this postcard was a key piece of evidence that Gertrude Schmidt acted as an accomplice in her father's scheming. The note, sent to boardinghouse landlady Cora Hetherington, requests that all of Augusta Steinbach's mail be forwarded to Helmuth Schmidt's Royal Oak address. Agnes Domaniecki thought Augusta may have signed the card, but she could not identify the handwriting of the note. The script matches known samples of Gertrude Schmidt's penmanship although she always denied writing it. *From the collection of a late Detroit reporter.*

Detroit reporters didn't need a trial or jury to convict the pretty teenager. They just needed Adele Ulrich Braun.

Adele Ulrich Braun came to Detroit with an axe to grind. A milliner in New York City, she fell under "Emil Braun's" spell in 1914 when she began corresponding with him after reading his matrimonial advertisement. Following a brief ceremony, the newlyweds moved to Schmidt's chicken farm in Lakewood, New Jersey, where Schmidt introduced his bride to his "sister"—twenty-eight-year-old Greta Braun—and daughter, Gertrude (later, he would use the same gambit by introducing Augusta Steinbach to his "sister" wife, Helen).

Fourteen at the time, Gertrude had watched her mother, Anita, vanish just weeks earlier. Schmidt explained the disappearance by telling Gertrude that her mother had returned to Germany. Then, a few days after Adele arrived, Greta Braun dropped out of sight. Greta, who was really Schmidt's longtime housekeeper and lover Margareta Baersch, also left him and returned home to Denmark, or so Schmidt told Gertrude. Baersch, however, simply vanished.

Schmidt planned a similar vanishing act for Adele Ulrich Braun. He tried to engineer an accident by crashing his car, but she survived the "accident" with a fractured hip. Afraid that Adele would hobble straight to the authorities, Schmidt took her life savings, appropriated her maiden name and left for Detroit, where he settled as "Emil Ulrich."

Adele Ulrich Braun hated Gertrude Schmidt. Despised her. The animosity became clear when Adele faced Gertrude in the office of the prosecuting attorney. Their epic confrontation occurred on Friday, April 27, 1918—almost a week after Schmidt's jailhouse suicide.

Adele walked into the prosecutor's office, which was crowded with reporters eager to witness the odd scene.

"Why hello, Gertrude," Adele said. She leered at the teenager who sat beside an oversized oak desk. Adele sat in the vacant chair beside Gertrude, whose lips curled up at the ends in a slight smile. "Surely you remember me."

"Why yes," Gertrude stammered, "I guess I do remember you. You are Adele."

"You surely know that I married your father in Lakewood."

"I didn't know that."

"Why, Gertrude, you attended the wedding."

Right: Gertrude's mother, Anita, who disappeared from Schmidt's Lakewood, New Jersey chicken farm. *From the estate of Gertrude (Schmidt) Kurth.*

Below: The Schmidt family a few years before they left Germany. Helmuth (*standing*); Gertrude (*about ten in this photograph*); Schmidt's mother and father; and Anita. Schmidt operated a Berlin jewelry store before fraudulent bankruptcy charges caused him to flee Germany. Schmidt used items from the jewelry store to bait lonely women in New York and Michigan. *From the estate of Gertrude (Schmidt) Kurth.*

Adele went on to describe Schmidt as her jailor and Gertrude as his eyes and ears.

I can't begin to tell you of the hell I went through in those four months I lived with that man. I had really loved him at the start and went to his home fully resolved to make him the best wife I knew how and to love his daughter like a mother. He told me to make the girl Gertrude little gifts from time to time and thereby win her over until she would love me. That was really one of the conditions of the marriage. Soon after the wedding, though, I was given to understand that Gertrude came first in my husband's home.

"Gertude was my jailor," Adele said and shot a glance at the teenager, who stared back, unmoved.

She watched me like a cat watches a mouse and she hounded my every footstep. If I said or did anything of which she did not approve she soon told her father and he would upbraid me at the first opportunity. Braun would go in and sit on Gertrude's bed at night to receive his daily report of my every word and act. She and her father were one in everything. She possesses his characteristics to a marked degree.

Adele became animated and spoke with her hands, jabbing them into the air as if conducting an invisible orchestra. "This girl Gertrude isn't the meek and innocent appearing young girl that she seems. I know her to be a girl of more than usual intelligence and fully as cunning and resourceful as her father."

The predominantly male media had a love-hate relationship with Gertrude: they loved to hate her. Correspondents from the *Detroit News*, *Times* and *Free Press*, along with the *Pontiac Press Gazette* and *Royal Oak Tribune*, sat in on interviews, pointed out minute discrepancies in her various interviews with detectives and tended to depict her as a conniving, manipulative imp who willingly aided and abetted her Bluebeard father. The story of a Bluebeard assisted by his wife and daughter made good headlines, and reporters seized the opportunity. They scripted sensational headlines in huge fonts next to photographs of a pie-faced Gertrude and a mustachioed Schmidt.

As German immigrants, Gertrude and Helen also fell victim to the anti-German sentiment sweeping through World War I–era Detroit. Adele believed Schmidt and the women in his life operated a spy ring—a theme emphasized in the press coverage of the case.

Detroit Free Press writer Carl Bird condemned Gertrude as a manipulative woman who used sex appeal to sway investigators. Bird characterized the key figure in the Schmidt case as a talented ingénue "who changes her expressions, modes and manner of meeting cross-examination as often as a chameleon changes its color."

Bird's chauvinistic attitude toward his subject colored his description of her:

> *Psychologists would revel in a study of her odd make-up. They would immediately be impressed by her use of a woman's wiles, which she has been using on all the officials who in any way have something to say about her future. She understands well that she is exercising her woman's prerogative to smile and pout, weep a bit, and "baby stare."*

Gertrude did have one sympathetic ear in the media. Buda Stephens, a female staff writer for the *Detroit News*, depicted Gertrude as the puppet of a cruel, tyrannical master. Stephens described Schmidt as "son of the soul-destroying, brutalizing school of Prussian militarism."

Acutely aware of the anti-German sentiment that had seeped into the news coverage, Stephens described Gertrude as a patriotic American: "As Gertrude sat in the living room waiting for a summons to Pontiac she looked out of the window at the large American flag floating so patriotically from the porch. She knew her father had been branded as a German spy and there was hatred and rebellion in her brown eyes at the hypocrisy of her parent. Gertrude talks true to America."

Stephens, who witnessed the confrontation between Gertrude and her former stepmother, described Adele Ulrich Braun as a wronged woman "filled with bitterness" who "fired reminiscent questions at the girl which confused her." What other reporters saw as a manipulative girl caught in a web of lies, Stephens saw as a flustered teenager put on the spot and unwillingly pushed under the limelight.

By the end of May 1918, the intense scrutiny and mental strain began to seep through to Gertrude's stoic countenance. Once known as fastidious with her appearance and a sharp dresser, she showed up at police interviews with her hair disheveled, and she began to look like a much older woman.

All of the evidence Detroit reporters used to convict Gertrude and Helen melted away under scrutiny.

Both Helen and Gertrude described Schmidt as a manipulative Svengali who bent people with his iron will. Fear may have forced them to play act as Neugebauer's sisters, but Helen and Gertrude steadfastly insisted they never met Augusta in the first place—a denial that seemed completely incompatible with the detailed descriptions Augusta wrote in letters to Agnes. Reporters and Detroit police alike jumped to the conclusion that the Bluebeard's women had lied.

Oakland County prosecutor Glenn Gillespie developed a theory that explained how and why Augusta wrote about the women without ever meeting them. During their courtship, Neugebauer told Augusta about his "sisters," so when they spent an afternoon alone together in his house—taboo in an era of chaperoned dating—Augusta used the information to preserve her honor. To mask premarital intimacy with Neugebauer, Augusta told both Agnes and Cora Hetherington that she met the "sisters" in person during her visits to Royal Oak.

Gertrude and Helen told detectives that Schmidt sent them to the cinema during the time frame in which he murdered Augusta—a fact supported by neighbors who saw them motor away in Schmidt's car. Similar evidence suggested that he sent both women on an errand when he exhumed the body from under his porch, dismembered it and incinerated the remains.

Gertrude suspected something amiss, but a good German daughter never questioned her father; she just did as he told her. Helen also had suspicions about Schmidt's schemes, but she later said that sheer fear had caused her to remain mute. Helen told Gillespie she wanted to go to the police but worried that she would become the next wife to disappear.

The entire ordeal unhinged Helen Tietz Schmidt, who suffered a nervous breakdown during the investigation. In the space of a few days, she discovered that she had married a bigamist and a con artist who incinerated his latest victim in their basement and then used her to dump the ashes in the stream running across the back of their property.

Bowing to pressure from Detroit authorities, and Adele Ulrich Braun, who wanted Gertrude charged as an accomplice, Gillespie went through the motions. Braun could hardly wait to testify against Emil's spy in court, but she would not have the chance. As Gillespie predicted, the case failed to progress beyond a preliminary hearing.

The final confrontation between Gertrude Schmidt and her former stepmother took place in the Oakland Country Probate Court, where Judge Ross Stockwell had the unenviable job of determining which widow was entitled to the Bluebeard's estate. It all came down to who said "I do" first.

Four women fought for Schmidt's treasure-trove: Adele Ulrich; Anna Hocke Switt, who claimed to marry Schmidt in New York the week before Ulrich and "Emil Braun" tied the knot; Helen Tietz Schmidt; and Gertrude. Numerous other "spouses" who claimed Schmidt, either embarrassed or financially unable to wage battle in court, dropped their claims.

Each of the wives presented marriage licenses, and Judge Stockwell scrutinized the signatures. "Emil Braun's" handwriting matched known samples of Schmidt's. "John Switt's" signature, according to Stockwell, did not; he dismissed Anna Hocke Switt's claim and ruled that Adele was Schmidt's lawful widow. Stockwell's decision officially nullified Helen's marriage as bigamous. With no legal leg to stand on, she submitted a list of items she brought into their marriage and hoped that Stockwell would exclude them from the settlement.

That left stepmother and stepdaughter to grapple over who received what. Like Helen, both submitted a list of items they wanted to exclude from any settlement.

These lists exposed an unexpected link uniting the two "wives:" several valuable diamond rings from the estate inventory that both claimed as her own property. Schmidt, who ran a jewelry store in Berlin, used the rings to woo women he targeted as "wives." In 1914, he put them on Adele's fingers; in 1916, he re-gifted them to Helen.

As Stockwell sifted through the tangled web that Schmidt wove for his "wives," the animosity between Adele and Gertrude began to fade to the point where they agreed to an amicable settlement. Adele received the bulk of Schmidt's estate, including the furniture and his Highland Park home. The Royal Oak bungalow went to Gertrude, who promptly put it up for sale. The stigmatized property, in which Schmidt butchered Augusta Steinbach, sat on the market for some time. No one wanted to buy what papers called Schmidt's "murder factory." It eventually sold at a reduced price.

Gertrude and Helen—harassed by a hostile press, zealous investigators and angry "wives" deprived of their life savings—survived the ordeal together. They remained close for the rest of their lives. Helen, who had no children of her own, considered Gertrude her daughter; Gertrude looked to Helen as a surrogate mother.

Passport photograph of Gertrude Schmidt, taken in 1920. *National Archives.*

In 1920, Gertrude—much older in appearance than her years—married Birmingham native Erich O. Kurth. Together, they raised three daughters. Gertrude seldom talked about her days with the "Detroit Bluebeard," but the memories constantly nagged her like a sliver in her psyche.

Tragically, Gertrude's life story ended abruptly, and prematurely, when she committed suicide in 1952. Only then did her daughters fully learn about the skeletons in their grandfather's cellars.

Suspected serial killer Helmuth Schmidt tried to indemnify Gertrude with his last testament scratched into the steel plating of a Highland Park jail cell.

Instead, she became his final victim.

11

THE WOMEN OF WET DETROIT

(1919–32)

*L*ydia Connor hung her head as she trudged to the beat of the "Rogue's March," pounded out by two drummers who followed a few feet behind the convicted whiskey peddler. An empty bottle suspended around her neck—a symbol of her crime and a mark of shame—swayed at the end of a black ribbon with each step she took. Her sentence for selling hooch to soldiers consisted of a walk of shame around Fort Lernault followed by permanent exile from Detroit.

The year was 1798, a time when horses, cows and other livestock—not Model Ts—roamed the streets, and the fort's watchtower—not a high-rise of steel I beams and concrete—dominated the town's skyline.

Connor's exile resulted from an early form of prohibition passed in 1797. The military brass wanted to keep soldiers who served at the backcountry wilderness fort from whiling away their boredom with strong spirits, so it issued a ban on selling liquor to troops. Within days of the order, Lydia Connor, William Mitchell and James Frazier faced a court martial for selling to soldiers. The court found all three guilty as charged, but Mitchell—a popular trading post proprietor who did brisk business with the military—received a slap on the wrist in the form of a verbal reprimand. The court also balked at punishing Frazier, a well-to-do Detroit merchant.

Lydia Connor enjoyed no such exalted status. Described in Anthony Wayne's Orderly Book as a "follower of the army," she received the long walk of ignominy alone.

Wearing a floor-length dress that had acquired a brown strain around the fringe from the dirt streets, she passed through the gates of Fort Lernault (the present site of the Penobscot Building) and into the history books as the first person in Detroit punished for violating prohibition laws.

The "Eve" of Detroit bootleggers, Lydia Connor blazed a trail followed by numerous women a century later when Michigan went dry. Throughout the Roaring Twenties, her matrilineal descendants—the women of wet Detroit—played a cat-and-mouse game with Prohibition agents and local law enforcement.

Their stories provide a fascinating glimpse into the Motor City during Prohibition.

No respectable male officer dared search a woman. Instead, the men in blue attempted to entrap suspected bootleggers by purchasing a bottle or two from them. This simple ruse led to the undoing of Anna Krobniak, a housewife who ran an illegal liquor store from her home on Tarnow Street.

Officer Frank Chamis purchased a bottle from Krobniak after the obligatory sample to ensure it was whiskey and to convince the seller he wasn't a cop. Chamis continued to test the whiskey as he made his way to court for a search warrant, but because the homemade hooch made him sick (or so he told Judge Thomas Cotter), he went straight to bed. He obtained the necessary paperwork the next day.

Warrant in hand, Chamis searched Krobniak's house and discovered a trove of bottles. Faced with ninety days in the Detroit House of Correction or a hefty fine of $250, Krobniak paid the fine and returned to her lucrative bottle business.

Eighteen-year-old Mary Howe was the Amelia Earhart of Detroit bootleggers.

In a souped-up boat powered by an airplane motor, she attempted to run a load of whiskey across the Detroit River. Pinched by Prohibition agents in October 1926, Howe became the first woman rumrunner arrested by the border patrol.

Julia Bencsik, who sold illegal booze out of her residence on South Street, hatched what she considered a foolproof plan to transport bottles under the noses of dry agents. She enlisted a third grader to make deliveries to customers. The scheme worked until a cop spotted a young girl carrying a bottle out of Bencsik's home. Terrified, the girl explained that she had worked as a runner for over a year, delivering twenty-five-cent half pints. Prohibition agents confiscated eight gallons of whiskey when they raided the illegal operation.

Bootlegging became a family affair for Sam and Sarah Spender, who peddled liquor from their home on Erskine Street. After purchasing a bottle from Sarah, an undercover detective slapped a pair of handcuffs on her and dragged her to the First Precinct Police Station, apparently unaware of the infant asleep in the house. When Sam returned home to the sound of a wailing baby, he swaddled the child and went straight to the station, where he offered himself as a hostage for his wife. Sarah and the child went home while Sam languished behind bars until the case came before Judge Harry B. Keidan.

Sam rocked the baby as Sarah stood before Keidan, who fined her $200 for violating Prohibition laws.

When federal Prohibition agent A.D. Beam approached Mary Melovich about a suspicious bottle in her possession, she attempted to get rid of the damning contents by dousing her dress with it.

The thirty-two-year-old Serbian native claimed she couldn't speak English. Judge Simons didn't believe a word of it. During her testimony, filtered through a translator, he abruptly turned to Melovich and asked her a question in English, which she promptly answered in flawless English.

Irritated with her ploy, Simons threw the book at her; he sentenced her to a $1,000 fine in addition to four months in the Detroit House of Correction.

After the sentencing, an older, heavy-set man with a thick Scandinavian accent approached U.S. District Attorney Delos G. Smith. Pete Miller, a

Danish sailor, had become so enamored with Melovich that he offered to take her place in prison. Such a beauty, he told Smith, didn't belong behind bars. "It's too bad such a pretty woman has to go to jail," he said.

Smith didn't agree and denied Miller's kind offer.

Female bootleggers had a leg up on their male counterparts. No self-respecting male agent would search them, so agents simply asked them to confess and cough up their illicit goods. A refusal put the agent in a bind—a fact quickly recognized and exploited by those involved in the illegal liquor trade. By 1931, women bootleggers accounted for an estimated 85 percent of all booze smuggled into Detroit, prompting customs collector Colonel Heinrich A. Pickert to press a group of secretaries into service as female agents.

In December 1931, the "matron" agents worked around the clock to stop "bottle smugglers." Immediately successful, they took some of the spirit out of the holidays. Christmas parties became less intoxicating, as the fruitcakes, pudding and punch lacked a key ingredient.

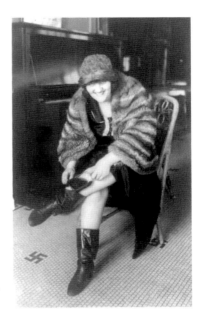

Woman bootleggers had a leg up on Prohibition agents because no self-respecting male officer would dare search a female. *Library of Congress Prints and Photographs Division.*

In 1933, the "Noble Experiment" ended. Detroit was wet once again—although thanks in large part to the women of Prohibition-era Detroit, it was never dry in the first place.

HELL HATH NO FURY

(1921)

*I*n a city beset by machine gun–toting gangsters, one of the most shocking criminal cases of Prohibition-era Detroit involved a petite milliner known by a dozen pseudonyms.

"[The case] presented Detroit detectives with one of the most baffling mysteries and finally with one of the most cruel murders in the city's history of crime," wrote a *Detroit Free Press* reporter.

Storm clouds began to gather in the western sky as six-year-old Max Ernest returned home from school on Wednesday, May 11, 1921. The forecast called for spring showers accompanied by a drop in temperature that left older Detroiters in agony from throbbing joint pain.

Max was an only child, and his mother tended to be rigorous about his safety, but she scanned the western horizon and didn't see any imminent danger of a thunderstorm. She gave her son the green light to cycle around the neighborhood of their Wildemere Avenue home on his tricycle.

She would never see him alive again.

When Max failed to return home after two hours, Mrs. Ernest became frantic. She walked around the block three times, each time her pace quickening in sync with her pulse. She knocked on neighbors' doors, but no one knew Max's whereabouts. One of Max's friends said he saw Max hopping into a red touring car with a woman around six o'clock.

Mrs. Ernest's heart sank. She knew the woman in the red car and why she might take Max.

Detectives Frank Fraley and Frank Collins went to work on the case within hours of the boy's disappearance. Based on information from the boy's father, real estate agent Frank Ernest, Fraley developed a theory that Max had been snatched by a disgruntled client as payback for a failed real estate deal. His prime suspect was Sarah Evelyn Elizabeth Lewen, also known by the colorful sobriquet "Madame LeGrande."

On April 18, Lewen had purchased a Longfellow Avenue home from the North Woodward Real Estate Company, with Frank Ernest and Arthur Barkley acting as agents in the transaction. She told Barkley that she would soon come into a bequest of $200,000 and owned $20,000 in furniture that she could use as collateral for the loan. She borrowed the down payment from Ernest, who held a chattel mortgage on the furniture, which Lewen stored in the Longfellow Avenue house. After Lewen moved in, however, she failed to make any payments. Ernest was on the hook for the entire mortgage.

On May 3, Frank Ernest and the North Woodward Real Estate Company pulled the rug out from under their deadbeat tenant's feet. On that morning, Ernest tricked Lewen into leaving the house. He drove her in his automobile to the real estate company office. Meanwhile, E.A. Moldenhauer, president of North Woodward Real Estate, changed all of the locks on the Longfellow house.

Lewen vowed revenge against both Ernest and Moldenhauer and apparently didn't keep her scheming a secret. Fraley had found several witnesses who said Lewen made threats of "getting even." According to one witness, Lewen said she went to the Ernest residence on May 9—two days before Max vanished—to murder Mrs. Ernest and the little boy but lacked the courage to carry out the plot. "It's an awful thing to say," she said, "but I went to Mr. Ernest's home the other night with the intention of killing his wife and little boy, but when I got there my courage failed me."

When shown photographs of the suspect, residents on Wildemere said they saw a woman matching Lewen's description loitering around the neighborhood days before Max went missing.

And on the day Max vanished, neighbors could place Lewen in the vicinity of the Ernest home from approximately 11:00 a.m. until 5:00 p.m. She apparently lay in wait for him to return from school.

Fraley sent Detective Collins to find Lewen, but by Thursday night, May 12, Collins hadn't found the suspect or the missing boy.

Sarah Elizabeth Lewen
suspiciously eyes the camera
in this portrait taken by an
unknown news photographer
sometime before 1921.
Author's collection.

As Thursday turned into Friday, May 13, Elizabeth Lewen remained on the loose, but Fraley and Collins continued to find evidence that she played a seminal role in Max's disappearance. They managed to locate Max's "velocipede" at the intersection of Grand River and West Grand River Boulevard.

From the tricycle, detectives worked backward and managed to piece together the hours after Max was taken from his neighborhood.

A woman matching Lewen's description and a little boy hopped aboard a streetcar on Jefferson headed east from downtown Detroit. They debarked at Parkview Avenue, walked to East Jefferson and took a cab. The driver said that during the ride the little boy appeared upset and began sobbing. With tears streaking down his cheeks, he asked the woman when she would take him back home.

The trail ended on East Lennox Avenue sometime around 6:30 p.m., when Lewen and the boy disappeared.

As police dug into the background of Lewen, they discovered a drama queen with a shady history of fraud and delinquency.

The fifty-two-year-old mystified police. Known as highly secretive, she revealed very little about her biography to any of her friends and acquaintances. No one seemed to know anything about her history before she came to Detroit five years earlier. In the Motor City, she ran several millinery shops and went by at least a dozen aliases, including Madame Berthe, Madame LeGrande, Madame Lauvin, Madame Chauvin, Evelyn Elizabeth Levine and Leah Hershberg.

In 1917, "Evelyn Lewen" ran a lingerie shop on Washington Boulevard, but her failure to pay the rent led to her eviction.

In April 1918, she stole $400 worth of lace from a Washington Boulevard store, and when police came to arrest her, she attempted to leap out of a fifth-

story window. As they dragged her off to the police station, she begged them to let her kill herself. The next month, as "Madame Berthe," she declared bankruptcy. Lewen, and her aliases, owed money to creditors all over town.

In 1920, she advertised for a business partner, someone with funds to help her set up a shop. Helen C. Peters answered the ad. Lewen took the money but never paid a penny back to her partner.

Investigators found one common thread woven throughout Lewen's life in Detroit: a bloated sense of self-importance. Her business partners characterized her as a monomaniacal woman who concocted elaborate, grandiose fortune-making schemes that she bankrolled with fictionalized bank accounts and assets. If Lewen had $100, she told everyone she had $10,000.

The key to finding Lewen, Detective Collins reasoned, might be held by one of her friends. So he began to question her acquaintances.

Charlotte Stott, who once worked for Lewen at a millinery shop on Washington, said that her former employer stayed with her on Thursday evening. Stott noticed something strange: Lewen's thumbs were swollen and her hands were mottled with bruises and crisscrossed with cherry-red scratches.

Collins struck pay dirt when he visited Madame Roget, a fellow milliner. According to Roget, Lewen visited her on Friday morning and asked for a loan of $10,000. She said she needed the money for payment on a property she owned, Roget said, and added a cryptic remark: "I must get out of town tonight."

Roget refused to lend her such a huge sum of money. Instead, she arranged for Madame LeGrande to stay at a boardinghouse on Horton Avenue.

At last, Collins had a lead on Lewen's location.

Just before noon on Saturday, May 15, Detective Michael Lannan found Elizabeth Lewen in the Horton Avenue boardinghouse. After he knocked three times, the door opened a crack and a woman appeared on the other side. He pushed the door open and elbowed his way past the stunned woman. Before Lannan had time to react, Lewen pressed the barrel of a .38, swaddled in a silk handkerchief, to her chest and threatened to shoot herself.

Lannan managed to talk the revolver out of Lewen's hand and took her to the Bethune Avenue Station for questioning.

Sure that she knew the whereabouts of Max Ernest, Assistant Prosecutor Robert Speed and Chief of Detectives Edward Fox interrogated her. After

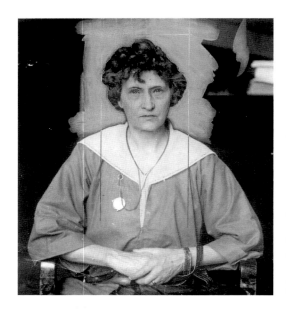

Left: As she awaited her 1924 trial, Madam LeGrande obediently sat for this photograph, sans hat. The case made national headlines, and this image appeared in several newspapers across the country. *Author's collection.*

Below: A distraught Sarah Lewen just after her arrest in 1921, a scene captured by a *Detroit News* photographer. *News photo in the Author's collection.*

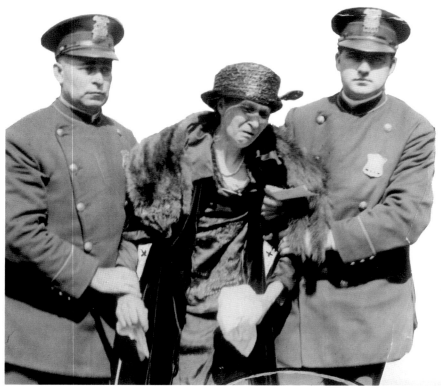

five hours of intense grilling, however, they managed to elicit from their suspect nothing more than a half-baked alibi for Wednesday evening.

While Lewen sweated out the interrogation, the Ernests held a vigil at their home. Surrounded by friends, they waited in their living room for any news about Max.

The red tricycle sat in the middle of the room. The riderless velocipede provided a somber reminder of their only child and represented their desperate hope that Max would walk through the front door any minute.

The noose around Lewen's neck tightened on Sunday, May 16, when friends and neighbors visited the Woman's Detention Home to identify Lewen as the mysterious woman seen on Wildemere Avenue on the evening Max Ernest disappeared.

The sly suspect tried to sidestep a positive identification by destroying a black hat that Frank Collins wanted her to wear during the lineup. Collins found the hat balled up and thrown in the corner of the bathroom. "There are lots of women in the city who wear hats just like that," Lewen explained, "and they might think it was I because I have one."

The scheme didn't work.

Three neighbors studied the hatless Lewen as she stood next to a police matron and fingered her as the woman they saw prowling around the neighborhood.

The most compelling identification came from four-year-old George Adams, a friend of Max's. "There's the woman who took Max away," he said as the police matron led Lewen down the corridor past him.

Later that afternoon, John Dwyer, a so-called acquaintance of the murder suspect, stopped by the Woman's Detention Home to visit with Lewen. As the matron—who remained in the cell to prevent a possible suicide attempt—eavesdropped, Dwyer represented himself as a friend of a friend. After an hour of conversing about the day's doings, he subtly changed the topic to the missing boy.

Lewen admitted taking Max from Wildemere to a Jefferson Avenue streetcar and riding to the end of the line. She said, however, that she did not harm Max Ernest.

Dwyer—actually Detective John E. Dwyer of Detroit Police—didn't coax out of the suspect the confession he wanted, but he had heard enough.

The open, spacious field between Ellsworth and Avondale Avenues along the eastern fringe of the city was popular among kids. When winter broke, they flocked to the two baseball diamonds, where they spent hours after school in impromptu pickup games, emulating the heroes of the day like Detroit stars Ty Cobb and Harry Heilmann.

After school on Monday, May 17, twelve-year-old Frank Dettmer and his fourteen-year-old brother Roy made a beeline to the fields in search of dandelions. They combed the tall grass along the fringe of a marshy area by the field, about twenty-five yards from the corner of Avondale and Drexel Avenues. As he moved deeper into the rough, Frank noticed a shallow ditch partially concealed by weeds and heavy bushes. A pair of shoes protruded from the abscess, and Frank thought he spotted the pink skin of an ankle. He dropped his bag of dandelions and ran home to report the macabre discovery to his father, who raced to the phone and called the police.

Hastily interred under a thin layer of weeds and old leaves, the boy had been buried face-down in his clothes: a black shirt, navy blue short pants and black socks. His face was covered by patches of purple bruises, and three circles on his forehead indicated that his slayer had stomped on the boy's head with a high-heeled shoe. A gag of sod had been stuffed into his mouth to stifle the cries as his slayer throttled him. He died of asphyxiation caused by strangulation.

A single strand of steel-gray hair of four to five inches in length clung to the boy's shirt.

The clothes left little doubt as to the body's identity, and Lewen's legal troubles morphed from kidnapping to first-degree murder.

Detectives flanked Elizabeth Lewen as she stood over the body of Max Ernest at the Dill Brothers mortuary on Hamilton Boulevard. Detective Frank Collins thought the macabre sight would shake his suspect into a full confession.

"You killed that boy," Collins said. "That's your dirty work."

As Lewen stared at the pale, lifeless figure on the table, Collins gave a vivid narration of the murder. The slayer had filled Max's nose with dirt and shoved a clump of sod down his throat to stifle his cries. Max would have

pawed at the hands coiled around his throat, his arms and legs thrashing and flailing, like a drowning victim desperate for a breath of air.

Collins noticed Lewen's legs buckle slightly and thought that an epiphany was imminent. Instead, she stiffened, rolled her shoulders, threw her head back and declared she had nothing to say. She asked Collins to take her back to the Woman's Detention Home.

Despite growing suspicions about something broken in Lewen's mind, court psychiatrist Dr. A.L. Jacoby determined her sane and fit to stand trial.

Jacoby penned an opinion of the suspect:

> *Mrs. Lewen fails to demonstrate to me any evidence that she is suffering from any of the acquired insanities. Her history as given to me indicates that she has an unusual and peculiar personality, and at the present time she is suffering from a psychoneurosis of a hysterical type. I feel that she must be regarded as responsible for her conduct in the accepted sense of that term.*

People v. Elizabeth Lewen, alias Madame LeGrande, opened on Tuesday, June 15, 1921. The usual court-goers, motivated by a desire to see the alleged child slayer in the flesh, joined a small brigade of reporters. The task of making a case against Lewen fell to prosecuting attorney Paul W. Voorheis—a relentless litigator with a knack for making defendants crack on the stand.

Armed with a strong case handed to him by Detectives Fraley and Collins, Voorheis went to work.

A *Free Press* correspondent described the alleged child slayer: "Mrs. Lewen, sitting quietly behind her attorney as the long afternoon hours slipped away, gave the impression of a once gentle woman, in her plain black gown, small hat with a small ornament and her chain of white beads."

Lewen watched, sans emotion, as Voorheis called a sequence of witnesses who testified to seeing her in the Wildemere neighborhood on the evening Max Ernest disappeared. Her visage remained stony while Mrs. Ernest, in between sobbing spells, described an occasion just prior to the murder when Lewen dined with her family. Her expression didn't change when Detective Dwyer described tricking Lewen into making the damning admission of having nabbed the six-year-old. She didn't even show a hint of emotion when Voorheis led jurors to the crime scene—the marshy ditch at Avondale and Drexel where the body was discovered.

Despite concerns about Elizabeth Lewen's mental stability, defense attorney John A. Collins decided to put his client on the stand. He planned to elicit testimony that illustrated the strong-arm tactics used in an attempt to coerce a confession. By the time he had finished, Collins hoped the jurors would believe police used everything but a rubber hose on the frail fifty-two-year-old.

"Tell us as well as you can what happened to you from the time of your arrest until you were arraigned in court. I don't want to lead you in any way. Just tell the judge and jury what happened. Were you alone?"

"Alone? Why I never was alone any of the time. They talked to me all of the time. I never got any rest. Sometimes there would be two to three at a time. Sometimes there would be only one."

"What did they say to you?" Collins asked.

"They kept telling me I had stolen someone's little child."

"Do you remember any of the men who talked to you? Any of these men before you?"

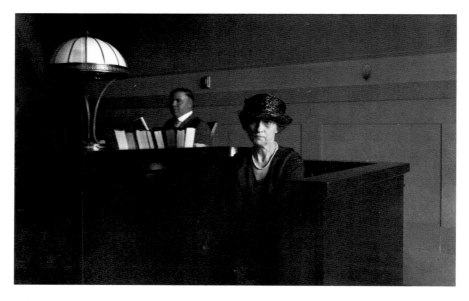

In her signature hat, Lewen testifies during her 1922 murder trial. While in jail, the suspected slayer tried to destroy the hat in an attempt to thwart positive identification by eyewitnesses, who noticed her prowling in the vicinity of the Ernest residence. *Courtesy of Wayne State University's Digital Motor City.*

Lewen glared at the prosecutor's table and pointed at Voorheis and Robert Speed. "Yes, the men at the table there. They took me to an office somewhere where these men were, and that one man laughed at me. He laughed about my crying when I couldn't speak. They took me somewhere and took my finger prints and pressed my thumb so that I thought they were killing me."

"What was it they kept telling you?"

"They kept telling me I killed that child, and every time I cried they mocked me. One man pushed me up against the wall and told me I was only putting it on, and tried to make my legs stand straight."

Collins paused for effect and took a deep breath. "Mrs. Lewen, did you kill little Max Ernest? I want you to tell the judge and jury."

Tears began to run down Lewen's cheeks. She looked at the jury. "I certainly did not." Her voice cracked. She looked up at Judge Heston. "I didn't do it. I wouldn't do it any more than any one else in this court room. There's no one in this room more guiltless than I am. I thank God they can't take my soul. I told Mr. Ernest I believed the Bible injunction an eye for an eye, a tooth for a tooth, but I never did anything."

Voorheis's summation contained a brutal assault on Lewen's character. Despite her living in Detroit for five years, he said, "not one single witness has been produced here to testify as to her character or as to her reputation for truth and veracity." The sheer number of stage names she used, he continued, suggested a woman who partially dwelled in a land of fantasy.

John Collins jumped up from his seat. "Objection," he yelled, his face flushed red and a large vein bulging from his forehead like a subdural worm. The remark questioning Lewen's reputation was irrelevant and misleading. At no time during the trial, Collins pointed out, did Voorheis raise the issue of his client's reputation for honesty. Collins demanded that the statement be stricken from the record, but Heston refused.

Voorheis continued.

"Why didn't she kill his wife or him?" Voorheis asked. "Cruel as she is, she chose a more despicable way. I don't like to think of womankind doing a thing like this....It was not the act of a degenerate. It was the deed of a woman bent on revenge."

Voorheis scanned the faces of the twelve men in the jury box. "Now she comes to you and asks for sympathy. Who is she to ask mercy? We've had

a hard time finding out. She is alias this and alias that. You gentlemen [of the jury] who are honest men, do not go around using one name one place and another name another place. This practice brands her for the kind of woman she is."

In his closing remarks, John Collins pointed out inconsistencies in the testimony of several witnesses and indicted the police department for cruel treatment. "We have been fighting the entire police department," he said. "The department has not been fair, for they knew their case was rotten and weak. They gave this elderly woman," he paused and pointed at Lewen, "the third degree for a week in an effort to force her to confess she killed the Ernest boy."

The climactic moment of the trial came on Saturday, June 18, 1921, when the jury returned after just an hour of deliberation.

Eyes closed as if in the middle of a nap, Elizabeth Lewen listened while the foreman of the jury read the verdict: "guilty." She sat, unmoved, as Judge William Heston polled the jury.

The now-convicted killer's stoic cast crumbled like a stale cookie as the realization of life imprisonment sank in.

When Heston asked her to stand and come forward, she lost her composure. She began moaning loud enough for the back row of the gallery to hear. "I can't stand up," she wailed. "Why don't you kill me? God knows I never did such a thing."

She gasped for breath and sucked air through her teeth, creating an eerie whistling sound. "I beg for God to take me."

Instead, four police officers carried the hysterical woman out of the courtroom. Her wails echoed as the officers carried her down the corridor.

Lewen held out hope that on appeal Michigan Supreme Court justices would find some error in the trial transcript and reverse her sentence.

As she waited, she rubbed elbows with fellow slayers Nellie Pope and Caroline Becker in the old Detroit House of Correction. An incident in March 1924 would add yet another twist to her serpentine case.

Guards heard banshee-like screams coming from Lewen's cell. They were used to odd sounds coming from the convicted child slayer. During her

first few years of incarceration, she often lay on her cot, wailed about her innocence and tore strands of hair out of her head.

But this sound was different.

When they reached Lewen's cell, they found her kneeling over what looked like a blood-streaked sack of gray clothes. She frenetically clawed and punched the sack, her arms flailing and spittle running from the corners of her mouth. She had pounced on a fellow inmate over a perceived jailhouse sleight involving some knitting and had pummeled the unsuspecting woman until her face looked like a pulpy mass of raw meat.

The guards managed to subdue Lewen and lifted the battered figure from the floor. The trembling woman's hair was matted with blood and her face bruised and streaked with scratches from Lewen's nails.

Following the attack, prison authorities sent Lewen to the State Hospital for the Criminally Insane in Ionia for observation and testing. When doctors proclaimed her sane, they sent her back to the House.

A few weeks later, Lewen received word that the supreme court had reversed her conviction, ruling that Voorheis stepped out of bounds when he attacked Lewen's character during his closing remarks to the jury. Unless a defendant's character arises during the trial, the court ruled, a prosecutor may not impeach it during his summation. "A prosecutor must not go outside the record or forget defendant is entitled to a fair and impartial trial," they noted in their opinion.

Sarah Elizabeth Lewen had one more chance to avoid a life behind bars.

Lewen's second murder trial took place in July 1924. Once again, the courtroom drama played to a full house. Sarah Elizabeth Lewen continued to bewilder and captivate the public, but the sequel did not compare to the original. Those who hoped to hear revelatory testimony left without any such sensation. Those who hoped to gain a better insight into the alleged perpetrator's background or psyche left the courtroom disappointed with the anticlimactic affair.

History would repeat itself in Judge Harry Keidan's court. The jury deliberated for precisely the same amount of time as the first trial: one hour and three minutes.

And they reached the same decision.

As Lewen received a second guilty verdict, she once again broke down and needed the arms of both defense attorneys—John A. Collins and Andrew Baird—to help her rise from her seat.

"Thus is written the last chapter to one of the most curious and mysterious murder problems that the police of Detroit were ever called upon to solve," waxed a *Free Press* reporter, "and even now the details, particulars and intimate motives that led up to the murder are more or less unsolved."

The already twisted case became more convoluted in 1932 when John Dwyer—a former police officer and the prosecution's star witness in the first trial—repudiated his testimony.

After the first trial, the former cop pursued a new line of work: bank robbery. Caught and convicted to twenty to forty years in prison, Dwyer made the trip south from Marquette to testify in Lewen's second trial but never made it to the stand. He managed to escape the new police headquarters, touted as an escape-proof facility. Police caught him just after the trial concluded.

Dwyer wrote a letter explaining that during the investigation into Lewen's whereabouts, he found witnesses that could support her alibi. He also admitted to perjury when he testified against her.

The shady ex-cop's story made it all the way to the desk of Governor Wilber M. Bruckner, but he refused to issue a pardon based on the word of a convicted bank robber. There were just too many witnesses placing Lewen in the neighborhood when Max Ernest disappeared.

Lewen read about Prohibition-era Detroit from her cell at the old House of Correction and about the stock market crash of Black Friday from her cell at the new House of Correction prison farm. When census-takers visited the prison in 1930, she provided 1869 as a birth year and described herself as a widow.

By 1940, Sarah Elizabeth Lewen had spent almost twenty years behind bars. Her health failing, she told a friend, "I'm not going to die. I just can't die until I am vindicated. I know there is power of justice which will reveal the truth about me before I die."

Lewen died two days later in the Detroit House of Correction. She was seventy-two years old.

13

'TIL DEATH DO US PART

(1922)

We are convinced that in Mrs. Ford the prosecution has a dangerous, cold-blooded death plotter," Chief Assistant Prosecutor Robert Toms said of May Ford. "We feel that our community is safer with her behind the bars. We are sure we have the goods on her."

She came to Detroit to marry a man she believed was related to automobile scion Henry Ford. She believed the nuptials would make her one of the richest women in the world. When she discovered that she had been tricked, she concocted a plot that led to one of the most bizarre court cases in the history of Detroit. Roaring Twenties headlines may have been dominated by Purple Gangsters, rumrunners and bootleggers, but December 1922 belonged to May Ford.

Drops of freezing rain struck the windows of the apartment with the sound of a thousand glass beads. The year had grown old, the weather had turned cold and a wintry mixture of rain and sleet had begun its assault on the city.

"Kansas City Ed," a contract killer, arranged for the meeting to take place in a small apartment on Park Avenue by Charlotte Street. The quiet, nondescript spot would make an ideal setting to discuss the contract on Ney Ford.

Three figures sat around the dining room table. The sole light in the room—a lamp dangling over the table—cast their shadows against the walls, giving the eerie appearance that the room itself had come alive.

May Ford, thirty-five-year-old wife of wealthy Dearborn farmer Ney Ford, knew Thomas Burton from their days together in Toledo, but she only knew the third figure as a shady ex-cop Burton introduced as "a tough guy from Kansas City."

Burton first met May when he roomed in a boardinghouse she managed. Years later, when May decided she wanted to bump off her husband, Ney Ford, she contacted Burton. "I want the old bird knocked off," she told him, "and if you will do the job, I will make you independently wealthy."

But Burton worked as a policeman with the Toledo Terminal Railroad, so he decided to pass on the job. "No, May," he told her, "I am too well known to pull that stunt myself. But if you like I can get you a man who will do it for you. Just say the word." At May's request, Burton arranged a meeting with a well-known assassin from Kansas City.

"Ed" would take care of May's "problem," her overbearing husband, for a fee of $20,000. And her husband's estate, worth an estimated $350,000, would take care of his grieving widow.

Kansas City Ed drummed his fingers on the table and nodded as he listened to the woman's proposition. The brim of his fedora, which he wore low over his forehead, shielded his eyes from the light. His three-day beard gave him a grizzled appearance, and the revolver he kept in a shoulder holster caused his coat to bulge.

May unfolded a hand-drawn map showing Ford's farm on Town Line Road near Plymouth Road and placed it on the table. She pointed to a corner of the barn where Ney kept the milking machine. The sound of the machine would drown out the assassin's footsteps. Kansas City Ed would slug the unsuspecting farmer over the head, drag him to a waiting automobile and transport the body to a barn about thirty miles away. After removing several gold fillings that could be used to identify Ney Ford's remains, Ed would torch the barn, and the flames would obliterate all evidence of foul play.

May slid a photograph across the table. Ed could use the picture to identify Ney Ford.

Ed eyed the picture. May, in her wedding dress, sat in an armchair while Ney stood behind her. The couple sent the picture to friends and relatives following their December 20, 1921, ceremony. Now, just short of a year later, the smiling bride was hiring a hit man to preempt the divorce proceedings.

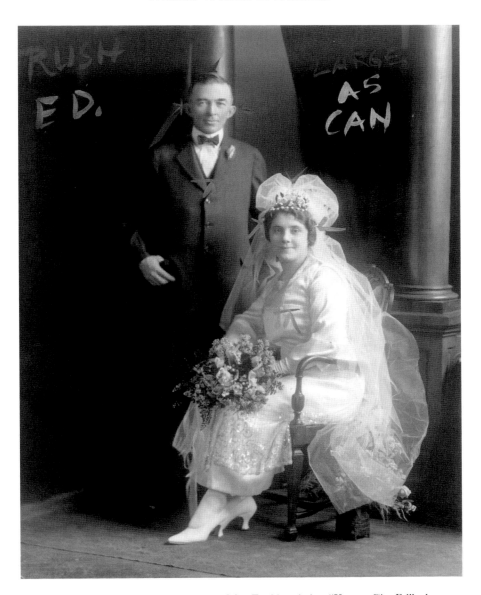

Hand-signed wedding announcement that May Ford handed to "Kansas City Ed" when they discussed the plot murder her husband, Ney Ford. Newspapers across the nation reprinted this wedding photograph in coverage of the case. *1922 Underwood and Underwood news photograph in the author's collection.*

May had clearly thought through the plan, going so far as to arrange for an alibi; she would fake a psychotic breakdown and wind up in a mental hospital. She had been practicing her "snap," she said with a hint of pride in her voice, and could "throw a fit" on cue. "I'll have more alibi than I need." May grinned.

"Very well," Ed said, "but you'll agree that I must have some money to pull me through right now. I must go over the farm myself before I do the job, and what about an automobile?"

"I haven't a cent to my name, Eddie, but if you know some John that's got $40 or $50 on him let's know about him and I'll roll him."

May wasn't kidding.

But Ed wouldn't agree to the deal without expense money, so May said she would try to find money and agreed to meet Ed at the intersection of Woodward and Temple the following morning, where he would receive additional instructions.

Kansas City Ed watched as May, alongside Thomas Burton, sidled out of the flat. Still a looker in her mid-thirties, May Ford would no doubt try to reestablish herself in the world of romance on the affluent farmer's dime.

As soon as the door closed, Kansas City Ed—a.k.a. Detective Lieutenant Edward Kunath—scampered into the kitchen. Through three holes bored into the wall, Sergeant Detective Ovid Straith heard the entire conversation. Thomas Burton, May's acquaintance from Toledo, had turned Judas when she asked him to help her find an assassin. He contacted federal authorities in Toledo, who in turn contacted Detroit chief of detectives Edward Fox, who put two of his best men on the trap.

Kunath had located an apartment for the sting, bored three holes in the partition separating the kitchen from the dining room, covered the holes with newspaper, and stationed a team on the other side to witness the wicked wife incriminate herself.

The next morning—Thursday, December 7, 1922—Chief Assistant Prosecutor Robert Toms had little trouble convincing Judge Harry Keidan to sign an arrest warrant charging May Ford with conspiracy to commit murder. Detective Ovid Straith arrested her at the prearranged rendezvous point on Woodward Avenue. She arrived at the county jail wearing a sable coat and a "sheik" hat.

The ordeal had unhinged May Ford, leaving her close to a real, not feigned, mental breakdown. She regained her composure in the prosecutor's office, where she confronted "Kansas City Ed"—Detective Edward Kunath.

"You know me, don't you, May?" Kunath asked. His question was rhetorical.

"No," May stammered and said, "I don't know you." Her denial hit Kunath like an uppercut.

She turned to Prosecutor Voorhies and took on the guise of a wounded victim:

> *What are you gentlemen trying to do with me, anyway? If you insist that I say I met Kunath in a Park Boulevard apartment, where you say I offered to pay $20,000 for the murder of my husband, then I can say I have met him. But it will be a lie. Do you think I couldn't have done away with Ford long before if I had intended to do that? That's all I have to say until I can consult my attorney.*

By Friday, December 8, May Ford had become front-page news. Throughout the next few months, the tangled affair dominated headlines. As criminal charges loomed over May and divorce proceedings slowly snaked through the system, reporters filled up columns airing the couple's dirty laundry. The stories almost always included the wedding photograph that May gave to "Kansas City Ed"—the memento of a joyous occasion now became a smoking-gun piece of evidence.

Despite being caught red-handed, May claimed the conversation inside the Park Avenue apartment took place only in the mind of her husband, Ney Ford. She explained her theory to an incredulous *Free Press* reporter during a jailhouse interview on Friday, December 8:

> *This tale about my conspiring with a gunman to have Ford killed is a frame-up by my husband. He has often threatened to have me locked up in jail. In his cross-bill which he filed shortly after I sued him for divorce in July, he charged that I once ran out onto the porch and aimed a revolver at him. Well he has carried out his threat, and here I am.*

May went on to attack the logic underlying her "murder plot":

Do they really think that I would have talked about killing my husband with a stranger? Never had I seen this man Kunath until they confronted me with him in the prosecutor's office this morning. I told him then, and to his eyes, that the thing was a frame-up. Ford's money has done it.

They should give me credit for a little more horse-sense than talking such stuff to a man whom I had never met. There are plenty of crooks in Detroit's underworld houses who would have knocked off Ford for me, and the price would not have been $20,000 either. Anyone of these crooks would have done it for $20.

Then May offered what Chief Assistant Prosecutor Toms believed to be a preview of her inevitable defense strategy: she claimed not to remember anything about the conversation that allegedly took place just two days earlier:

After all, though, if I have actually met Kunath and another man in an apartment in Park boulevard and have devised with him a plan whereby my husband should be killed and burned in a hay barn for $20,000, then I don't remember anything about it. I do forget things I have done. There were other instances during the past few months that I did things and then forgot completely about them. Once, for example, I dressed up, got into an interurban, came to Detroit and returned to my home in Dearborn, all without knowing anything of what I was doing.

May explained that she suffered from "acute nervousness" and insisted the meeting at the Park Avenue apartment never took place. The subsequent rendezvous with the hit man also was a fiction. She just happened to be walking along Woodward near Temple, minding her own business, when Detective Straith clamped a pair of handcuffs over her wrists.

When the reporter asked May if she went to the intersection at the request of "Kansas City Ed," she refused to answer the question.

May wanted to make the most of her fifteen minutes of fame, as she explained when primping for her press photograph. "Let's make it a nice picture," she nodded to the photographer. "This is my first time in jail, and I want to look nicer in the paper than the other women photographed after they have been locked up."

Meanwhile, reporters had a field day with May's background.

May's December 1921 trip down the aisle with Ney Ford wasn't her first. It was her third. Her previous two marriages ended in divorce.

Born May Dutton in 1888, she grew up on a farm near Denton, Ohio. At seventeen, May left the farm as the teenage bride of Ray Blenn, a railroad man with a quick temper. They had two children together before divorce ended the marriage after six years. According to May, the precipitating event occurred after a heated argument during which a cauldron of boiling water was knocked over, scalding her and her son.

May moved to Toledo, went to school to become a nurse, learned the real estate business and met Ora Hallett, who operated an automobile garage. They wed in 1918, but the marriage survived just a little after the honeymoon period, ending a year later amid allegations of "another woman." It was during this second marriage that May worked as a masseuse in a massage parlor, told fortunes as a spiritualist and managed a boardinghouse, where she first met Thomas Burton—the go-between who later introduced her to "Kansas City Ed."

Through a friend, May learned that Ney Ford, a prosperous farmer from the Detroit area with the right surname, was seeking a wife. Ford had been married to a Dearborn schoolteacher named Blanche Winn, but the relationship didn't last.

May sent an introductory letter, and Ney traveled to Toledo in July 1921. Smitten, Ney begged May to accept his proposal of marriage, luring her with his fortune, which he said topped half a million. He presented himself as a relation to automobile tycoon Henry Ford and hinted that May would become one of the richest women in the world. Her life in Dearborn would not consist of farm chores, he promised, but of salons and tea parties. First, they would take a lavish honeymoon trip to Florida.

The farm girl from Denton became intoxicated with the possibilities. "At the time we first met and later, Ney tempted me with luring word pictures of the immense wealth that would come our way if I married him," May later reminisced from her prison cell. "He gave me to understand that he was on intimate terms with Henry Ford. I was a poor woman and the call of gold was too insistent."

Their marriage took place on December 20, 1921. According to May, Ney reneged on his promise to fete her in Florida. Instead, she spent her honeymoon on Ney's farm in Dearborn.

Then she realized her fantasies of instant wealth would not materialize. "After we married I found that my husband was a moderately prosperous

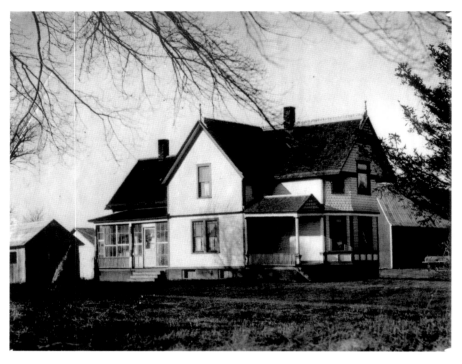

The palatial farmhouse of Ney Ford, who used his distant relationship with automobile pioneer Henry Ford to dupe May Blenn into matrimony. She hoped that "Kansas City Ed" would help her even the score. *Anonymous news photograph in the author's collection.*

farmer, but for all the chance there was of nipping Henry's millions Ney's surname might have been mud." May came to the painful realization that she "had been pulled by the leg."

Instead of living the life of a plantation wife, May lived like a slave. She cooked meals for Ney and his hired help and delivered them to the fields. When not slaving in the kitchen, she hung wallpaper, painted floors and did various upkeep to the farmhouse.

And Ney, according to May, was a cruel master. "One of the things Ford delighted in doing," May later recalled, "was to have me shadowed. Strange men prowled around my front yard in Dearborn, and I knew I was shadowed after I came to live in Detroit. At last I went to Toledo and told the chief of police there about my troubles. He told me to beware of assassins."

Eight months later—on August 8, 1922—May filed for divorce.

The June trial had all of the makings of great reality drama. Both characters arrived in court coated in mud courtesy of the press. May was the gold-digging, three-time loser who financed her lifestyle by acquiring new husbands as often as some women acquired new Sunday dresses. She came to Detroit not for the love of Ney but for the love of his modest estate, and when she realized he had duped her, she concocted a plan to inherit his money. And there was a pretty good indication she was mentally unstable.

Ney didn't elicit much sympathy, either. He was either a mean-spirited and manipulative puppet master who yanked his wife's strings or an incredibly naïve country bumpkin who got in over his head with a semiprofessional gold-digger whom he lured to Detroit with tales of grandeur.

The trial opened to a standing-room-only crowd the week of Valentine's Day—February 16, 1923.

Of all the witnesses against May Ford during the trial, "Kansas City Ed" provided the most damaging testimony. Detective Kunath detailed the plot that May Ford unfolded during their one-hour conversation. "She suggested I slip up behind Ford who is slightly deaf while the noise of the milking machine would drown other sounds, and hit him over the head or slug him in the jaw with something. Then I could drag him into a waiting automobile and finish him. I was then to drive 30 miles away and burn his body in a barn," Kunath recalled.

"Mrs. Ford warned me that Ford had several gold fillings in his teeth which might be identified if found among the ashes of the barn and said I might dig them out of the mouth with a knife before I finished him." Kunath testified that "Ed" suggested using pliers to remove the teeth.

Thomas Burton also testified about May Ford's intentions, but he admitted that the meeting did not produce a contract between "Kansas City Ed" and May Ford. The expense money brought the negotiations to a halt.

This seemingly minor point killed the prosecution's case. May Ford's lawyer Maurice Fitzgerald successfully argued that in this case there was a difference between preparation for an act and the overt act needed to prove a conspiracy charge; in other words, just talking about it did not make May Ford guilty. It made her guilty of nothing more than a hypothetical, he argued. And to make a conspiracy charge stick, the prosecution needed to prove May committed an overt act.

The prosecution's case also took a hit when Burton admitted on cross-examination that he notified Ney Ford's attorney about May Ford's inquiries into a hit man before the meeting took place in the Park Avenue apartment and

that Ney Ford paid the lawmen's expenses during the trap. Ney Ford had financed the scene to expose his wife's scheming.

During his closing argument, Toms characterized May Ford as an aberration. "She is not a natural woman, but just as a dwarfed, gnarled tree sometimes occurs. Just as a rotten apple appears among the sound ones, so will a woman be found occasionally among the true mothers and wives of earth, possessed of the harsh, cruel and vindictive heart of an animal."

Fitzgerald argued that the vindictive heart belonged to Ney Ford, who engineered a frame for his wife as a way to worm out of paying her a hefty divorce settlement. The entire conversation at the Park Avenue apartment, he argued, was taken out of context. The outcome depended on whom the jury liked least between two highly unlikable characters. They didn't like Ney Ford very much.

It took the jury just forty-three minutes to return a verdict of not guilty.

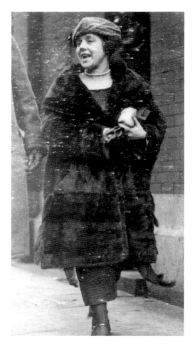

A triumphant May Ford, captured in mid-stride by an anonymous *Detroit Times* news photographer in December 1922. *International Newsreel Photo in the author's collection.*

In the wake of her acquittal, May Ford attempted to drum up support for her cause in the forthcoming divorce proceedings. In a two-page feature article, she provided a narrative of her life with Ney Ford and explained her frame-up theory. According to May, Ney Ford attempted to frame her so he wouldn't have to pay her a divorce settlement. Burton started the frame by giving her a flask of spiked booze that caused her "to lose all consciousness." As a result, she didn't remember a thing about the meeting with "Kansas City Ed."

"As God is my witness, that is all I remember of that night!" she wrote. "Whether I actually went into the house I do not know. I knew nothing until next morning when I awoke on my bed in the Graham home on Pacific avenue, fully dressed."

Seven months later, Ney and May faced off in divorce court. The proceedings morphed into the ultimate he-said, she-said affair, with both claiming the other did the active wooing. Ney, May said, couldn't wait to tie the knot. May, Ney said, proposed to him and seemed intoxicated by the promise of wealth.

Fitzgerald scored points when he showed that Ney's first wife, Blanche, sued for and obtained a divorce in 1913 on the same grounds as May: cruelty.

Ney's lawyer Frank Eaman scored points when Louis Smitt, an acquaintance of May's, testified he accompanied her to several blind pigs, where she proceeded to become half drunk and then half dressed. Smitt even characterized her as a woman of ill repute. Another witness testified to seeing May with a lover.

The various witnesses threw enough dirt during the proceedings to cover Eight Mile. In the end, May received a settlement of $100 a month for three years in addition to $245 to cover her medical expenses and attorneys' fees.

The ordeal apparently unbalanced May, who was committed to a Fort Wayne, Indiana insane asylum. In 1925, she was judged to be sane and released.

Ney James Ford didn't shy away from matrimony, marrying for a third time to Grace May. He died in 1958.

14

WICKED WOMAN'S WILL

(1924)

"They [her eyes] were coal black, and snapped and sparkled in the dim light," wrote the last reporter who interviewed Sophie Lyons Burke. "Aglow they seemed, and charged with the intensity that appeared in her voice when she spoke."

Dubbed "the most dangerous woman in the world" by New York City police and "Queen of the Underworld" by the press, Sophie Lyons mellowed out in her advanced years. Tired of a life of crime, hounded by a troubled conscience, she returned to Detroit, where she attempted to use her ill-gotten fortune to make amends with her past.

In May 1924, Lyons died under suspicious circumstances. Amid whispers of foul play—a rumored hit by a vengeful enemy of the past—a postmortem dispute over the (former) wicked woman's will erupted, leading to one of the most bizarre scenarios in the history of Motor City crime.

The vault of the Union Trust Company felt twenty degrees cooler than the warm, humid air that smothered the city outside like a wet blanket. Judge Ira Jayne, special administrator to the estate of Sophie Lyons Burke, pried open the lid of the safety deposit box and gently removed a small paper parcel. A tiny fragment of notebook paper, pinned to the brown wrapper, contained a note: "God bless this flag. My dear father, brother, and only son died for it. That is why it is so precious to Sophie Lyons Burke." Jayne

gently pulled back one of the flaps of the wrapper to reveal a small American flag.

Next, Jayne removed a black velveteen satchel held closed with a series of safety pins. After unclipping the pins, he reached into the long, sock-sized bag and pulled out the first jewelry box. As he lifted the lid, the contents sparkled under the incandescent lights. The first box contained diamond and pearl rings, earrings, a diamond-encrusted brooch and a sunburst adorned by an eight-carat stone.

The next box contained more diamond-studded jewelry, including the twelve-stone ring "Billy the Kid" Burke gave Sophie on their wedding day. Another box contained gold chains and other pieces of jewelry. Another contained an assortment

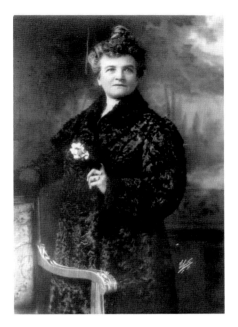

Portrait of Sophie Lyons used as the frontispiece in her 1913 autobiography *Crime Does Not Pay. Author's collection.*

of gold pocket watches—a bit of irony recognized by Jayne and older Detroiters who remembered the Lewis-Lyons feud and the trouble one hot watch caused Sophie Lyons way back in 1885.

The last item Jayne removed from the box was a small black leather volume. He flipped through the pages and breathed a sigh of relief. He had been searching for this book for days and faced a legal migraine if he failed to find it.

The volume contained the last will and testament of infamous career criminal–turned real estate tycoon Sophie Lyons Burke and laid out specific plans for her considerable fortune.

It was to be the Queen's legacy.

Driven out of Detroit by Theresa Lewis and the Detroit police in 1885, Sophie Lyons returned to New York, where she met con man extraordinaire Billy Burke. Together, the pair fleeced Europe's social elite aboard transatlantic cruises. Their favorite gambit involved hosting a dinner party for the most affluent

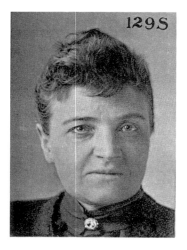

129S

Sophie Lyons is a dead ringer for the Wicked Witch of the West in this portrait taken sometime around 1900. *Sophie Lyons, unidentified artist, circa 1900. Collotype. National Portrait Gallery, Smithsonian Institution; gift of Pinkerton's Inc.*

passengers. Lyons wore her trademark sable fur and diamonds; Burke wore his silk hat. During dinner, the con artists would take stock of their guests' jewelry and, in the ensuing days, systematically target the socialites who sported the most expensive baubles.

Lyons hid the purloined jewels in the false bottom of a steamer trunk, where they remained hidden from their mystified marks and customs officials alike.

Another Lyons stratagem involved high heels. "I have a fancy for high heels," she once told a shoe store clerk. "I'm naturally short and I need to acquire several inches of height some way." It wasn't elevation Lyons wanted but evasion. She hollowed out the heels and used them to smuggle gemstones.

Together, the crime power couple terrorized European high society and ran law enforcement in circles. But inevitably, their reputation preceded them. Police would arrest them on sight and, after they spent a brief cooling-off period behind bars, escort them to the nearest train station or boat dock.

Burke and Lyons grew tired of the cat-and-mouse game with police and decided to leave their life of crime and go "home" to Detroit. Despite being a onetime target of Detroit police, Lyons felt she could live unmolested there if she walked the straight and narrow. That was in 1912. In 1913, Lyons finished the first stage of her atonement: her autobiography. Aptly titled *Why Crime Does Not Pay*, the memoir documents her life in crime as a cautionary tale to would-be thieves.

Burke died a few years later. Sophie never remarried, instead adopting two giant Saint Bernards that accompanied her everywhere. She could be seen walking the neighborhood in a fur coat and flanked by her canine companions. They even went to restaurants with her, eating from plates Lyons placed on the floor by her table.

From a humble house on Twenty-Third, Sophie Lyons Burke invested heavily in real estate, purchasing parcels of property on Twenty-Second, Twenty-Third, Twenty-Fourth and Twenty-Fifth between West Fort and Lafayette Streets.

Indefatigable and tireless, Lyons subdivided her house into eleven rooms, made repairs and rented them along with the other houses she had acquired. In a male-dominated era, Lyons broke all societal norms and stereotypes by running her own business from the ground level all the way to administration.

The former matriarch of thieves used the income from her assets to make amends for a life of crime.

When the Roaring Twenties began, the seventy-three-year-old former thief had amassed a portfolio that included forty houses. Financially stable, she began a campaign of philanthropy.

Lyons turned the tables on the Detroit House of Correction. Several times an inmate herself, it was as if she had never entirely left. Each week, she visited the prison with a basket of sundries to distribute to the inmates.

Lyons had a soft spot for those who had, like her, fallen into a life of crime. Her largess was largest when legal trouble threatened to break up families. On one occasion, she rented a house for a destitute ex-convict whose wife was expecting and helped the man find a job. She once bonded a convict she had never met because his imprisonment left his family without means.

She wanted to purchase three derelict streetcars and use them as centerpieces for playgrounds, but the inventive attempt never materialized. In 1924, Sophie Lyons died under mysterious circumstances.

On Tuesday, May 6, 1924, three gentlemen callers came to Lyons's residence to inquire about renting rooms. Gertrude Antle, who rented a room in Sophie's house, answered the door and led the men up the flight of stairs to Sophie's second-story room.

A few minutes later, Antle heard, in a hoarse whisper, Lyons gasp, "Quit! Don't do it!" A few seconds later, a second plea. "Quit! Don't! Let me alone!"

Antle knew better than to meddle in her landlady's business, so she decided to leave the boardinghouse instead and find some help. By the time she returned, orderlies were carrying Lyons out on a stretcher. Apparently, one of the three men called a doctor before bolting.

Sophie Lyons died of a cerebral hemorrhage the next day in Grace Hospital. On the table next to her hospital bed was a copy of her memoir, *Why Crime Does Not Pay*.

The sinister undertones of her demise, her ties to the underworld and the era's sensationalized press conspired to create rumors that someone with a grudge murdered the elderly reformer.

Detroiters reveled in the irony of the underworld maven murdered by one of her criminal contacts. A story circulated that three weeks before her death, Sophie attempted to reform three wayward souls who rejected her attempts and accused her of ratting on them to the police. They cornered her in a restaurant and shoved her around, and then one of them allegedly threatened to get even. It was all part of the Sophie Lyons mystique. The "Queen of the Underworld" needed a dramatic exit from the public stage, but the reality was much more mundane than the myth.

Police investigated but found no evidence of foul play, and the attending physician, Dr. G.H. Campau, found no marks of violence that would suggest a struggle. "My diagnosis," Dr. Campau told the press, "was that high blood pressure had overcome her. Probably she had a shock, but her death had all the appearance of being natural."

On Friday, May 9, hundreds of curious Detroiters crammed into the chapel at Woodmere Cemetery to eavesdrop on the final chapter in the celebrated life of Sophie Lyons Burke. J.F. Wright, the founder of Pathfinders of America, presided over the service.

The throng swayed slightly to the rhythm as fellow reformer Emma Pease sang two hymns.

After the brief ceremony, the remains went to a crematorium and the ashes later deposited in the grave of her son, Carleton Marshall Lyons. She had remained close to Carleton and considered him her favorite.

The reading of the will took place a few days after the funeral. Sophie Lyons had nine children, but she divorced herself from most of them because she wanted to spare them, she said, from the notoriety that came with being the Queen of the Underworld's child. One daughter she consigned to a French convent and never returned to see her. That girl grew up without ever knowing her connection to criminal royalty.

In her will, however, Lyons did remember three of her children: daughters Florence Bower, Madeline Brady and Lotta Lyons Belmont.

Brady lived in London, and Belmont—an acclaimed opera singer—lived in Geneva, Switzerland.

Fifty-year-old Florence Bower had mixed emotions about her mother's estate. Lyons spent all of her time on her projects, which left little time and energy for family. Estranged from Lyons, Bower hadn't seen her mother in years. "I can't tell you anything about my mother, don't know anything about her. I'm just the little girl that Sophie Lyons forgot," she told the press. "My mother cast me aside when I was a tiny child and I got along alone all these years."

She married "an honorable man" and kept secret her family ties with her infamous mother. Now widowed, Bower was raising her daughter, thirteen-year-old Esther, alone.

Madeline Brady and Lotta Lyons Belmont each received a bequest of $2,000, but the bulk of her estate—half of her assets—went to her estranged daughter. In addition to several pieces of valuable jewelry, Florence Bower received her mother's cottage and half of the income from her various rental properties, which Lyons' will specified, could not be sold for fifty years.

The other half of the estate would go to creating and maintaining the Sophie Lyons Memorial Home—a center for children aged two to four with at least one parent incarcerated. The home, located on one of Lyons's properties on Twenty-Third Street, was to be maintained by earnings from her other properties. Lyons specified that the children of the home would be given four annual trips to Belle Isle, a Christmas celebration and a playroom stocked with toys.

Lyons never forgot her past, and she knew, from her dozens of stints behind bars, that hard time can be made a little less hard with diversions such as music and books. She set aside $1,000 to purchase a Steinway grand piano for the new Detroit House of Correction and $375 for annual subscriptions to magazines, such as the *Saturday Evening Post*, for several prisons including Sing Sing and Auburn in New York, Jackson and Marquette in Michigan. Another $50 per year was earmarked for sundries for Sing Sing's Death House inmates.

Overcome with emotion and the generosity of a larger-than-life figure she hardly knew, Florence Bowers vowed to make sure her mother's last wishes were honored.

Madeline Brady did not share her sister's emotions. She felt slighted and wanted an equal share instead of the token $2,000 bequest. She decided to

contest the slap-in-the-face will, which had left more to complete strangers than Sophie's own blood.

The legal action delayed the various bequests for years. Finally, in 1929, Bowers and Brady came to an agreement in order to avoid any further delay and any further litigation, which would deplete the value of the estate. This time, Brady received $42,000 in cash, which quieted her complaints about Lyons's postmortem gifts to prisoners.

With the estate finally settled, Lyons's grand plan went into action.

Sophie Lyons's generosity continued for decades after her death. For over thirty years, dozens of death row inmates enjoyed a last supper paid for by the Queen of the Underworld.

Sophie Lyons Burke, savior of countless felons, could not reform the condemned. So she bought them dinner instead, hosting their last suppers before they took the long walk to Sing Sing's electric chair.

THE HIDDEN CEMETERY

(1924)

*F*or three years, a wicked secret lay hidden in the darkness under the crawl space of a small frame house on Dwyer Street. Discovery of the hidden grave site would drag into the daylight Detroit's "Lady Bluebeard"—a cool character who was so dangerous to her lovers that two of her living husbands once congratulated each other on surviving.

While Detective Lieutenant Frank Collins waited in the car with their chief suspect, Sergeant Paul Wencel shimmied under the crawl space of the tiny house on Dwyer. Once he reached the halfway point, he began stabbing the earth with the bladed end of his crowbar. The dirt was sandy and easily gave way to the repeated thrusts.

After a few jabs, the crowbar struck something solid, about a foot under the surface, with a thud. Cupping his hands together, Wencel scooped out the loose dirt until a small crater formed. He then thrust both hands into the hole to probe for the object found by the crowbar. He felt something hard, like a tree branch, which he yanked out of the dirt with one firm tug. It was a human thigh bone.

He reached into the hole again, felt around the loose dirt, and removed another bone. And another. Wencel realized that he had found the clandestine grave.

Curious onlookers loiter around the infamous murder cottage, where suspected serial killer Euphema Mondich buried her last victim, 1924. Detroit News *photograph in the author's collection.*

A small crowd of curious had gathered to watch the strange excavation. They formed a hollow square around the front yard and watched as Wencel arranged the bones on the front lawn to form a skeleton.

This was all that remained of "John."

The serpentine path leading to Wencel's discovery of "John's" skeleton began with a missing person report, prompted not by the disappearance of the victim but by the disappearance of the perpetrator.

Steve Mondich reported his wife, Euphemia, missing. She apparently left after taking $5,700 in cash and valuables. Mondich explained to Detective Lieutenant Frank Collins that Euphemia's previous husband, Joseph Sokolsky, had vanished without a trace three years earlier—in July 1921—which had prompted a police investigation at the time. Based on

certain hints Euphemia had dropped over the previous months, Mondich believed she did away with Sokolsky.

Euphemia's marital history was a tangled tree with several gnarled branches.

A native of Poland, Euphemia Mondich married the first in a parade of husbands in the old country when she wed George Woodwood. When Woodwood died three years later, she immigrated to Toronto, where she married George Woropchuk. Whether he abandoned her, as she later claimed, or vice versa, as he later claimed, the marriage ended in 1914. Euphemia moved to Detroit, where she married Joseph Sokolsky in 1921. After he disappeared later that year, she filed for divorce on the grounds that he deserted her. The court awarded the divorce, and she went on to tie the knot with Steve Mondich.

To find Mondich's allegedly stolen bankroll and uncover the truth behind the disappearance of Sokolsky, detectives decided to bring in Euphemia for questioning.

Collins and Wencel scoured the neighborhood looking for Euphemia Mondich and interviewed neighbors on Osbourne who knew Euphemia and Joseph Sokolsky. They didn't find the elusive woman, but they did uncover some shady information that seemed to dovetail nicely with Mondich's theory about his predecessor's untimely demise. They learned that in the weeks before Sokolsky's disappearance, Euphemia was frequently seen in the company of a man unknown in the neighborhood. And when Euphemia subsequently moved to Dwyer Street, the unknown man stopped coming to her Osborne address. This unknown man, detectives reasoned, may have helped Euphemia get rid of husband number three.

Collins organized a full-fledged woman-hunt for Euphemia Mondich, but by Monday, September 8, authorities still hadn't managed to locate her. Then late that night, Collins received a cryptic tip from an anonymous caller; they could find her hiding in plain sight at the county courthouse. Euphemia Mondich intended to sell her house and leave the United States for Europe, the tipster explained.

Realizing that Mondich was one steamship ticket away from slipping out of his grasp forever, Collins raced to the courthouse, where he found Mondich alongside her attorney, Arthur Willard.

After a private conference with Willard, Mondich admitted to killing a man named "John" and agreed to take detectives to the spot where they could find his remains.

Darkness had begun to slowly descend on Detroit as the excavation under the Dwyer home came to an end.

Paul Wencel, his overalls covered with mud and dirt, stood by the side of the police wagon where Frank Collins waited with Euphemia Mondich. His eyes burned and his back ached. He did most of the digging by candlelight with his back hunched in the tightness of the crawlspace. By the end of the dig, however, they had uncovered all of "John," along with a steel pipe and a few pearl buttons.

Wencel put one foot on the running board, leaned against the car and looked at the woman in the back seat, now just an outline against the blue-hued twilight. She smiled, an expression that seemed to engage every muscle in her face. Her cheeks rose, her eyes narrowed and wrinkles formed beside each eye and at the both corners of her lips. Her lips puckered like she was sucking on a sour lemon drop. Besides the crow's feet and laugh lines, she appeared youthful. At first, Wencel couldn't read her expression, and then he realized that it was the look of self-satisfaction.

The hardboiled detective felt a tingle in his spine, as if an icy finger had slid up his back. The woman in the back of his car seemed to lack remorse. In fact, she appeared to be pleased.

After the excavation, Frank Collins interviewed Euphemia Mondich, who appeared completely unfazed by the discovery of a body under her cottage. Collins set a hat box on the table between them, took a chair and listened as Euphemia narrated the sordid story through a Polish interpreter.

"John" was John Udorovich, the unknown man seen with her just before Sokolsky dropped out of sight. Udorovich had rented a room in Sokolsky's house, where he fell in love with his landlord's wife. After a night on the town, the three were heading home when Udorovich and Sokolsky began to argue over Euphemia. Udorovich dropped Euphemia off at a friend's house while another man whom she didn't know climbed into the car. She never saw Sokolsky again.

"John and another man took my husband away and he never came back. John later told me he killed him and buried the body," Euphemia told Collins. Udorovich told her he buried Sokolsky's body in a giant hole on

Mack Avenue near Connors. The cavity was used as a dump, so the body was buried under tons of garbage.

After he widowed Euphemia, Udorovich made a play for her hand. "Then he asked me to marry him. I refused and moved away." She explained how she rented the Dwyer house to escape, but Udorovich found her anyway. The jilted suitor would not take "no" for an answer, which led to a confrontation at the Dwyer house. Euphemia described the fateful scene that played out inside the cottage bedroom.

Udorovich threatened to murder her if she didn't agree to marry him on the spot and pointed a revolver at her nose. Terrified for her life, she went along with it. He put the gun on a nightstand and lay on the bed. Euphemia lunged for the gun and shot Udorovich in the right eye, but the bullet did not kill him. With his eyeball jangling from the optic nerve, he made a break for it. Euphemia shot him a second time in the back while he tried to crawl out of the bedroom window. Then as he squirmed on the floorboards, she shot him a third time, this time under the chin.

Euphemia had told the story in an even, unbroken tone and without a hint of emotion. The lack of inflection seemed natural for the interpreter, who simply repeated the words he heard, but was unnatural—bizarre even—for a suspect admitting to murder. In his years on the force, Collins had never seen anything quite like it before.

Eying the hat-sized box sitting on the table in the interrogation room, she asked Collins what it contained. Collins pulled off the lid, reached into the box with both hands, removed Udorovich's skull, and placed it in front of Mondich. He was careful to place the skull with its empty eye orbits facing Mondich; he wanted to see if the grisly sight would change his suspect's demeanor. It didn't. Euphemia Mondich remained emotionless.

She stabbed a bony finger in the air toward the skull. "See, I tell you the truth. There's a hole under the right eye where I shot him, and there is the other under the chin."

Collins stood and with his index finger traced two hairline fractures on the top of the skull. These cracks were not caused by bullets, he noted. Euphemia had conveniently omitted how her victim had acquired these injuries, caused by a considerable force to Udorovich's cranium.

"I no know," Mondich said. "Maybe when I dragged body across floor?"

Collins knew Mondich was lying. If the hairline fractures occurred when she dragged the body, they would be on the posterior region of the skull. And fractures like that would have occurred only after significant trauma, like a blow to the head with the steel pipe they found next to Udorovich's skeleton.

There was something else bothering Collins. The furtive grave didn't contain clothes or clothes fragments. Mondich said that Udorovich was in his underwear when she shot him.

Again, Mondich seemed to be caught in a lie. She said the shooting took place in the late afternoon, so why wasn't Udorovich dressed? The lack of clothes suggested another scenario. Euphemia stood over Udorovich while he lay sleeping and shot him in the face. Collins suspected that Euphemia grew tired of Sokolsky and used Udorovich's affections to coax him into killing her husband. According to a neighbor Collins had interviewed, Euphemia offered her fifteen dollars to help her contract a hired killer to murder Joseph Sokolsky. Failing to find one, she used Udorovich. Then she did away with the hit man to obliterate any traces of her crime.

Euphemia Mondich had a lot to answer for, which she would do in front of a jury, members of the press and her two surviving lovers when the trial opened a few months later, in December 1924.

News of the sensationally bizarre case traveled fast, and the press further sensationalized it by exaggerating Euphemia Mondich's marital history. "WOMAN, WED 9 TIMES, HELD AS MURDERER," screamed the September 9, 1924, headline in the *Detroit Free Press*.

Incensed by the news, Mondich's attorney Arthur Willard went into full defense mode. He characterized his client as "feeble-minded" and explained that Steve Mondich used what incriminating information he knew about Sokolsky's murder to blackmail his wife into staying with him. He also condemned Udorovich as a crazed stalker who decided to murder Euphemia when she spurned his advances.

Willard denounced the story promoted by the police and published by the papers as misinformation. He called out Collins for perpetuating the mythical account:

> *Collins did not tell you that Mrs. Mondich had said that she had been threatened on numerous occasions by Udorovich and that from the day that he killed her third husband, Joseph Sokolsky, Mrs. Mondich lived in fear of her life. He did not tell that on the night she shot Udorovich he had brought the gun to the house and told her he had come to kill her. That part of the story was kept from the newspapers.*

The trial began on Thursday, December 13, 1924. Euphemia Mondich sat between her attorneys and within a few feet of John Udorovich's skull. For the first day of the two-day affair, she kept her composure despite the macabre, bullet-perforated reminder of her crime. On the second day, however, she began to unravel. With a Bible clenched in her trembling hands, Euphemia's stiff upper lip began to tremble, revealing underneath a deeply disturbed woman pushed to her emotional limit.

Holding her Bible, she testified on the trial's second day. Although minor elements of her story differed from what she initially told police, Mondich stuck to the main elements. Udorovich, she said, brained Sokolsky to widow her so he could become her next husband. The murder occurred during what she called "the death ride," when they were on the way home after the three had been out drinking together. During a subsequent argument, Udorovich clubbed Sokolsky. Careful to keep herself out of the car during the actual murder, Mondich testified that while Sokolsky lay unconscious, Udorovich dropped Mondich at a friend's house and drove off with her unconscious husband. She never saw Joseph Sokolsky again.

The next morning, Udorovich showed up at the friend's house, still drunk, and threatened to kill Mondich if she whispered so much as a word about the murder. When police questioned them about Sokolsky's disappearance a few days later, she stayed with the script and said nothing.

Mondich characterized Udorovich as an alcoholic Jekyll-and-Hyde of whom she lived in absolute terror. He became violent when he drank, which was often. Udorovich, she said, slept with his revolver under his pillow, and he frequently used it to threaten her. The fatal moment for Udorovich came after an argument over furniture. He threatened to shoot her if she didn't go buy new furniture with her own money. Afraid, she agreed.

When Udorovich placed the revolver on the nightstand and lay down on the bed, Euphemia reacted. Out of impulse, she grabbed the gun and shot him in the eye. Stunned by the nonfatal wound, Udorovich leaped from the bed and was half out of the bedroom window when Mondich shot him a second time in the back. Mondich then stood over him as he writhed in pain on the floorboards and shot him a third time, execution-style, in the neck. After the coup de grace, she waited until nightfall, when she dragged his bleeding body to a trapdoor leading to the crawl space beneath the house. She buried him in a shallow grave by candlelight.

It was murder, but it was done out of self-preservation. Udorovich wasn't silenced to protect Euphemia's plot to murder Sokolsky; he was a love-crazed alcoholic whose heavy-handedness ultimately led to his own demise. Euphemia's defense was a classic case of blaming the victim, who could not defend himself.

Or could he? The dark, empty orbits of Udorovich's skull faced the witness stand during the entire trial, as if the victim had come back from the grave to add his two cents. Ironically, the skull would provide some of the most convincing testimony in the case.

During a brutal cross-examination that left Euphemia Mondich sobbing convulsively, Robert Toms pointed out contradictions between her testimony and the forensic evidence. She claimed to have shot Udorovich in self-defense, but the skull fractures at the top of his cranium indicated at least one blow, and probably several, with a club-like weapon such as a two-by-four or a pipe. Mondich did not mention that detail in either her statement to police or during her testimony. To a chorus of "oohs" and "aahs" from the courtroom gallery, Toms held up the skull and showed the pencil-line fractures to the jury.

Then Toms pulled out the card that would trump Mondich's version of the shooting: a rib bone, excavated under her house on Dwyer by Detective Paul Wencel. The rib contained a groove that Coroner French testified was likely caused by a bullet wound to the front, not the back, as Mondich testified. Toms hadn't shown the bone to Mondich's defense team, who were caught entirely by surprise and didn't have a plan to refute the evidence.

By the time the jury returned its verdict less than two hours after retiring, Euphemia Mondich had regained her composure. "Not even an eyelash fluttered," wrote a *Free Press* reporter, when she listened to the guilty verdict.

She was still clutching her prayer book when Steven Mondich—her current husband—and George Woropchuk—her former husband in Toronto—said their goodbyes to her as she stood in the prisoner's dock. According to some accounts, each man shook the convicted slayer's hand and then, outside the courtroom, congratulated each other on surviving Euphemia Mondich.

In the new Detroit House of Correction—a prison farm in Plymouth Township that replaced the aging facility constructed in 1861—Euphemia Mondich kept to herself. Known as a loner who loved flowers, Mondich was put in charge of caring for the garden around the prison infirmary building.

When not tending to the garden, she could be seen around the grounds, sprinkling bread crumbs for the squirrels and the skunks that wandered in from the adjacent forest.

No one came to visit the lonely prisoner, and no one wrote her any letters to say hello or to pass on neighborhood gossip. For her first decade behind bars, she didn't receive a single piece of correspondence other than a periodic form letter from the Salvation Army. The headline-making woman had become yesterday's news, her name consigned to a pile of yellowing newspapers in the corner of the basement or used as a dropcloth for oil spills. Detroiters forgot about their "Lady Bluebeard," who became nothing more than another skeleton in the city's overly crowded closet.

In the late 1930s, Mondich fell chronically ill and spent her last decade inside a room at the infirmary. The lonely murderess made headlines one last time on August 29, 1961, when she died at the age of seventy-seven. The *Free Press* ran a short obituary, which summarized her crimes, under the headline "Death Claims a Kindred Old Soul, 77."

Joseph Sokolsky remains a missing person of sorts. A building was later constructed on the site at Mack where Euphemia Mondich located the makeshift grave, so police could not disinter the secret burial or confirm this portion of Mondich's statement.

His fate remains unknown.

16

THE FEMME FATALE

(1930)

\mathcal{T}he end to one of biggest robbery crews in Detroit history came at the hands of a pretty, twenty-two-year-old former nursing student who turned state's evidence and became the linchpin in the prosecution's case. Once arrested, the beautiful femme fatale dropped a dime on the six members of a gang led by former Detroit cop Henry Boroo.

Less than a week after a spectacularly brazen, February 10 robbery of the Bank of Michigan branch at the intersection of Wyoming and Puritan Avenues—which netted the thieves $5,542 in greenbacks—an unmasked thief waltzed into the lobby of the Presbyterian Hospital.

It was an unseasonably warm February 16 morning when a man approached Sister Mary Rosario, who was doling out payment to the hospital employees at 6:50 a.m. Noticing the stranger on the other side of the wrought-iron gates separating the general office from the lobby, Sister Mary suggested the man go to the information desk. Her mouth slowly dropped open as the man reached over the gate and unlocked it. The gate had a special lock, and only someone familiar with it could open it so effortlessly.

Sister Mary noticed the man eyeing the tin box. He lunged for it, but she plucked it from the table and clutched it against her chest. The man grabbed her from behind, slapped his left hand over her mouth and yanked the box from her grip with his right. He scooted back through the gate and ran out

the exit onto Wabash Avenue, another clue that he knew his way around the hospital lobby. The take consisted of $3,943 in currency.

The shaken nun described her assailant to Detectives Fred Drechsler and Harry Schouw. In his early twenties and well-dressed, the man kept his hand tucked into his pocket as if palming a pistol.

Police had no little to go on, but they did have one hot clue: whoever did the job had inside information. The thief knew where, and more importantly, when employees received payment. He also knew enough to unlock the gate and the fastest route from the lobby to Wabash. Detectives began scouring the list of employees past and present.

The Providence Hospital was hit a second time on February 28 when two men cornered Sister Mary McCormick in the tunnel leading from the nurses' home to the hospital. They demanded the hospital payroll, which McCormick said she didn't have, and the frustrated thieves bolted empty-handed.

After this second attack, Inspector William J. Collins—chief of the "hold-up squad"—zeroed in on a possible source of the inside information: Ruth Jones, a former employee, sacked, according to Sister Rosario, because the nuns discovered she was married. Rumor had it, though, that Jones filched some linens. Curiously, Jones had telephoned her former co-workers at the hospital two days before the second hold-up and asked about the payroll dates.

Jones provided an innocent explanation for the suspicious inquiry. One of nurses at the hospital owed her money, and she wanted to know when she could expect payment. Collins decided to leave Jones in play for the time being.

Meanwhile, robberies continued to dog police.

On March 22, a gang robbed the Ohio Bank and Trust Company branch in Toledo, Ohio, and made away with $7,022 in cash.

The masked crew left virtually no evidence. It was as if ghosts had targeted the area's banks. Police chased down empty tips and phantom suspects but remained clueless until one of the spectral gang's members made a critical mistake.

After the First National Bank Branch at the corner of Woodrow Wilson and Glendale was hit on April 3, netting the robbers $2,558, police found the getaway car at the intersection of Dexter Boulevard and Elmhurst Avenue and discovered that one of the robbers took a cab to a boardinghouse. The suspect, who matched the description of the man that held up Sister Mary

McCormick, had moved out of the house but left behind a shirt with a laundry tag containing a name, Leonard Koven, and an address.

Koven wasn't home when detectives came knocking, so they searched the apartment and found a picture of a student nurse. Several employees of the Providence Hospital identified the nurse as Ruth Jones. The pieces fit. The payroll robbery at the Providence Hospital was too well orchestrated for a random hit. Whoever planned the heist knew when, how and where the funds would be transferred.

Jones lived with a thirty-five-year-old named Edith Casppuies, but once again, police knocked on the door of an empty apartment. Canvassing the neighbors, investigators discovered that Casppuies owned a pet bulldog. With the photograph of Ruth Jones in hand, they pounded the pavement and found the two women walking Casppuies's bull dog. On April 5, 1930, they took both women into custody.

It didn't take long for Jones to roll over on her friends. "It was easy," Schouw wrote in a 1936 *Detroit Times* feature article about the case. "So easy, I couldn't believe it. We had her in tears in 10 minutes."

Ruth sang to Inspector William Collins. Her aria, a narrative of the gang's history, contained six names, including that of her boyfriend, career criminal Leonard Koven.

The twenty-two-year-old Ruth Jones had the kind of face that simultaneously conveyed innocence and mischievousness. The doe-eyed beauty gazed at detectives the way a daughter looks at a father when scolded. With her toes pointed inward, her knees pinched together, and her hands folded on her lap, she looked like a complete innocent, yet a sparkle in her eyes hinted at a more deviously playful side behind the placid exterior.

A native of Canton, Ohio, Ruth left her estranged husband, Everitt Jones, and baby daughter and moved to Detroit. For awhile, she worked as a student nurse for the Providence Hospital until allegations of theft, based on missing linens, led to her dismissal in December 1929.

Jones's association with organized crime began when she started seeing Matthew Cremmins shortly after arriving in the Motor City. Cremmins made his living taking scores with a gang of bank robbers, which included a charmer and schemer named Leonard Koven.

Koven's criminal odyssey began at the age of fifteen when he helped a pair of seasoned thieves dynamite a safe in Minot, North Dakota. When caught,

the two older men received sentences of twenty to forty years, but the teenager escaped with the comparatively minor penalty of two years in a reformatory. He wormed his way out of an automobile theft charge in December 1928. Six months later, he began a life on the straight and narrow when he married in June 1929—a marriage destined to fail after he met the alluring Ruth Jones.

In an attempt to impress his friend with his stunningly beautiful girlfriend, Cremmins introduced Jones to Koven.

It was a bad move for Matt Cremmins.

Ruth Jones dumped Cremmins and began an affair with the married Koven, who left his newlywed wife on Valentine's Day 1930. He subsequently moved in with the Boroo brothers, former Detroit cop Henry and his brothers Samuel and Thomas.

The best kept secret of gangland Detroit, Henry Boroo had by that time already masterminded several heists. Along with Cremmins and Koven, the Boroo boys formed the nucleus of a gang that began taking major scores during the spring of 1930. Kovens introduced his roommates to his lover, Ruth Jones, who lived with Edith Casppuies at 620 Peterboro Street. Through Jones, the Boroos met Casppuies's sweetheart, Ralph Benham, who became the sixth member of a group later known as the Boroo Gang.

At first, Jones downplayed her role in the group, depicting herself as nothing more than a bank robber's girlfriend who watched the game from the sidelines. The evidence, however, suggested that Jones was more than a cheerleader and may have actually designed some of the plays, particularly those involving the Providence Hospital.

Inspector Collins believed that Ruth Jones and her housemate Edith Casppuies aided the men by casing the banks. They would open accounts and, during subsequent transactions, study the bank interiors. Then, they would make sketches for the men. Collins also believed the pretty moll played a seminal role in planning the Providence Hospital payroll heist; this scenario explained how the gunman knew so much about the hospital.

Jones, however, denied any direct involvement in the gang's operations. She only admitted to talking to her friends about the hospital's payroll dates and procedures prior to the February 28 attempt. It just so happened that those friends also belonged to an infamous crew of thieves. In speaking to Collins, however, Jones let a few damning details slip about her exact role in the Providence Hospital thefts. She subsequently copped to planning the second robbery of the Providence Hospital but still insisted she had nothing to do with the first. In fact, she said, she thought of the second robbery only after reading news of the February 16 heist.

"I had left the hospital," Jones told Collins, "but called a nurse I knew by telephone and learned the details. After I found out everything I could about the way the pay money would be handled, I drew a diagram of the hospital and gave it to Leonard Koven. He led the holdup." For her inside information, Jones said, she was to receive a third of the take.

Edith Casppuies steadfastly denied any wrongdoing besides keeping mute about the crimes. "I knew what was going on all the time but was too afraid to take part," she told Collins. "I had nothing to do with any holdups." Despite his suspicions, Collins had no concrete evidence against Casppuies and excluded her name from any of the arrest warrants.

Police arrested the other gang members and held Ruth Jones as a material witness. With the possibility of an arrest warrant dangling over her head, Jones had little choice but to cooperate and turn state's evidence. Collins didn't want the moll; he wanted the muscle.

Burned by Jones, both Cremmins and Koven gave lengthy confessions, naming the three "Anderson brothers" as their partners-in-crime and "Mr. Anderson" as the gang's ringleader. Anderson, Koven squealed, was the alias of former vice cop Henry Boroo.

Despite Collins's suspicions about the depth of Ruth Jones's involvement, enterprising Detroit reporters embraced the sensational notion of an ex-cop as a gangland mastermind. They couldn't resist pointing out that some of Henry Boroo's earlier jobs occurred while he served on the force. Fred W. Frahm, chief of detectives during the decade of the turbulent twenties, went so far as to state, "In several instances, he and his mob held up banks in the morning, and when he came to work in the afternoon, he was assigned to the very bank jobs in which he had participated."

Inside Detroit, Henry Boroo became the poster child for a corrupt police department with a list of Prohibition-era crimes longer than Woodward Avenue, but outside of the Motor City, some reporters seized on the novel idea of two women masterminding a theft ring. The *Mt. Pleasant Daily Times* headline about the arrests capitalized on Collins's suspicions in size seventy-two font: "WOMEN NAMED BRAINS OF GANG." One Ohio rag dubbed her "queen" of the bandits.

Whether the brains of the operation or merely a part-time plotter, Ruth Jones started a chain reaction that brought down the entire gang. She gave police Leonard Koven and Matt Cremmins, who in turn fingered the Boroo brothers. With Jones's complicity still a question mark, investigators focused on the gang's most notable member and most likely chief, Henry Boroo.

Once fingered by Koven and Jones, Henry Boroo gave several, lengthy confessions in which he detailed over a dozen robberies. It was an odyssey of crime that began when the sirens of sin lured a good cop to the other side of the law.

According to his twenty-four-year-old wife, Marie, Henry's downfall started when he went to work for the Central Station's "cleanup squad"—a vice unit with an illustrious history of graft allegations and inappropriate liaisons with the city's madams. Exploring the city's seedy underbelly affected Boroo, and he began to drink heavily. "He drank only occasionally," Marie recalled, "until he became a member of the Central station cleanup squad....He drank heavily and often remained away from home until late, giving police duties as his excuse." At this point, the patrolman had turned to a life of a crime and began taking scores, first minor jobs such as holding up a taxi driver on Grand River Avenue and robbing a gas station at Fourteenth and McGraw Avenues.

Each time, he steeled his nerves with whiskey, but the rush of the robberies provided the real intoxication. Boroo described it like a narcotics habit that had taken ahold of him. And, like a junkie, he needed bigger and more grandiose jobs to achieve the same high. He graduated from knocking over gas stations for $30 to hitting the American State Bank at Hamilton and Moss Avenues for a haul of $10,000—a job he did with his brother Thomas. Proving that there is no honor among thieves, Henry shorted Thomas on the take.

Eventually, his double life caught up to him. In January 1930, the department dismissed him for drinking on the job, and he turned to theft as a full-time occupation. He even used Koven in an unsuccessful attempt to obtain a machine gun for $500. At the height of the gang's operations, Boroo had acquired a stockpile of small arms that he kept buried in a field adjacent to Nine Mile.

By this time, Koven had fallen for Ruth Jones, and through his love-struck confederate, Henry Boroo met both Jones and her roommate Edith Casppuies. According to Boroo's confession, the gang, now numbering six, subsequently engineered several high-profile bank robberies. The bandits exonerated Ruth Jones in their confessions, although doubts lingered among some investigators.

Whatever role she did or did not play in plotting the heists, Ruth Jones knew something incriminating. The prosecution held her as a trump card against the other bandits. She testified against Henry Boroo and his two brothers, all of whom eventually pleaded guilty.

Henry Boroo, who admitted to fourteen robberies—thirteen with this brother Thomas and one with his brother Samuel—begged the court to go easy on his brothers. In his final statement before sentencing, he told Judge Henry S. Sweeney that he had led his brothers into a life of crime and asked Sweeney to give them light sentences. "I am responsible for them going into the stick-up racket," Boroo admitted to Sweeney.

Sweeney didn't listen. Samuel received five to twenty years; Thomas, fifteen to thirty; and Henry, twenty to forty.

A few weeks after the cell doors slammed on the Boroo brothers, Ruth Jones testified against former boyfriend Matthew Cremmins and current love Leonard Koven. According to Jones, Cremmins was the man who cavalierly walked into the lobby of the Providence Hospital on February 16 and walked out with the institution's payroll. During the second robbery, Jones said, Koven stopped Sister Mary McCormick and demanded payment, while Cremmins manned the getaway vehicle.

Cremmins received one to ten in the Big House at Jackson; Koven, who also played a role in the April 3 robbery of the First National Bank, received seven and a half to fifteen.

The case captivated Detroiters.

On Saturday night, May 17, WJR radio in Detroit capitalized on the notoriety of the gang and ran a dramatization of the gang's exploits. As the fictional bandits tangled with molls and evaded gumshoes, their real-life counterparts settled into their cells for a long stay at the State Penitentiary in Jackson.

Jones, who evaded mention in any of the arrest warrants, remained in Women's Detention Home until May 21, when authorities decided to release her. William Collins reluctantly acknowledged they didn't have sufficient evidence to proceed with charges. "We haven't enough evidence to take her into court," Collins told the press. Jones avoided any legal consequences for her association with the infamous bandit gang.

She vowed to wait for "Len," no matter how long it took.

Thanks in large part to his femme fatale, it would be awhile.

IF SHE CAN'T HAVE HIM...

(1944)

*M*y love for him was so great," Nina Housden said about her soon-to-be-ex husband, Charles, "that I could not sleep. He had been running around with women and I could not stand that. Now I feel perfectly free. It is a great load off of my mind. I have never felt better in my life."

She was a woman scorned, and she created the perfect plan to take revenge on her philandering husband. Then, fate intervened.

Nina Housden had a special Christmas gift for her estranged husband, Charles, which she planned to give to him on the evening of Monday, December 18, 1944.

A native of Paducah, Kentucky, Nina was married and working as a waitress in a diner near an army base in Missouri when she first met Charles Housden, a soldier stationed at the base and a fellow Kentuckian. The son of Ashley and Queenie Housden, Charles grew up on a farm near Concord. Smitten, Nina quickly divorced her first husband to make room for Charles.

Their unhappily-ever-after began when they tied the knot a few months later. The marriage was doomed from the start. Nina later alleged that Charles had a violent streak and frequently beat her, which led to not one but two miscarriages. According to Nina, Charles Housden also had a zipper problem and openly bragged about his affairs.

He may have been all of these things, or none of them, depending on how truthful Nina was when she later described their relationship from a jail cell.

Despite Charles's innumerable trysts, his heavy-handedness and his vexing tendency to compare Nina to his various sexual conquests, she desperately wanted to keep the flame ignited. By September 1944, however, she had admitted defeat and filed for divorce.

Yet Nina could not let go. "It was hell with him," she later said, "and hell without him."

So, she followed Charles to Detroit, where he had taken a job with the Greyhound bus company, and began to stalk her ex. She called him, sometimes hanging up just as he answered, and sometimes berating him in lengthy rants. She sent him letters and telegrams. She followed his bus in a taxi, and when the taxi passed by, she yelled at him from the backseat window. She showed up at the bus terminal and sometimes even rode on Charles's bus, watching him from one of the back seats. He tried to push her away by boasting about the many women he picked up on his route, even inviting her to watch him in action. But as hard as he tried, the bus-driving Lothario could not shake Nina, so he took the drastic step of seeking legal protection. In October, a judge issued a restraining order.

Despite this court-ordered protection, on the eve of their divorce—December 18—the couple went out to dinner and a movie: one final date before the courts severed their union forever.

Somehow—probably using the promise of sex—Nina lured Charles to her basement apartment at 50 Gerald in Highland Park for a nightcap. In a statement to police, Nina set the scene: Charles emerged from the bedroom in his underwear and began to gloat about his many affairs. With this description, Nina hinted that she and Charles had some makeup sex that night, and he may have compared Nina's performance in the bedroom with that of another woman, or he may have made a disparaging comment about her lovemaking. Or he may have told her that this was really "goodbye"—an eventuality Nina would not or could not accept. Or he may have simply slipped out of the bedroom to stretch his legs and smoke a cigarette.

She also told police that she had scripted the next scene over a year earlier; she hatched the plot sometime in late 1943—nine months before she had applied for a divorce.

As Charles stood with his back turned to Nina, she found a length of cord in the closet, created a makeshift noose, tiptoed behind him, and slowly slipped the loop over his head.

Before Charles had time to react, Nina yanked on the ends of the garrote, pulling it taut. He clawed at his neck as she pulled it tighter, propping her leg

against a chair for leverage. The cord appeared to sweat beads of blood as it bit into the skin of Charles's neck. When the noose slipped, Nina slid a knife handle in the knot and twisted, tourniquet-style, until it wouldn't budge. Charles cringed, his face turning into a maze of creases and taking on the appearance of a crumpled, damp napkin.

His legs jerked spasmodically, but the more Charles kicked, the tighter Nina twisted the tourniquet. Her knuckles turned white, and the muscles of her forearms popped through the skin like steel cables, as Charles's body jerked several times. Every muscle in his torso seemed to harden. She held her grip as his body softened and slumped to the floor.

As she caught her breath, she stared at her palms, which were crisscrossed with rope burns.

Then she sat at the kitchen table and worked on a crossword puzzle.

After awhile, she dragged the body to the edge of her bed. She tucked her arms under his armpits and, using her body as a counterweight, hoisted the corpse onto the mattress.

Nina finally had Charles just where she wanted him.

She left the corpse on her bed and took a walk.

The lights of the Detroit skyline faded and darkness descended on the city as Nina Housden sped south on the Dixie Highway toward Toledo on the evening of Friday, December 22. Gusts of frigid air created small swirls that danced across the highway. As the year grew older, the temperatures dropped; the mercury hadn't reached the thirties in over a week. Detroiters tried to keep warm by huddling into movie theaters, watching Bogart and Bacall sizzle in *To Have and Have Not*, or flocking to taverns, where they downed shots of liquid heat. In Europe, the Battle of the Bulge raged—the German army's last major offensive in western Europe.

Housden glanced at the two boxes and roll of rubberized cloth sitting on the back seat: a dark secret she hoped to bury in the caves near her hometown of Paducah, Kentucky.

Then, about twenty miles north of Toledo, her car broke down.

The wind howled outside the Leonard Garage as Nina Housden sat in the back seat of her car. Mechanics said it would take two days to fix the

automobile, but oddly, Housden refused to leave the vehicle. She appeared overly protective of the foul-smelling boxes in the back seat, which she said contained venison. To keep away prying eyes, she even ordered meals delivered to the garage.

When she fell asleep in the back seat on Saturday night after a twenty-four-hour-long vigil, a curious mechanic peeked into one of the boxes. He pried open the lid to find two lifeless eyes staring at him. The box contained Charles Housden's decapitated head.

Nina Housden spent Christmas Eve in the Toledo police station talking to Detective Ralph Murphy of the homicide squad.

A petite thirty-three-year-old with high cheekbones, dark chocolate–colored hair and full pouty lips accentuated with crimson lipstick, Nina had the kind of good looks that kept boys up at night. Waves of loose curls spilled down her right shoulder as she explained, in a soft drawl, how Charles Housden wound up in pieces on the back seat of her car.

She had planned the murder for over a year she said, suggesting that as far back as December 1943, she had decided to do away with Charles as a way of keeping him for herself. At first, she envisioned stabbing him with a butcher's knife but later abandoned the blade in favor of the rope. Her last "date" with Charles would be a fateful one.

"I put the rope around his neck," she told Murphy, "braced myself on a chair, and pulled until he was dead."

"This is the first peace of mind I've had. Now I know where he is. He was my soulmate," Nina explained. The vengeful wife also wanted blood from Charles's lovers. "If I were free," she told Detective Murphy, "I would go to Kentucky and kill a couple of women he had affairs with." It was clear that Nina Housden was prone to obsession and extraordinarily possessive to the point where she drove around Detroit with her husband's dismembered corpse for a few days before taking the pieces south for a secret interment.

As Detroit kids ripped open presents on Christmas morning, Nina Housden rehashed the murder and dismemberment of Charles Housden to Assistant Prosecutor Harold Helper.

This time, she provided a less selfish motive. "I knew I had to kill him because he took special pride in going out with wives of other men he met at the station," she said without emotion. "He boasted about them and I was jealous."

Nina added a few gruesome details during her second confession.

After the murder, she dragged the body to her room and placed it on her bed. She walked around the block a few times to steel her nerves and, when she returned, moved the body onto a sheet of rubber she purchased to make a raincoat. Then, using a razor, she sawed off both feet, then the legs at the knees, the arms at the elbows and, finally, the head.

She placed the head and arms in one box, the legs and feet in another. Then she rolled up the torso in the rubber sheet.

"I'm sorry he's gone," she said during a moment of introspection. "I really loved him."

A curious scene took place in the courtroom of Judge George Badder during Nina Housden's arraignment.

Asked to plead, Nina looked back at Charles Housden's sister in the audience and answered, cryptically, "I'm guilty, but so are a lot of other people." She blamed the woman for pandering to Charles Housden's insatiable sexual appetites by setting him up with various paramours.

In Nina Housden's twisted way of thinking, that made her sister-in-law partially to blame for Charles's murder. "He was maneuvered into a situation where I had to kill him," she later explained about her bizarre statement.

Judge Badder dismissed Nina's plea as ambiguous.

Nina Housden's ten minutes of infamy arrived when she testified in front of a jury consisting of seven women and five men during her first-degree murder trial of April 1945.

The icy expression and unbroken tone that characterized her confessions had evaporated during her sixth months behind bars. She dabbed at her eyes with a handkerchief and tried to speak in between fits of sobbing.

Her time on the stand consisted of postmortem mudslinging at Charles. He promised to give her children but beat her so relentlessly she miscarried twice. He ran around constantly and rubbed his affairs in her nose. He

compared her to other lovers. A few of the female jurors winced when Nina described how Charles ridiculed her body.

She contradicted her previous confessions when she claimed that, after she garroted Charles, she tried to resuscitate him. This attempt to undo the murder, she hoped to persuade the jury, proved that she had committed a crime of passion and not a calculated, premeditated murder.

The jury instead believed Chief Assistant Prosecutor Frank Schemanske, who pointed out during his summation that Nina completed a crossword while her husband lay dead on the floor with a rope still twisted around his neck.

Nina Housden stood motionless as the jury foreman read the verdict, a product of four hours in the deliberation room. For the first time during the trial, she kept her composure even as she stared at the bleak prospect of life in prison.

After serving twenty-two years, Nina Housden was released from prison in 1967. A battered wife who acted out of a self preservation, or a spurned lover who would not tolerate life without her soul mate? The question remains.

THE END

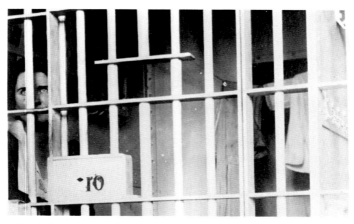

A lonely inmate peers through the bars of her cell, circa 1916–18. One of the leading manufacturers of prison cells at the time was E.T. Barnum (not to be confused with P.T. Barnum, the great showman), a Detroit-based manufacturer of steel and iron goods. *Library of Congress Prints and Photographs Division.*

FOR FURTHER THOUGHT
AND DISCUSSION

1. In the days before women's suffrage, female defendants often tried to win sympathy points with all-male juries. Cite three examples of this tendency.

2. Chicago attorney John Wayman created a profile for garden-variety husband-slayers. According to Wayman, she commits her crime not on impulse but on a carefully engineered plan. She takes her "victim unaware," usually in some type of blitz attack—while he's asleep or his back is turned. If caught, she doesn't bat an eyelash to besmirch her victim's reputation. And she invariably claims temporary insanity. In what way(s) does this profile apply to May Ford, Euphemia Mondich and/or Nina Housden?

3. According to societal norms of the late nineteenth and early twentieth centuries, childrearing was the job of women. How did Isma Martin and Nellie Pope try to take advantage of this gender stereotype?

4. Successful con artists excel at manipulation. What strategies did Isma Martin and Mother Elinor employ to manipulate others? What character traits did they or their fictitious personas share?

5. According to criminologists, a psychopath exhibits the following characteristics: exceptional charisma and charm, an inflated sense of self-worth or narcissism, a lack of remorse, a lack of empathy, pathological lying, a tendency to take big risks and an uncanny ability to manipulate others. Which, if any, of the wicked women featured in this volume match this profile?

BIBLIOGRAPHY

Books

Buhk, Tobin T. *The Shocking Story of Helmuth Schmidt: Michigan's Original Lonely Hearts Killer*. Charleston, SC: The History Press, 2011.

Burton, Clarence Monroe, ed. *The City of Detroit, Michigan, 1701–1922* (5 volumes). Detroit, MI: S.J. Clarke Publishing, 1922.

Catlin, George. *The Story of Detroit*. Detroit, MI: Detroit News, 1923.

Farmer, Silas. *The History of Detroit and Wayne County and Early Michigan* (2 volumes). Detroit, MI: S. Farmer & Company, 1890.

Ross, Robert, and George Catlin. *The Landmarks of Detroit: A History of the City*. Detroit, MI: Evening News Association, 1898.

Willemse, Captain Cornelius, George James Lemmer and Jack Kofoed. *Behind the Green Lights*. New York: Garden City Publishing Company, 1931.

Documents

"Passport Applications," compiled January 6, 1906—March 31, 1925. Record Group 59: General Records of the Department of State, 1763–2002. M1490, Textual Archives Services Division, National Archives and Records Administration, Washington, D.C.

State of Michigan Probate Court for the County of Oakland, Michigan. "In the Matter of the Estate of Gertrude Schmidt, a Minor." Case file 14375.

———. "In the Matter of the Estate of Helmuth Schmidt, Deceased." case 14376.

Newspapers

Ann Arbor Courier
Cincinnati Inquirer
Detroit Advertiser
Detroit Evening News
Detroit Free Press
Detroit News
Detroit Times
Detroit Tribune
Grand Rapids Herald
New York Herald
Pontiac Press Gazette
Royal Oak Tribune

ABOUT THE AUTHOR

A connoisseur of crime (history), a gourmet of the ghastly, an aficionado of the atrocious, a fanatic of the felonious and a maven of misdeeds, author and researcher Tobin T. Buhk enjoys exploring the back alleys of Michigan history and shining a flashlight on the contemptible characters and dastardly deeds hiding in the darkest corners. *Wicked Women of Detroit* is his tenth published book. To research his first book, he spent a year as a volunteer in the Kent County Morgue. Find his speaking schedule at www.tobinbuhk.com or take a walk on the dark side of history at his blog, www.darkcornersofhistory.com.

Visit us at
www.historypress.com